ANTONY GORMLEY

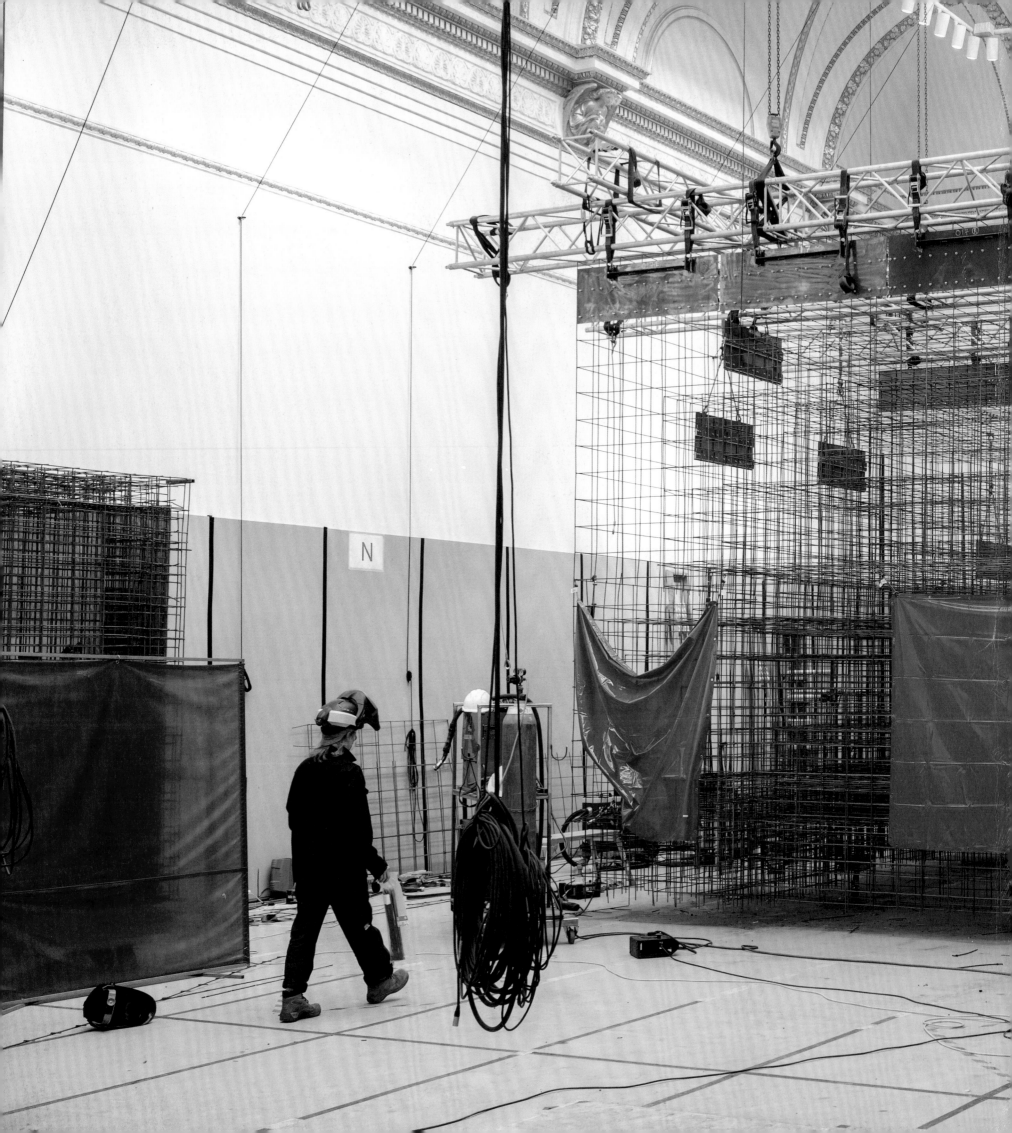

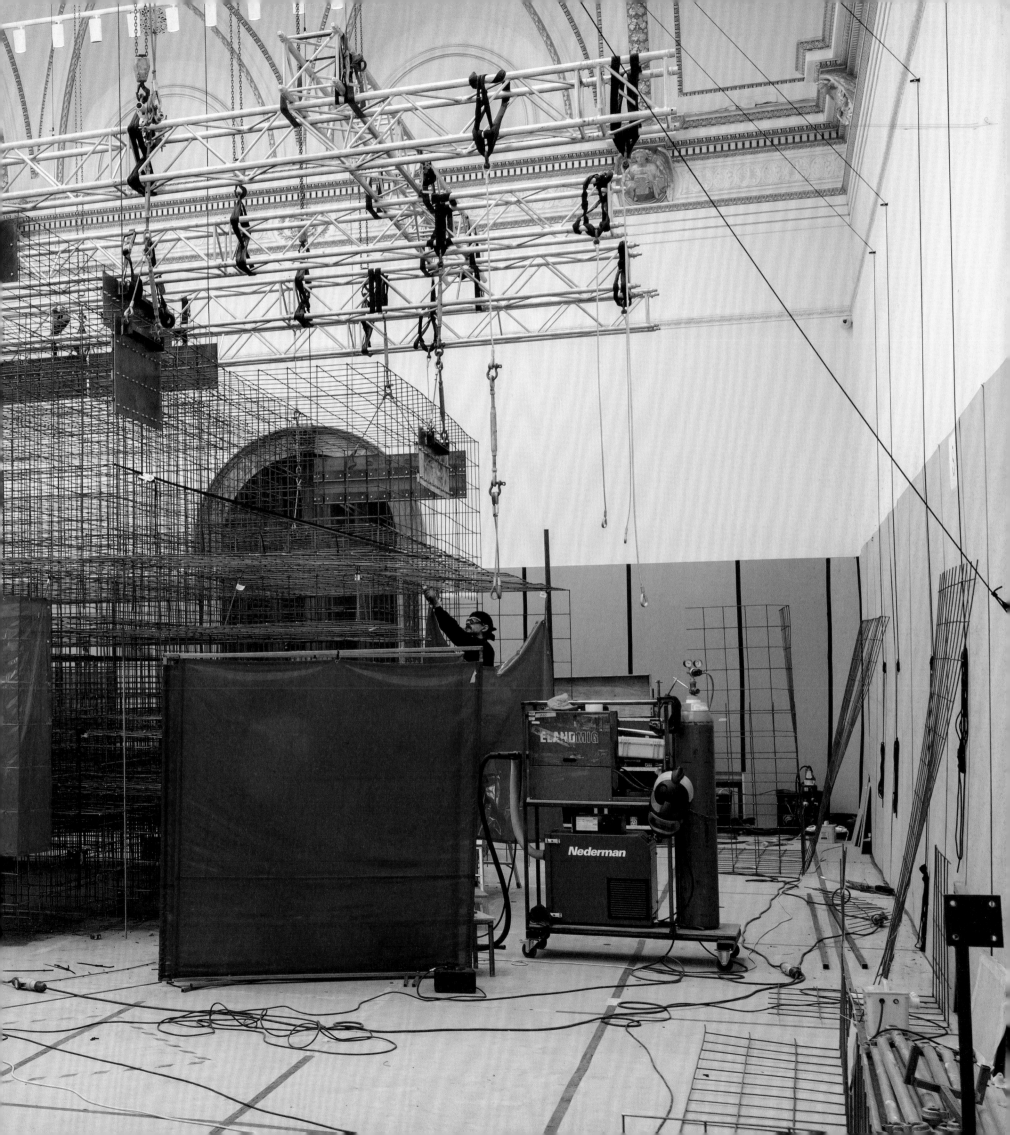

ANTONY GORMLEY

Royal Academy of Arts

First published on the occasion of the exhibition
'Antony Gormley'

Royal Academy of Arts, London
21 September – 3 December 2019

Lead supporter

The bank for a changing world

Generously supported by

WHITE CUBE

Generously supported by

FAMILY FOUNDATION

Supported by

The Steel Charitable Trust

Cate Olson and Nash Robbins

ROYAL ACADEMY OF ARTS

Artistic Director
Tim Marlow

Exhibition curated by Martin Caiger-Smith,
with Sarah Lea, assisted by Lucy Chiswell

Exhibition Organisation
Idoya Beitia
assisted by Nancy Cooper

Photographic and Copyright Co-ordination
Caroline Arno

Exhibition Catalogue
Royal Academy Publications
Florence Dassonville, Production Co-ordinator
Alison Hissey, Project Editor
Carola Krueger, Production Manager
Peter Sawbridge, Editorial Director
Nick Tite, Publisher

Antony Gormley Studio: Rosalind Horne,
Publications Manager
Picture research: Sara Ayad
Design: Lizzie Ballantyne
Colour origination: DawkinsColour, Ltd

Printed in Italy by Graphicom

All works and text by Antony Gormley
copyright © the artist, 2019
Text by Jeanette Winterson CBE copyright © the author, 2019
Copyright © 2019 Royal Academy of Arts, London

British Library Cataloguing-in-Publication Data
A catalogue record for this book is available from the
British Library

ISBN 978-1-912520-29-9 (paperback)
ISBN 978-1-912520-05-3 (hardback)
ISBN 978-1-912520-32-9 (signed limited edition)

Distributed outside the United States and Canada
by ACC Art Books Ltd, Sandy Lane, Old Martlesham,
Woodbridge, Suffolk IP12 4SD

Distributed in the United States and Canada by ARTBOOK
| D.A.P., 75 Broad Street, Suite 630, New York, NY 10004

Editors' Note
Dimensions of works of art are given in centimetres,
height before width (before depth).
All works illustrated are by Antony Gormley unless
otherwise stated.

Illustrations
Endpapers: *Branches*, 1992 (detail)
Pages 2–3: *Matrix III*, 2019; work in progress at Royal
Academy of Arts, September 2019
Page 9: Antony Gormley installing *Pile I*, 2017 and *Pile II*,
2018, Royal Academy of Arts, September 2019
Page 11: Drawing Studio at Vale Royal, 2019; *Exercise
Between Blood and Earth*, 2019, on the wall in the
background

Contents

President's Foreword

Of all the forewords written over the past eight years, I am especially pleased to be introducing this major exhibition by Antony Gormley, an artist I have known and greatly admired for many years.

The Royal Academy has in recent years earned a reputation for some of the most important monographic exhibitions by living artists, and this has underlined one of our key points of differentiation, namely that we are a place where artists take the initiative. Our exhibitions, whether with David Hockney, Anselm Kiefer, Ai Weiwei or Phyllida Barlow, are characterised above all by a spirit of collaboration, and by encouraging the artist to take the lead in the most ambitious ways they can conceive.

The sense of profound possibility and concentration of energy that animated Antony's work when I first saw it in 1980 continues to this day. Tirelessly he has worked on aesthetic renewal, seeming too busy with invention and discovery and the occasional self-imposed physical hardships of making to have time for the lesser artistic mode of irony. His is an attitude suffused with the romance and promise of art, but that is not how he would put it. Yet, and this is how I would put it, those qualities may well be essential in defining whatever we may come to describe as great.

The Royal Academy's relationship with Gormley began in 1998, when *Critical Mass II* was displayed in the Annenberg Courtyard – a group of 60 cast iron figures in twelve different positions lying on the ground and suspended from the building's facade, making an acute commentary on both the traditionally presented bronze sculpture of Joshua Reynolds by Alfred Drury, and the conventions of Western art. Gormley's celebrated *Angel of the North* had been installed just three months previously outside Gateshead in Tyne and Wear. Over twenty years on, Gormley returns to the Academy with his most significant exhibition in the UK for over a decade, continuing to observe aspects of life that we take for granted and to explore our place in a wider universe. Living in 2019, in a world that is increasingly man-made, Gormley proposes a deeper relationship with the built and natural environments that surround us. He was elected a Royal Academician in 2003, and this monographic exhibition now provides us with an opportunity to show works that range over the full 45 years of the artist's career to date.

We are extremely grateful to Antony Gormley for his dedication and commitment to this exhibition. Martin Caiger-Smith has worked with the artist to shape the curatorial vision for the project, which brings together existing works as well as those that have been especially conceived for the occasion. Martin's expertise and understanding of Gormley's *oeuvre* has been invaluable. The selection includes works on a widely diverging scale, from intimate objects to expansive and ambitious installations that take on and energise the entire space of the Royal Academy's Main Galleries and Annenberg Courtyard, and which justly show the varied nature of Gormley's practice.

This ambitious undertaking would not have been possible without the tireless commitment of Antony Gormley Studio, who have worked on the project for the past three years and who have shown unparalleled devotion in the final months.

Fundamental to the making of this exhibition has been the dedication of the staff at the Royal Academy. I am particularly grateful to Tim Marlow, Artistic Director, who initiated the project and has been actively involved throughout. Idoya Beitia, Head of Exhibitions Management, has been integral to the success of this exhibition, which has surpassed all previous exhibitions in terms of its logistical complexity. Idoya has been ably assisted by Nancy Cooper, Assistant Exhibitions Manager, in facilitating all practical aspects of the exhibition. The advice of Philip Pearce, Head of Surveying, and Philip Cooper, Director of Structures at CAR Ltd, has been vital, and demonstrated that creative thinking reaches every aspect of exhibition making. Further thanks go to Sarah Lea, Curator, and Lucy Chiswell, Assistant Curator, who have been committed to bringing the project to completion. I would also like to thank the great many members of staff who are not mentioned here but who have gone above and beyond in the realisation of this ambitious project.

Finally, we are indebted to our lenders and sponsors. We sincerely thank the private collectors and museums who have made their works available for loan for the public to experience. BNP Paribas have once again been munificent in their support, sponsoring the Royal Academy for the 19th year and extending the reach of this exhibition with their *AccessArt25* programme. We are immensely grateful to White Cube, the Blavatnik Family Foundation, the Steel Charitable Trust, and Cate Olson and Nash Robbins, all of whom have generously sponsored this endeavour. Without these supporters it would not be possible for us to present exhibitions of this visionary scale and quality.

Christopher Le Brun
President, Royal Academy of Arts

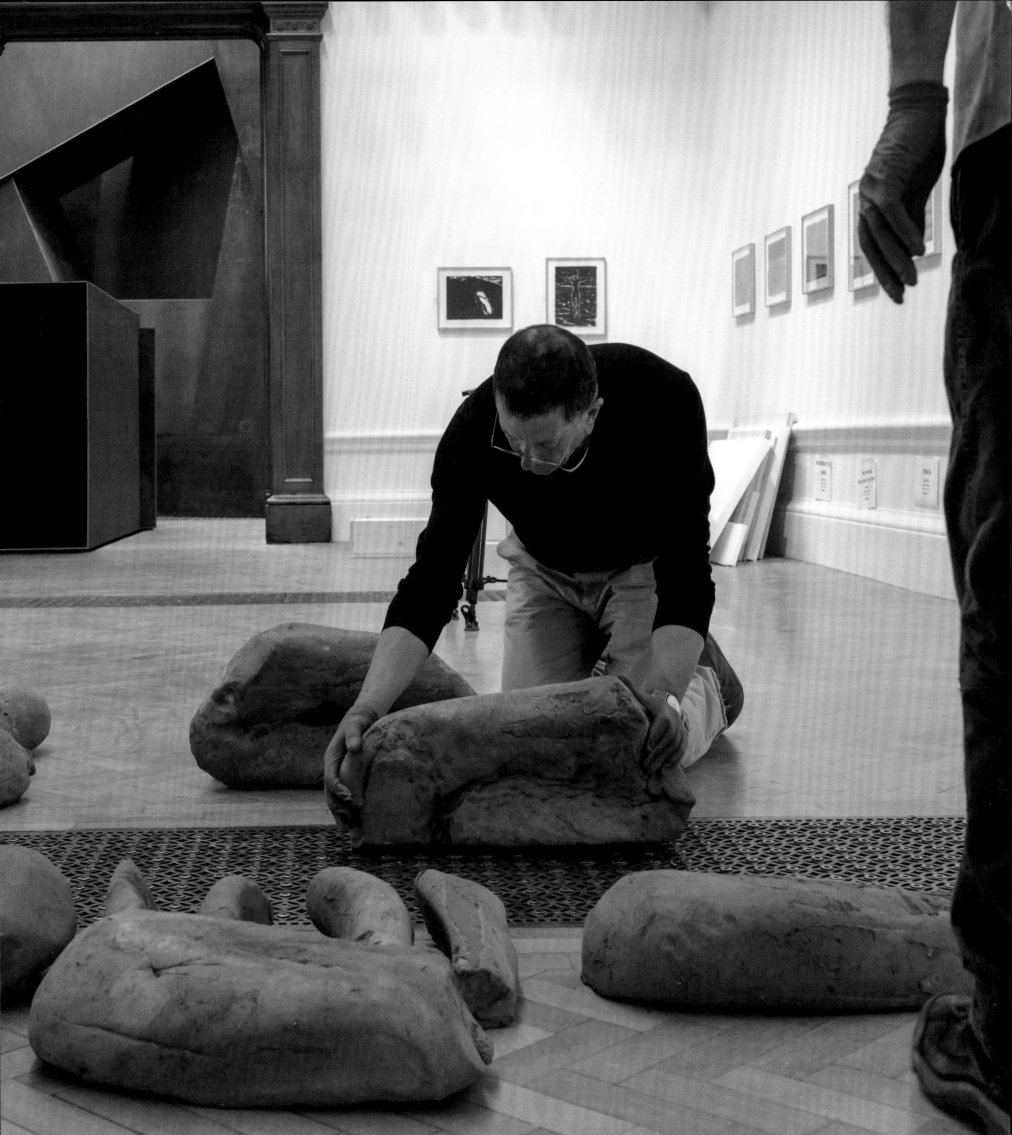

Sponsor's Statement

As the bank for a changing world, BNP Paribas is committed to building a more balanced, sustainable society.

We believe that art plays a crucial role in this effort, as reflected by our 19-year partnership with the Royal Academy of Arts. We are proud to extend that relationship by supporting this landmark exhibition by Antony Gormley.

Knowing the vital role art plays in building a better society, we believe it should be accessible to all. Through our *AccessArt25 programme*, we will enable 3,000 young people who are new to the RA to visit 'Antony Gormley' for free through a series of specially designed events.

Anne Marie Verstraeten
UK Country Head, BNP Paribas

Acknowledgements

ArcelorMittal: Tony Mulock, Dave Sheedy, Phil Taylor; Lizzie Ballantyne; Arup: Anthony Davis, Jim Deegan, Vasilis Maroulas; Brider & Bull; Martin Caiger-Smith; Cambridge Art Insurance: Peter Milne; Philip Cooper; DawkinsColour: John Bodkin, Simon Neal; Harry Dwyer; Michael Gallie & Partners: Sam Lloyd, Steven Langdown; Ian Gardner; James Garside and Son Ltd; Martin Grainger; Julian Harrap Architects LLP: Lyall Thow; Tim Harvey; Guy Haywood; HG Matthews: Jim Matthews; ICB Waterproofing: Mick Smith; SR Welding & NDT Technology Ltd: Mick Hurt; Isometrix: Arnold Chan, Kate Lownes, Isaac Matovu, Michael Sillitoe, Laura Voss; JH Specialist Roofing: James Hopkins; Kiveton Park Steel: Alex Davie, Rachel Leedell; Listers Haulage; Helen Luckett; Nick Mclaughlin; MER; M.G. Precision Engineering: Roger Clark; Momart Ltd: Darryl Beever, Ray Cooke, Scott Daniels, Simon Franklin, Mark Harton, Shannon Maris, Connor Mills, Guy Morey, Ben Newton, Julie Prance, Neville Redvers-Mutton, Sam Ryan, Fausto Sanmartino, Rich Thompson, Stuart Wrenn; Andrew Nairne; Priyamvada Natarajan; Michael Newman; John O'Rourke; Pentagram: Tiffany Fenner and Harry Pearce; QA Weld Tech: Andrew Dean, Peter Harrison, Ian Hutchinson, Richard Knowles, David Pickles, Ian Scott; Vincenzo Reale; Heinrich Rohlfing GmbH: Michael Adler, Volkan Akyüz, Carsten Balshüsemann, Patrik Bollhorst, Matthias Broschat, Anton Harder, Matthias Kallage-Schlieter, Andreas Köhn, Dirk Langanke, Roland Quintana Mas, Johann Mut, Falk Reinert, Gerd-Henrich Rohlfing, Richard Rohlfing, Oliver Rosonsky, Meik Schleufe; Sharon Scott, Rene Vögeding; Sheetfabs: Mark Herrod; Tristan Simmonds; Oak Taylor Smith; Thumbprint Editions: Peter Kosowicz; Giancarlo Torpiano; Unusual Rigging: Sam Carter, Robin Elias, Paul Rhodes; Weber Industries: Tomas Carter, Rolo Rawlinson, Gavin Weber; Weil, Gotshal & Manges LLP: Marco Compagnoni, James Harvey, Candice Lambeth, Victoria Lloyd; West Yorkshire Steel: Rob Ellis; Jackson White; Stephen White; Jeanette Winterson; Wintwire Ltd

Antony Gormley Studio
Vale Royal: Eduard Barniol Ferreres, Kerrie Bevis, Isabel Bohan, Philip Boot, Jamie Bowler, Ruby Brown, Ella Bucklow, Tamara Doncon, Giles Drayton, Danny Duquemin-Sheil, Sam Ford, Ondine Gillies, Rosalind Horne, Fred Howell, Adam Humphries, Gethin Jones, Pierre Jusselme, Bryony McLennan, Anna McLeod, Ocean Mims, Philippe Murphy, Cassius Nice-Garside, Lucy Page, Lucy Parker, Laura Peterle, Alice O'Reilly, Maria Ribeiro, Alice Steffen; *Hexham Studio*: Cat Auburn, Oliver Beck, Sacha Delabre, Pauline Elliott, Ashley Hipkin, Emily Iremonger, Mike Pratt, Matthew Young; *Hexham Studio Castings*: Chris Bell, Mick Booth, Ben Bryant, Max Condren, Rory Coulson, Stewart Creek, Jessica Freeman, Carmine Fortini, Daniel Jackson, Joe McDonough, Carol Robson, Stephen Tiffin, Zachry Vernon; *Project-specific support*: François Brunet, Sam Cook, Nathaniel Faulkner, Luke Felstead, Hayley Griffin, Tom Gutierrez, Carmel Mannion

Testing a World View

Martin Caiger-Smith

This essay title, of course, is borrowed; it's Antony Gormley's own. *Testing a World View* (fig. 1) is a key work, first shown in Sweden in 1993; five identical solid iron body forms made from a cast of the artist's body – arms tight to the torso, legs and torso describing a rigid right-angled pose, like a lever – are set in various orientations on the floor, against the walls and hung from the ceiling of an otherwise empty gallery space. The title gives a sense of the range of Gormley's address in his work, and in this case the 'test', as he affirms, is in part against the architecture itself, the bounds of the interior space in which the sculptures are installed. And the five body forms, placed and encountered so differently, each carry a distinct emotional charge. For Gormley, everything changes with context. 'In different places we become different,' he maintains; the same might be said of his sculpture.

Every exhibition, bringing together works made over time in one particular place, is a singular event; every one, too, is a test, in a number of ways. A test of the works themselves, first and foremost, of the way they work together; of the space they occupy; even, in a sense, a test, or a challenge, for the viewer. Gormley's perspective – his world view – has always been an expansive one. The body of work he has produced since the late 1970s is enormous and far-flung, and his various ways of showing are always seen as opportunities for a determined testing of the work, of the contexts in which it is presented, and – not least – of the expectations and responses of those who confront it. The exhibition at the Royal Academy is no exception.

From the entrance to the exhibition, across the length of two large galleries, a single work can be seen quietly to hold its space at the far end.

It is a drawing of roughly concentric lines inscribed in chalk directly on the wall, encompassing – if you read the lines inwards – the outline of a small running figure at its core, and – reading outwards – expanding into space, a sort of diagram of the energy field that surrounds a body. *Exercise Between Blood and Earth* acts as a kind of talisman, hinting at the exhibition's central concerns; also, like the annual rings exposed in a section of cut-down tree, as a mark of the passage of time. A version of this drawing was included in Gormley's first solo show, his first major public statement as an artist, in the late spring of 1981.

That early exhibition (fig. 2) was, in one sense, fleeting: it occupied the upper floor of the Whitechapel Gallery, across town in London's East End, for less than three weeks. This was not the most propitious time to make a debut. Britain was in deep recession, London in a state of unrest; the weekend the exhibition closed was marked by an outbreak of riots and conflict between police and local inhabitants in Brixton, a few miles over the river. Looting, burning and CS gas: tensions spread and spilled throughout London and to cities around the country. The quiet, complex and confident statement made by Gormley's exhibition at the Whitechapel must surely have had a hard time competing for public attention against the turmoil of events outside.

Fig. 1 *Testing a World View*, 1993. Cast iron, 5 body forms: each 112 × 47 × 118 cm. Installation view, 'Antony Gormley: Testing a World View', Konsthall, Malmö, 1993

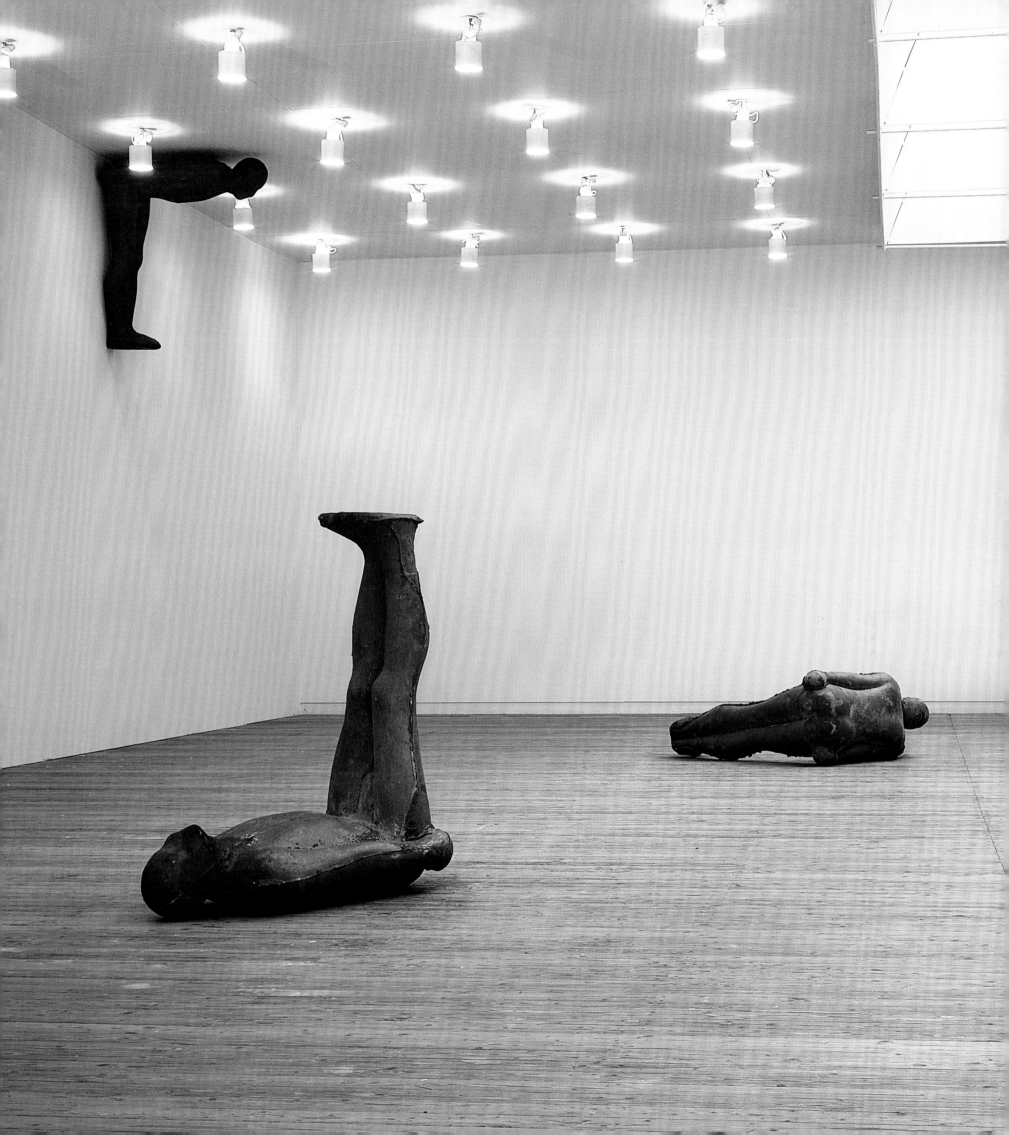

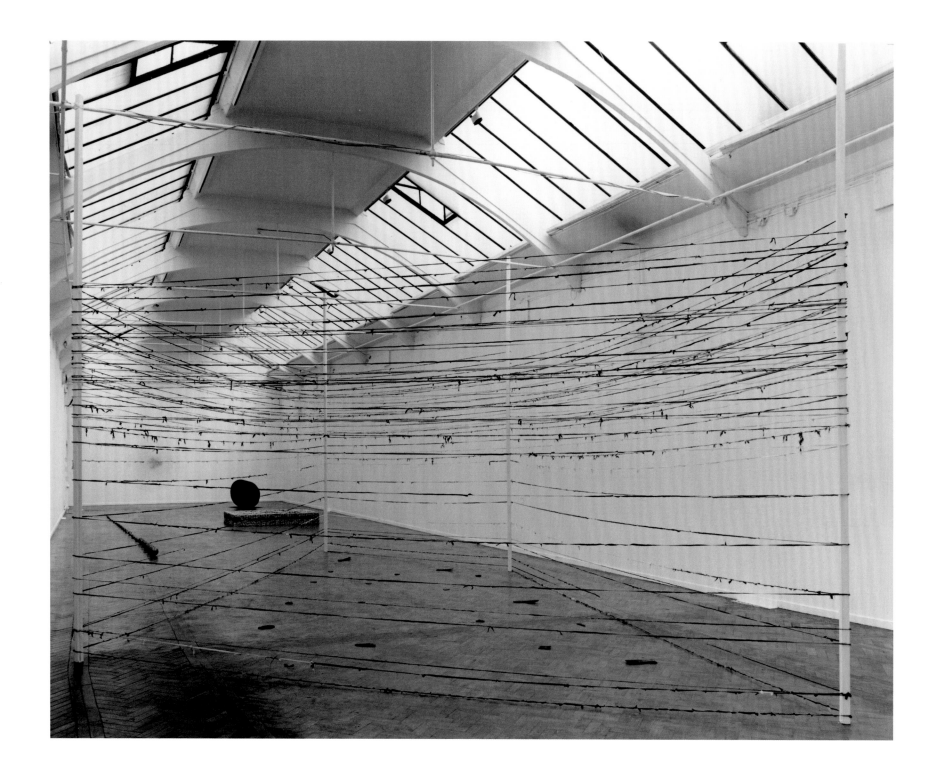

Gormley had put together a spare selection of five works, ranged across the herringbone wooden floor of the long, narrow white-walled room. Most had been made in a burst of activity over the previous month or so. At first sight they might have appeared a disparate gathering. In that exhibition, too, *Exercise Between Blood and Earth* looked out over a succession of sculptures spread across the length of the room: a large, rough-hewn, charred lump of elm wood; a long line of diverse small objects, generally spherical in shape, each concealed in a sealed wrapping of lead sheet; a low-lying, rectangular plinth composed of thousands of slices of preserved bread, into the surface of which Gormley had excavated – literally eaten – two cavities, half-body forms, together the equivalent of his own body space; and a fragile rectangular enclosure of poles strung around with long lines of thinly shred fabric – a full set of the artist's own clothes – fencing off an enclosure empty of all but a few scraps of shoe, like a boxing ring, or a small room – again the space of a human life, rendered in very different, almost architectural form.

On the face of it, Gormley's preoccupations must have seemed disengaged from the noise of the streets across town. The press who

Fig. 2 'Antony Gormley: Sculpture', installation view, Whitechapel Art Gallery, London, 1981. Left to right: *Natural Selection* (1981), *Exercise Between Blood and Earth* (1979–81), *End Product* (1979) and *Bed* (1980–81; background) and *Room* (1980; foreground)

(Right, clockwise from top left)

Fig. 3 *Grasp*, 1982; work in progress

Fig. 4 *Bread*, 1980–82; work in progress: dipping bread in wax and laying pieces out at Broxbourne studio, Hertfordshire

Fig. 5 Lead cutting at Talfourd Road studio, Peckham, London

Fig. 6 *Blanket Drawings*, 1982–83; work in progress at Talfourd Road studio

(Overleaf) Fig. 7 *To the Ends of the Earth* and *Free Object*; work in progress at Acre Lane studio, Brixton, London, 1987

commented on the exhibition made no allusions to contemporary events; but the work was taken seriously, perplexing some and impressing others; it was agreed that something serious was being proposed.

For Gormley himself, this first significant showing was a pivotal moment of public recognition and of personal decision. He was already thirty years old. His generation had grown up in the 1950s, in the decade after the War and the shadow of the bomb. He'd gone to university in 1968, that seismic year of protest and open revolt, had travelled for several years, mainly in India, and got deep into Buddhist meditation. He'd come back to art school in London at a time when the currents of post-minimalist art in Europe and North America were being keenly followed – when, it seemed, the very question of what constituted sculpture was open as never before. He'd gone on afterwards to travel across America with his partner, the artist Vicken Parsons, in search of a sculptural lineage, and (among other things) the great sites of American Land Art. He'd met sculptors, visited Richard Serra, made friends with Walter De Maria. He'd returned to work, married, set up home; the couple were about to start a family. Much of all these experiences marked his formation as an artist; much, in a sense, was embedded in these five quiet works. Each showed a preoccupation with basic objects and materials, natural and man-made, with the various sculptural processes and ways of working by which they could be transformed – inscribing, cutting, bending and enfolding, burning and beating, even chewing – and an attachment to

rigorous method, to working in series and with minimal means. Evident, too, was a preoccupation with the bigger questions: the cycle of birth and death, entropy and regeneration, the nuclear threat; the works carried a sense of foreboding as well as of hope. And already there was an emerging sense of the body as the vehicle through which our surroundings, the world, are experienced. With hindsight, it is not difficult to see Gormley's core concerns, those that drive his work to this day, nascent in that show.

For an artist, exhibitions pull together diverse directions in the work and expose the state of play; in this they can provide clarity, even suggest the way forward – move the conversation on. After the Whitechapel show Gormley was picked up on by critics and curators, invited to participate in group shows representing different positions – pressed into different moulds, you might say – but within the year the work itself had undergone a sea change – perhaps inevitable, and certainly presaged. At the end of 1981 Gormley made his first lead body case sculptures, the works that came to dominate his practice for the next decade and beyond, and which, in large part, came to define his profile as an artist as he emerged on the international scene. Some months later, Gormley sent photographs of the first body-case sculptures to Walter De Maria in New York. 'The sculpture looks really good!' De Maria wrote in reply. 'I should think it would be good to keep on this – for some time. Make many works – many variations/poses (or even small variations of the same poses). Have many gallery and museum shows – and do it for years.'

Heartening advice, from an established artist whose rigorous, systems-based working methods, minimalist aesthetic and uncompromising grand gestures in the desert landscape of the American West had spoken so strongly to Gormley when he had first encountered them. Gormley's work progressed in just the manner that De Maria advised: he made many such works, had shows, did it for years. The physical making of the lead body cases, at that time, was arduous, methodical, studio-bound, often solitary, but he had found his language. Over the next decade a whole vocabulary of body forms, all derived from the artist's own body, issued from the studio and into exhibitions across the country and, increasingly, abroad.

In group shows, even those in which he joined his peers as part of a loose group that came to be designated by some the 'New British Sculpture', Gormley's work somehow stood apart. Its stance, in broad surveys of contemporary sculpture in those early years, appeared decidedly against the grain; most sculptors, at this time, had turned their backs on sculpture based on the recognisable human form. Gormley was aware of the particularity of his position, the risk of the work being seen as somehow retrograde, a return to a pre-1960s world before abstract sculpture began to hold sway. But he was intent on finding a new way to incorporate the body, to find a space for it in sculpture after modernism, as a vehicle through which to convey direct bodily experience. In ways that would, he hoped, elicit a corresponding, empathic bodily response in the viewer. In relation to his sculpture Gormley speaks of the dark space of the body as the 'objective correlative', drawing on the literary term used by the poet T. S. Eliot to describe the objects, situations or events used in a text to create a specific emotional reaction or feeling in the mind of the reader. That his sculpture is able to call forth something similar, that it can for the beholder in like manner *evoke* rather than merely *express* emotion – a demand on sculpture and viewer alike – is, Gormley maintains, the 'wager of the work'.

If the laborious procedures involved in the making of these lead body cases – the meditative state that attended the long moments of casting, the hours spent encased in hardening plaster, the weeks and months required to beat lead sheet round the plaster forms – began to feel rather restrictive, so too Gormley began to feel some dissatisfaction with the unvarying gallery spaces in which he was invited to show, with their white walls, their conventions and their limited publics. It is telling that having made the second in a series of triads of lead body cases,

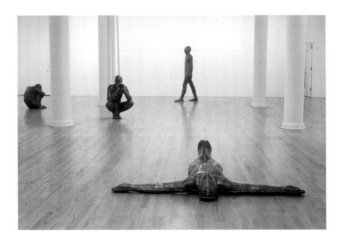

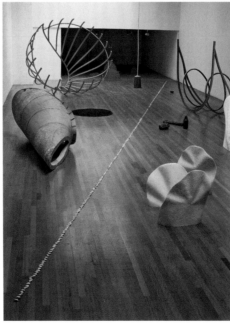

(Far left) Fig. 8 'Antony Gormley: New Sculpture', installation view, Salvatore Ala Gallery, New York, 1984; showing *Fill* (1984) and *Three Calls: Pass Cast and Plumb* (1983–84)

(Left) Fig. 9 'Objects & Sculpture', group exhibition, Institute of Contemporary Arts, London, 1981. Works by Anish Kapoor, Peter Randall-Page and Richard Deacon are shown alongside (centre, left to right) Antony Gormley's *Floor* (1981), *Fourth Tree* (1981), *Bread Line* (1979) and *Fruits of the Earth* (1978–79)

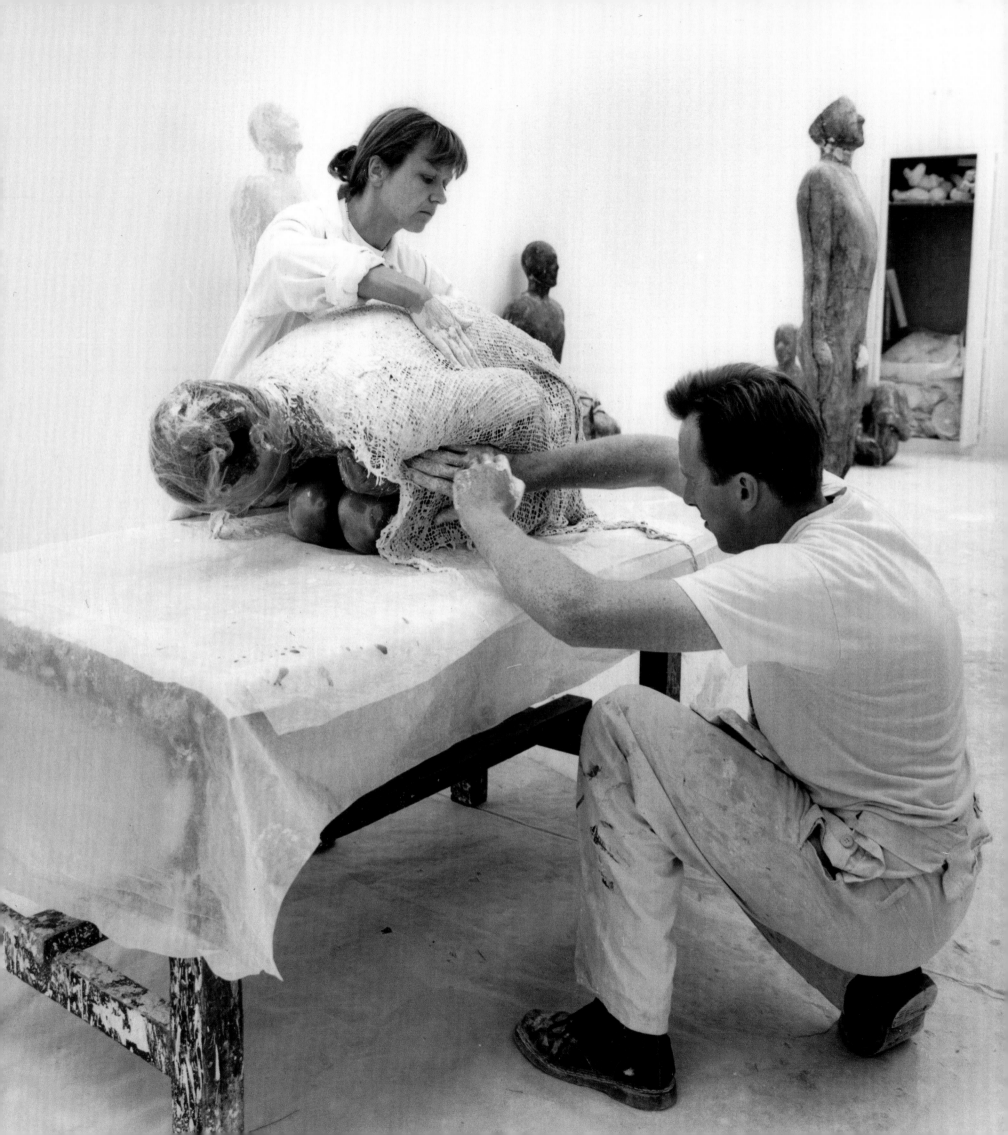

Land Sea and Air II, in 1982, Gormley lugged the three works down to the beach near his parents' summer home in Sussex to photograph them together as if in an infinite landscape, set against sand, sky and roaring sea. The gallery and museum shows he had in London, Europe and New York were to demonstrate the expanding range of his sculpture through the 1980s – the permutations and possibilities of sculptural form derived from his own body – but in search of new ways of showing, Gormley found himself turning to new terrain, to more singular locations exposed to the outside world, the attack of the weather and the response – the test – of a broader, and maybe less guarded, audience.

Working outdoors was nothing new for Gormley. His first tentative sculptural marks had been made in the open, on the rock face behind the art room when at school in Yorkshire; years on, he'd carved into the exposed granite walls of a quarry on the Isle of Portland: low-relief outlines of bodies, falling, as if trapped in geological time. He'd dug body-sized cavities out of the ground in the Welsh mountains. He'd recorded his own ephemeral sculptural actions in the Arizona Desert while on the trail of the Land Art of De Maria, Michael Heizer and Robert Smithson; the Land

Artists' commitment to 'site-specific' art located well beyond the realm of the gallery was a powerful early stimulus. By the mid-1980s there was also more opportunity to place work outside, beyond the gallery. This was a moment of resurgence for 'public sculpture', a time of broad rethinking of sculpture's relationship to the urban setting, in a deliberate riposte to the centuries-long debased tradition of monumental and memorial figurative statuary (of the monarch, the military man, the local worthy), as well as a broad questioning of the tired conventions of more recent corporate-funded sculpture commissioned for the forecourt and the plaza.

The sort of raw public exposure Gormley looked for was to be found most readily in historically charged sites. An important work made in 1987, *Sculpture for Derry Walls* (fig. 12), offered exposure *in extremis*, when Gormley was commissioned as part of a nationwide sculpture project to site works on the fortified walls of the historically Protestant stronghold in Northern Ireland. On this high fault line between communities in conflict, Gormley made three forms, double figures, standing, as if crucified, back-to-back and facing both ways, out towards Protestant and Catholic streets alike. Inevitably, in such outlying territory for art and at the height

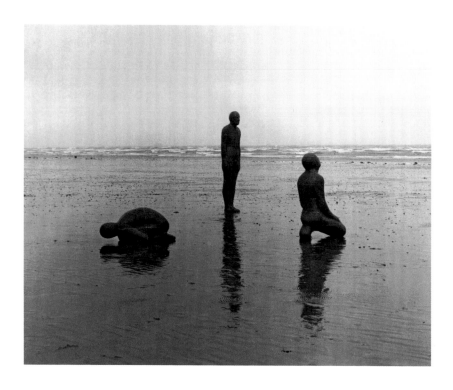

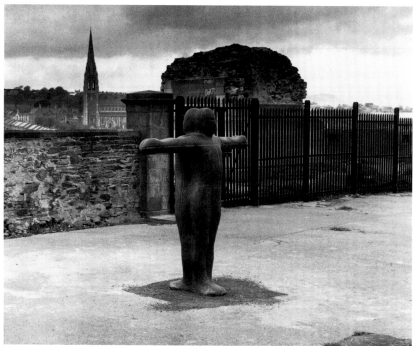

Fig. 13 *Angel of the North*, 1998. Steel, 20 × 54 × 2.2 m.
Permanent installation, Gateshead, Tyne and Wear.
Commissioned by the Gateshead Metropolitan Borough Council

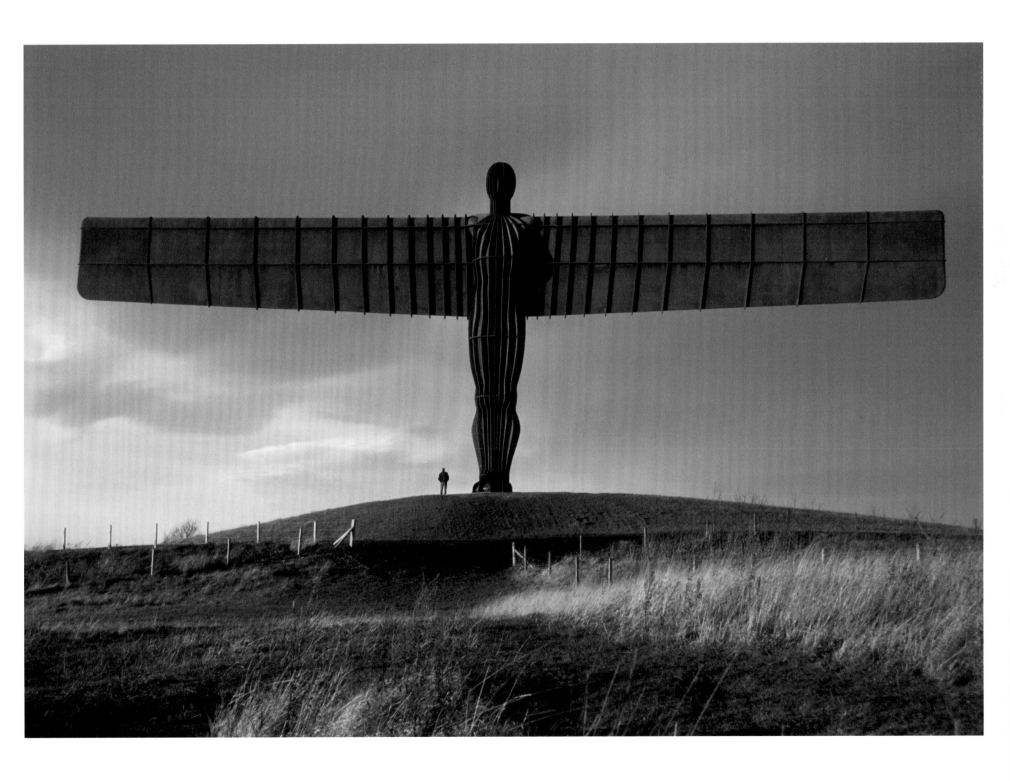

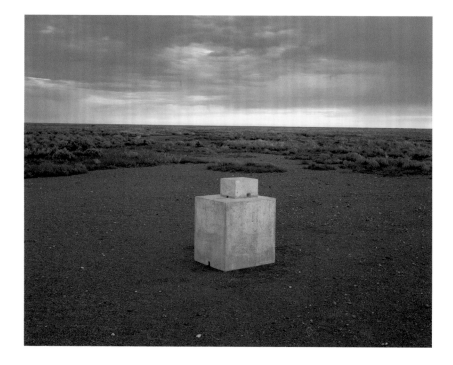

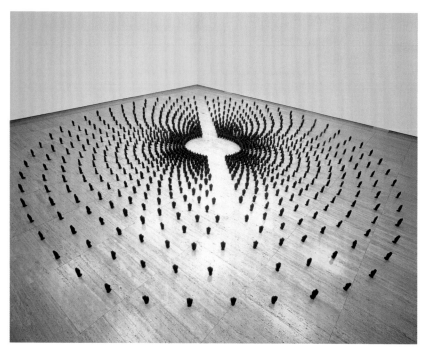

of the Troubles, the work attracted suspicion and drew considerable criticism from both sides. This was quite literally a baptism by fire (the works were immediately stoned and torched) but also a declaration of intent: so much of Gormley's work, in the three decades since, has been made as a response to the particularity of a site, or a context, has sought in the broadest terms to respond to and connect with the place, its people, its history and its current condition, somehow to effect a change.

The *Angel of the North* (1998; fig. 13) standing proud on raised land on the site of a disused colliery close to the motorway outside Gateshead, is the best known, the most seen. On occasion, though, Gormley has sought out the furthest, most remote places. The undisclosed location of *Room for the Great Australian Desert* (fig. 14) – a hollow concrete block, its dimensions just sufficient to contain the space of a human body – somewhere deep in the interior of the continent, stood as a conscious and pointed counterpart to the companion piece he made at the same time, in 1989, *Field for the Art Gallery of New South Wales* (fig. 15): one was a sculpture made and placed in uninhabited, 'unconditioned' space, accessible only via photographic record or in the mind's eye; the other was laid out at the feet of an audience located firmly within the 'white cube' of an urban art gallery. In conceiving and making – or placing – works 'out there' in the world, Gormley has always sought a 'rootedness', a sense of connection – the kind of deep relationship to place that he had admired, in 1978, in De Maria's masterwork *Lightning Field* (1977), in the Arizona desert, which Gormley described as a 'sort of acupuncture of the landscape'. Gormley's *Another Place* (1997; fig. 16), an environmental work first conceived for the Elbe estuary at Cuxhaven, Germany, and now permanently installed on Crosby Beach, north of Liverpool, effects something similar: 100 upright solid iron body forms sited at varying points for a mile or more along the shore, above and below the tide line as it rises and falls, implanted, impassive, facing out to sea.

This sense of connection could have to do with the historical resonance of a site; it could also lead to engagement with a living community. Lengthy, even protracted and at times confrontational processes of consultation and public involvement have preceded the making and placing of many works in public space. The proposal for *Broken Column*, in Stavanger, Norway, in 2003, in part a homage to Brancusi – its 23 separate cast-iron body forms placed in public and private sites of ascending height above sea level across town to constitute a virtual *Endless Column* – occasioned years of wrangling, in town hall and meeting place and in the media, before consensus was reached and permission granted for its production and installation. Such attendant complexities, though, are an integral, even necessary aspect of Gormley's project. The need he feels

Fig. 16 *Another Place*, 1997. Cast iron, 100 body forms, each 189 × 53 × 29 cm.
Installation view, 'Follow Me: British Art on the Lower Elbe', Cuxhaven

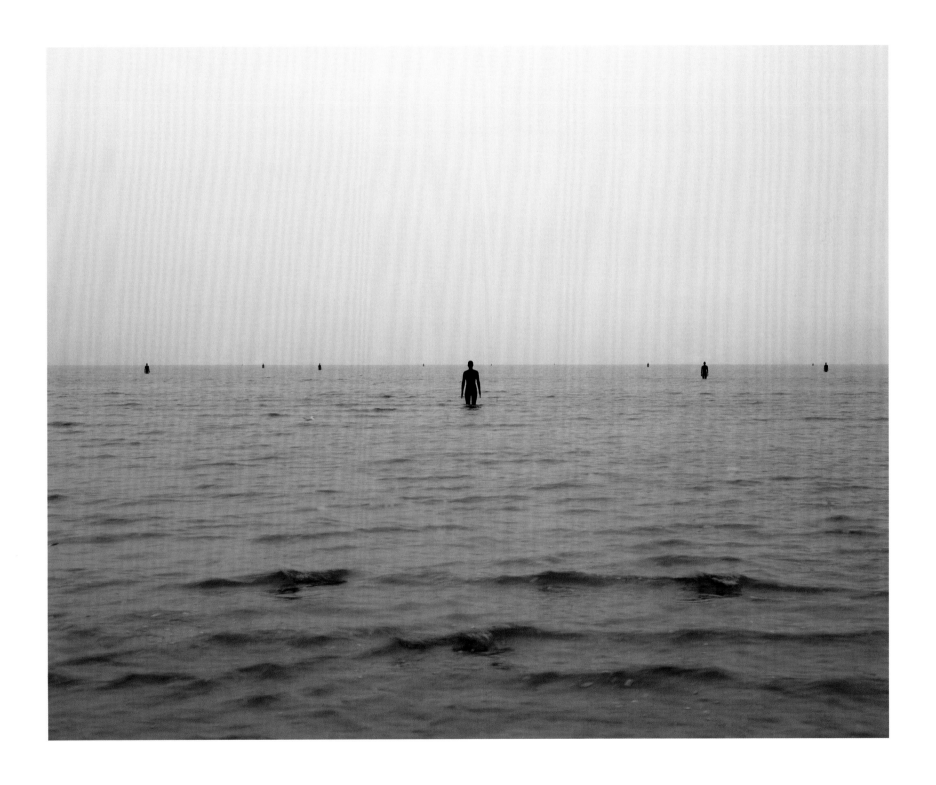

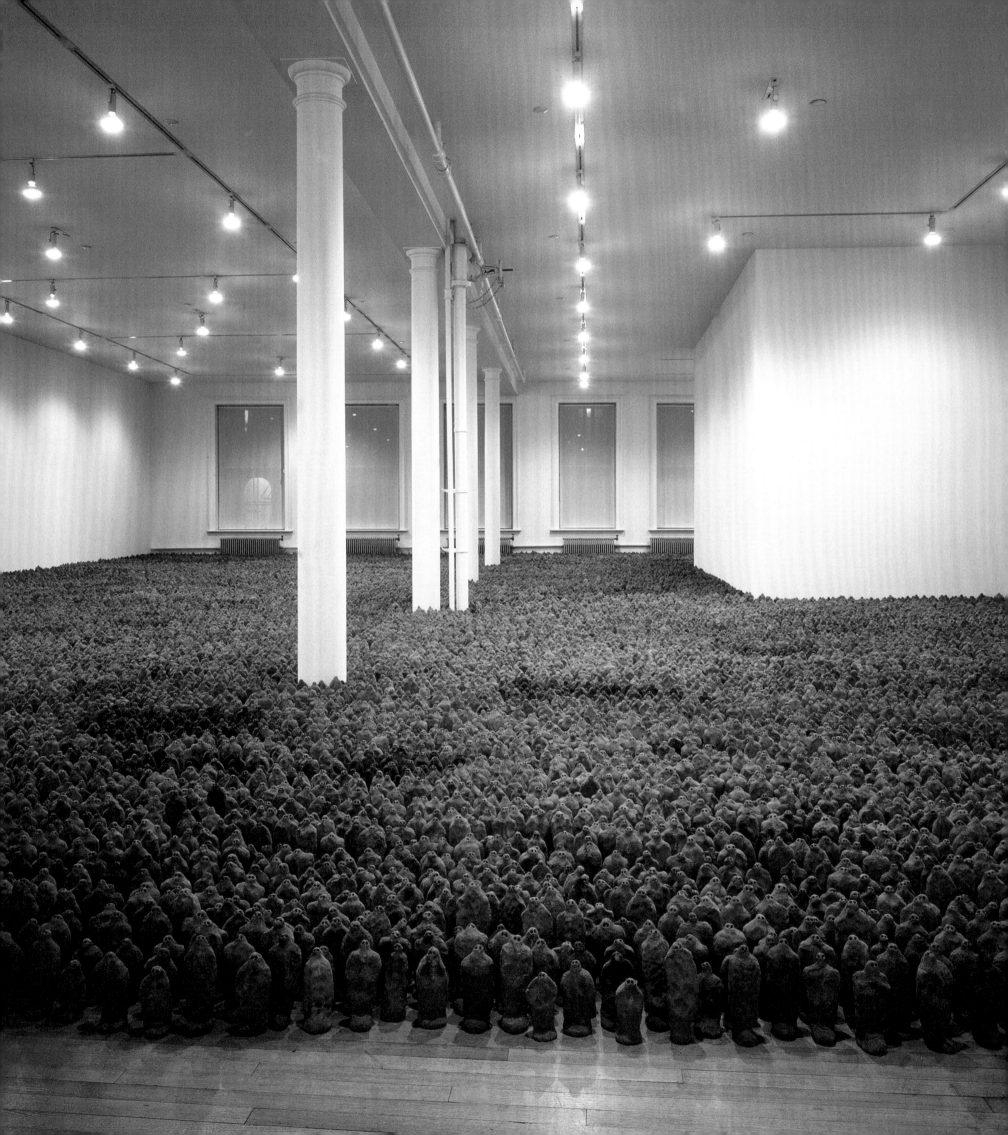

Fig. 17 *American Field*, 1991. Terracotta, around 35,000 elements, each 8–26 cm, overall dimensions variable. Installation view, Salvatore Ala Gallery, New York

Fig. 18 *American Field*, 1991; work in progress with the Texca family, brickmakers in the parish of St Matías, Cholula, Mexico, December 1990

Fig. 19 Antony Gormley and others making *Field for the Art Gallery of New South Wales* at the Art Gallery of New South Wales, Sydney, 1989

(Overleaf) Fig. 20 *Inside Australia*, 2003. Cast alloy of iron, molybdenum, iridium, vanadium and titanium, 51 body forms based on 51 inhabitants of Menzies, Western Australia, installed in Lake Ballard. Commission for 50th Perth International Arts Festivaal, Western Australia

to establish a connection with his public has also led him to invite others to participate in the making of the work itself. The first full-scale version of *Field* (fig. 17), his well-known work, an ocean of simple small terracotta figures, was made over a period of three weeks at the end of 1990 with the involvement of one large extended family, three generations of brick makers, in a small town outside Mexico City – a work of 35,000 parts, made with their clay, by their hands (fig. 18). Subsequent versions of *Field* have, in similar manner, involved local communities on four continents. And for his project *Inside Australia* (fig. 20), in the Western Australian desert, some years later (in 2003), Gormley persuaded the Aboriginal inhabitants of the small town of Menzies to submit their bodies to a scanning process in order to generate the forms for the 51 slender metal *Insider* figures that were then installed at intervals, as far as the eye could see, across the vast blinding white salt-crust expanse of neighbouring Lake Ballard.

If the figures of *Inside Australia* were to be visited – and destined to remain – out in the barren land, the 35,000 figures of the first *Field* were made to show back in the city, in the spaces reserved for art: much of the power of that extraordinary work, for those who first saw it in a New York gallery in 1991, lay in the unexpected encounter, in the middle of urban Manhattan, with such an expanse of unadorned, fired clay, the rough stuff of the earth. Alongside a later version of the work, *European Field* (1993), shown in Kiel in 1997, Gormley made an installation that constituted an even more marked assault on the 'cultured' spaces of the Kunsthalle: *Host* filled the floors of the museum's contemporary wing with mud and water, raw, pungent and volatile, a sort of invasion. *Host* appeared in stark contrast to the framed landscape paintings (historical, Romantic) in the adjacent picture galleries; its effect on viewers was multi-sensory, immediate, undeniable and tenacious.

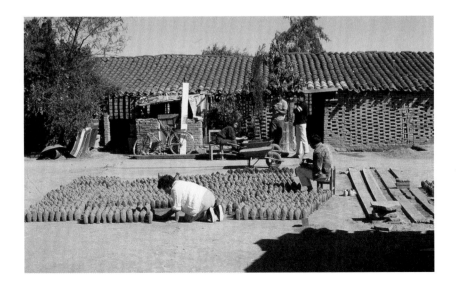

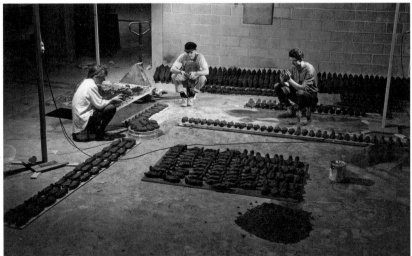

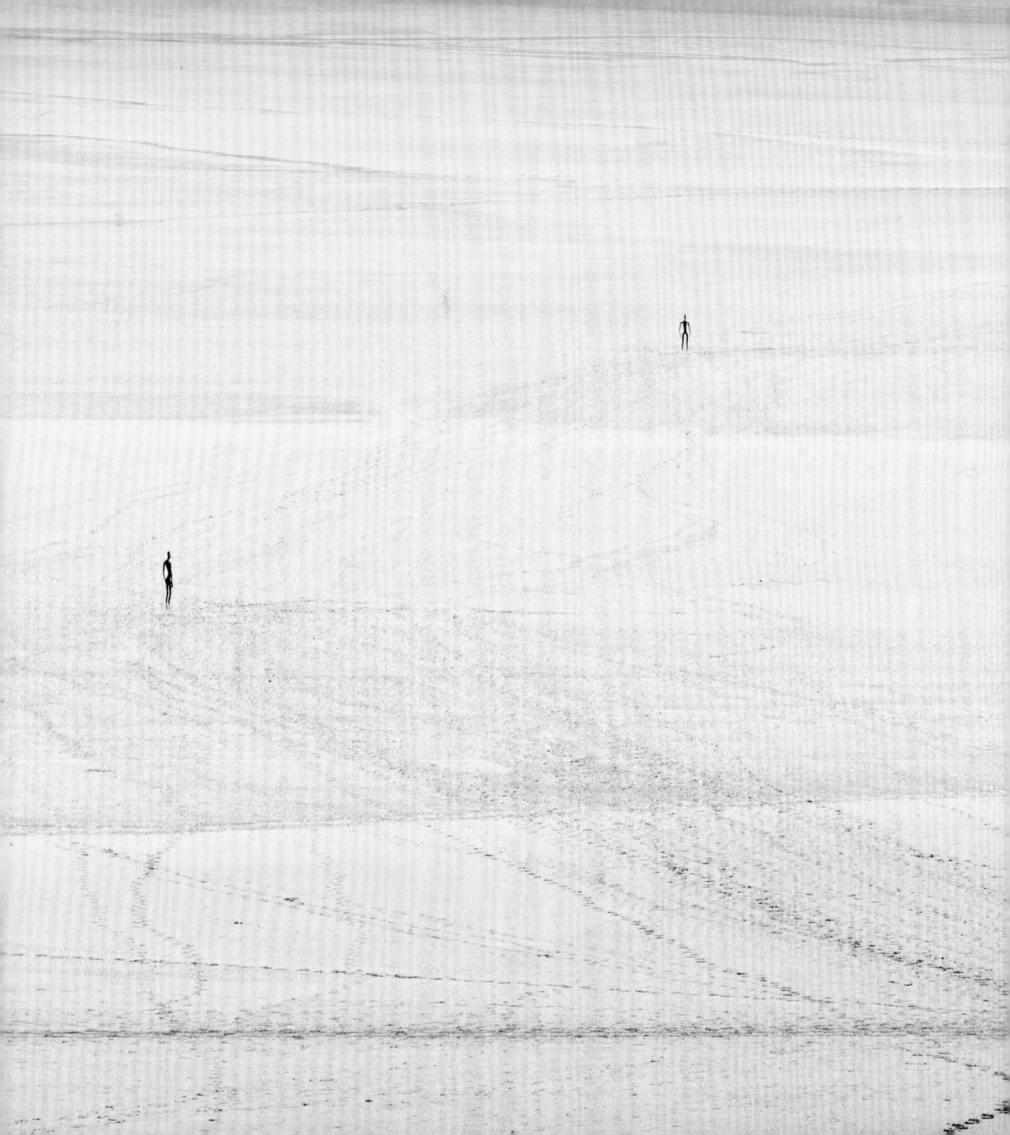

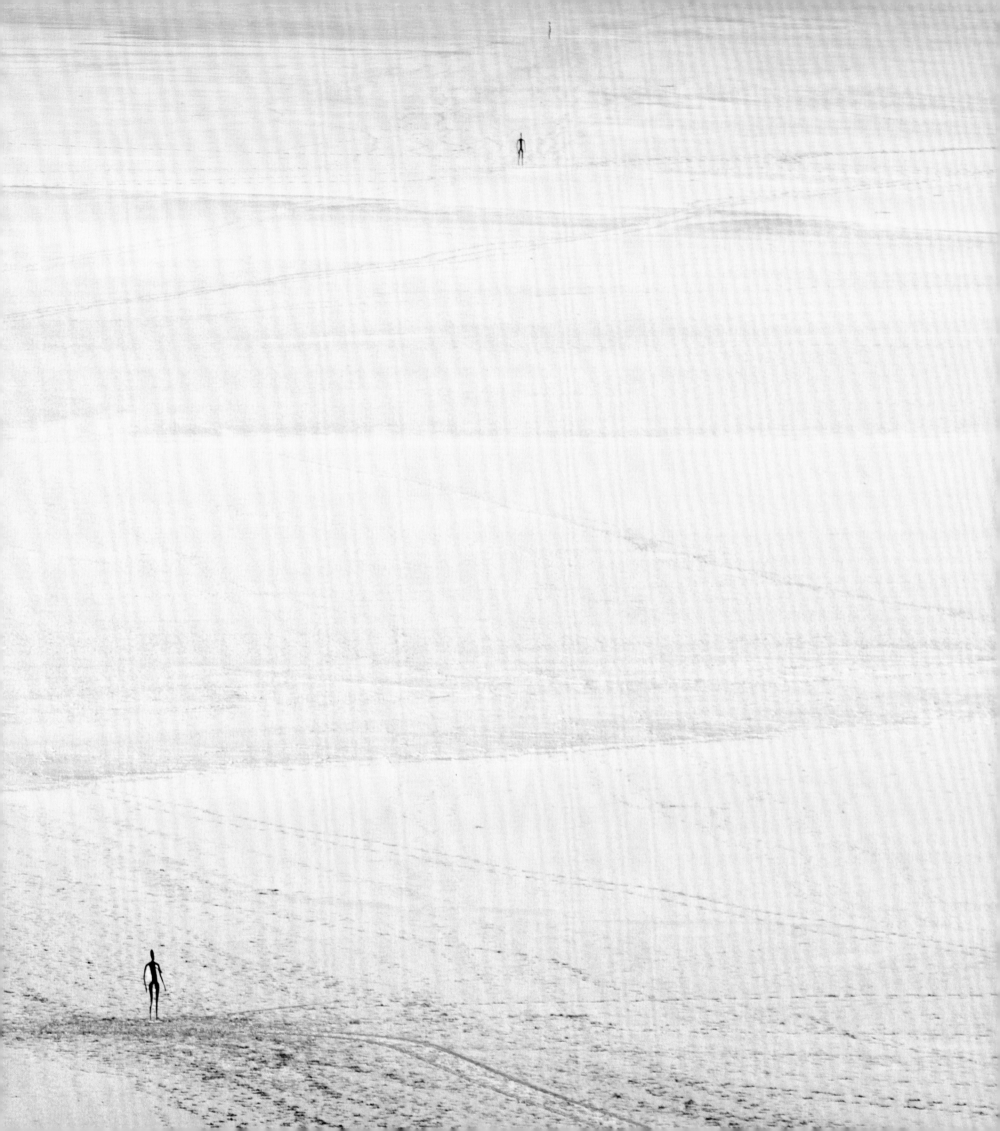

Fig. 21 *Model*, 2012. Weathering steel, 5.02 × 32.4 × 13.6 m.
Installation views, 'Antony Gormley: Model', White Cube Bermondsey, London

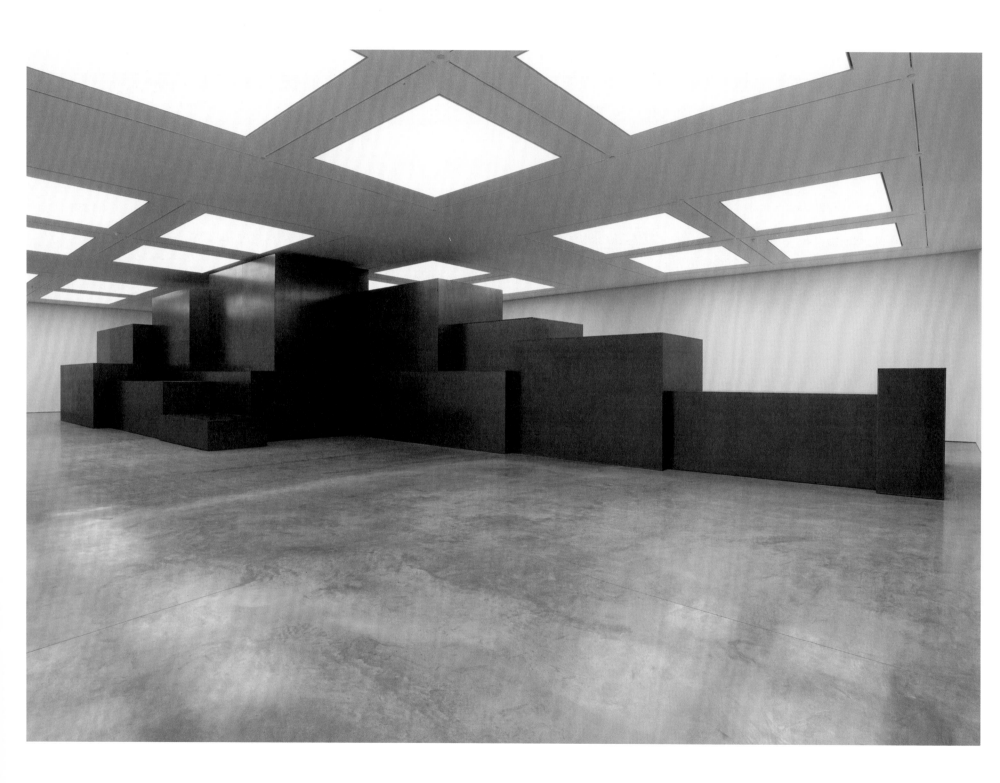

In the ensuing decades, as Gormley's reputation grew and the production of new work increased massively in pace, galleries – those of his dealers on four continents – have continued to provide an essential conduit through which the work could find a public; they have allowed a testing of whole new bodies of work, year after year, and extended conversations between new languages of form that have arisen from long periods of experimentation in the studio. On occasion, even the most neutral white-cube gallery has provided the right context for a precise testing of the relationship between sculpture and the spatial volumes of its containing walls (one thinks of the extraordinary event of the installation of *Model*, a description of a body in architectural language on an architectural scale in the colossal interior space of White Cube Bermondsey, in 2012). And still, through all this, the incentive to break out has been strongly felt. Offered the whole of the long, airy space of the Kunstverein in Cologne back in 1996, Gormley installed a solitary iron body form inside; a further five he placed outside the gallery, one looking back in, others standing and lying on pavement and street, as decoys, as if to trip the unwary passer-by, to prompt, again, an 'unguarded' encounter

(fig. 23). And the last time he took over a large public space in London, at the Hayward Gallery in 2007, the works he installed inside, in a complex interrogation of the 'resonating chamber' of the gallery's windowless, brutalist concrete spaces, were complemented by the many figures of *Event Horizon* installed, to be viewed from the gallery's outdoor sculpture courts, on rooftops ringing the gallery and extending out across the city, all the way to the visible horizon (fig. 22).

Another confrontation regularly enacted has been that over time: Gormley has on numerous occasions set his work against that of the past – most often the distant past. In the classical galleries of the State Hermitage Museum in St Petersburg, in 2011, in an exhibition entitled 'Still Standing', he installed seventeen recently-made solid iron *Blockworks* in a space cleared of the museum's Antique statuary; in another, gods and goddesses, which he had brought down from their original plinths to stand on the floor, were rearranged to share common ground, as it were, with the viewer and with his own sculptures. In a conversation across millennia and between fundamentally contrasting ways of harnessing the expressive potential of the body, the subtle registers of emotion in Gormley's contorted, rusting,

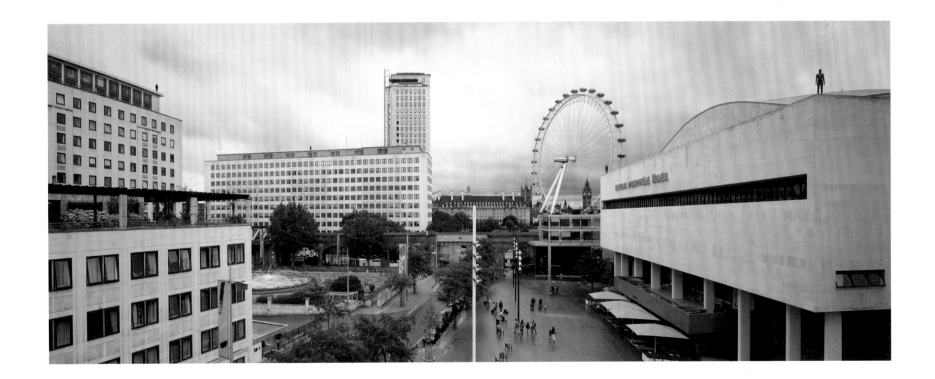

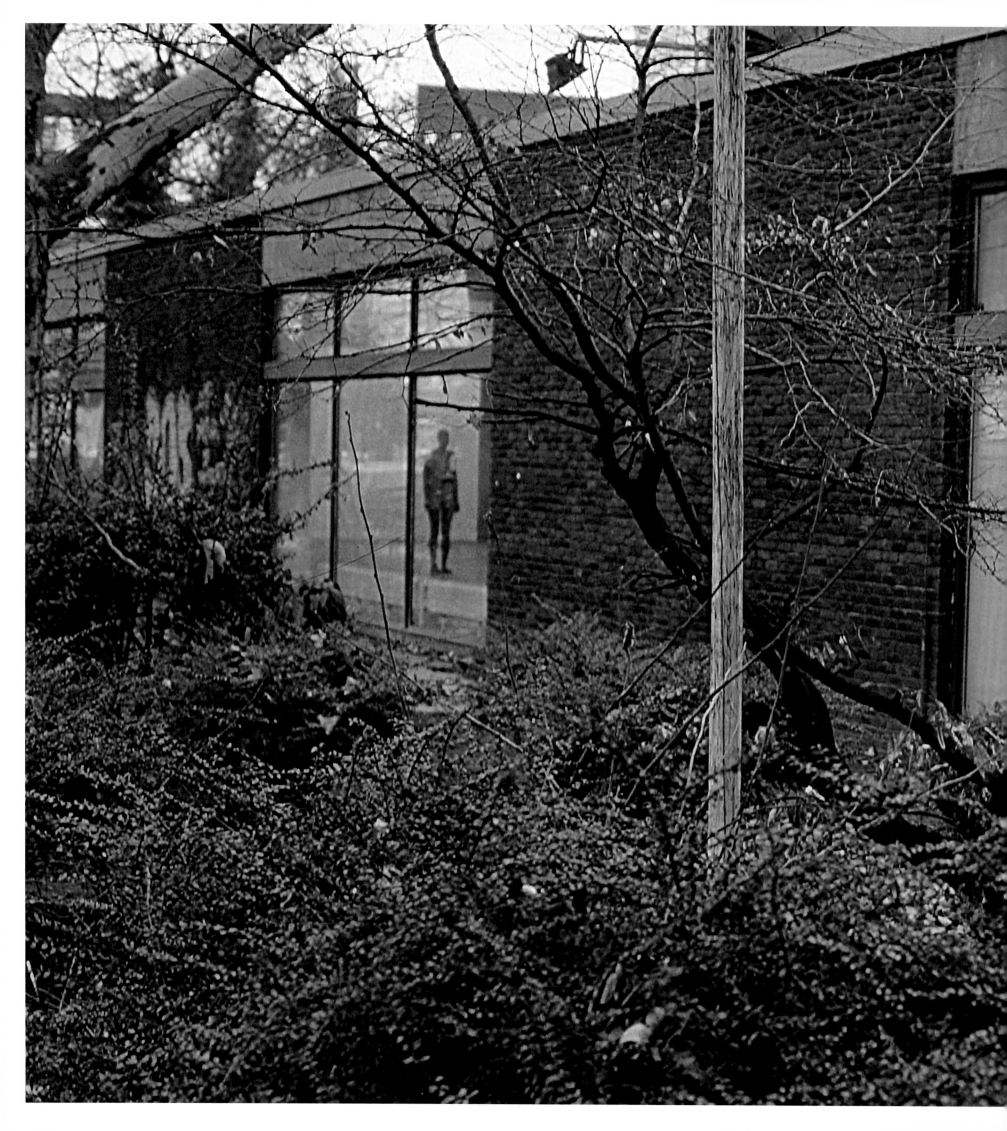

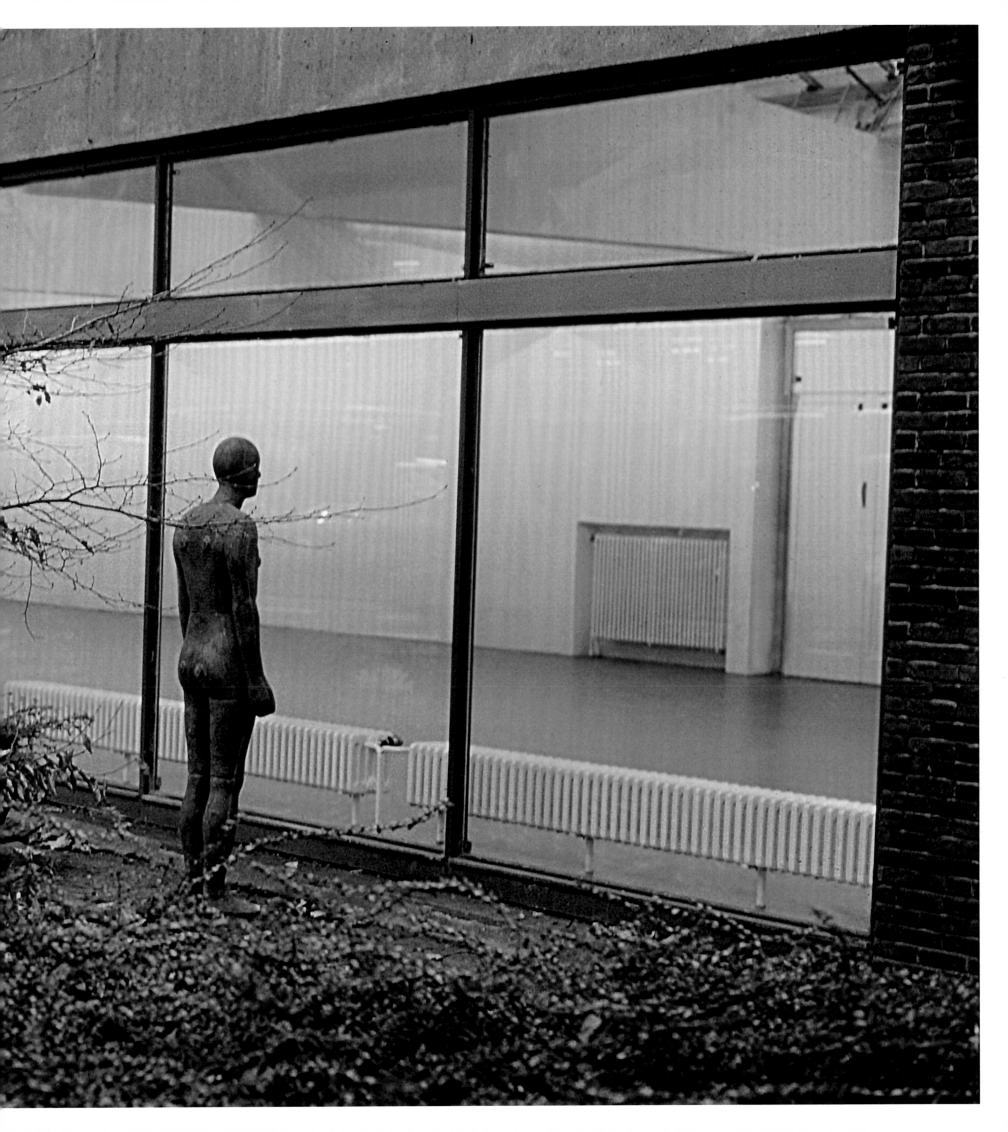

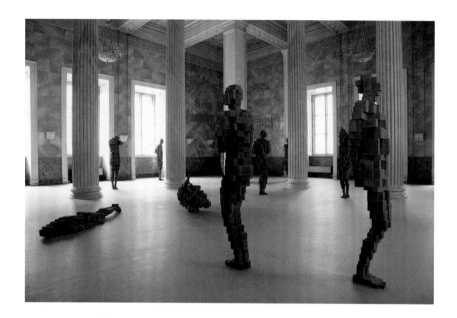

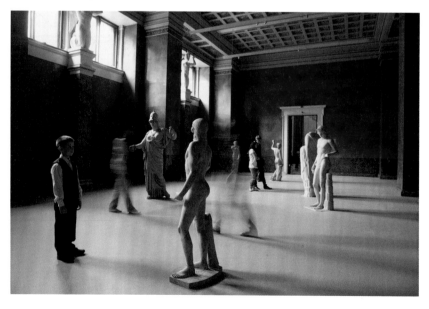

pixelated sculptures were set against the expansive, declamatory gestures of Apollo, the smooth marble whiteness and tender pose of Aphrodite (figs 24 and 25). A similar form of engagement was staged in early 2019 at the Uffizi, in Florence, in a small, red-walled room, theatrically lit, between a Roman copy of the famous Greek *Sleeping Hermaphrodite*, which Gormley turned around so that its body faced, on the floor before it, his own work, *Settlement IV* (2018), a prone body form made as an aggregation of small steel blocks that seemed to hover somewhere between a human figure and a model of an urban grid (fig. 26). A dialogue, between two renderings of in-between-ness, one sexual, animate, the other seeming to speak of mortality, entropy, a transitional state of unbecoming.

Such confrontations between works, over time and in place, have become key to Gormley's way of working and thinking, to his meditation on the passage and direction of the human project, on where we stand and where we're headed. His work has evolved over the years in part following its own necessity, as a process of ongoing experimentation in the studio, but also through tests such as these, in response to situations and opportunities, to the challenge, whether invited or self-imposed, to find context, purpose and meaning for the work, to put it to work, out in the world. It might be said, even, that the principle of confrontation underlies all these acts of showing the work. And this applies, in a number of different ways, to this exhibition at the Royal Academy.

Here, new works are presented alongside others much earlier, some of which have been reconfigured for these spaces; Gormley has seemed more ready, in recent years, to bring his older work into conversation with more recent. And yet he resists the notion of conventional exhibition format; he's emphatically not here to explain himself or be explained. Gormley's progress is marked more by continuity than by novelty; what is revealed here is a back-and-forth of ideas across decades. The most recent work connects readily to his first experiments; older works can return in different guise, repurposed, or they can derive new meaning in fresh contexts. But this is in no sense a full 'retrospective', with its implication of completeness, even of finality. It is no more than a temporary stabilisation of his concerns. There is no sequential or chronological 'unspooling' of his development, nor any notion that there is an evolution of 'style' or linear genealogy of form to be found. His is a work

Fig. 26 'Antony Gormley: Essere'. Installation view, Uffizi Gallery, Florence, 2019. Showing, from background to foreground: *Sleeping Hermaphrodite*, (first – second century AD) and Antony Gormley's *Settlement IV* (2018)

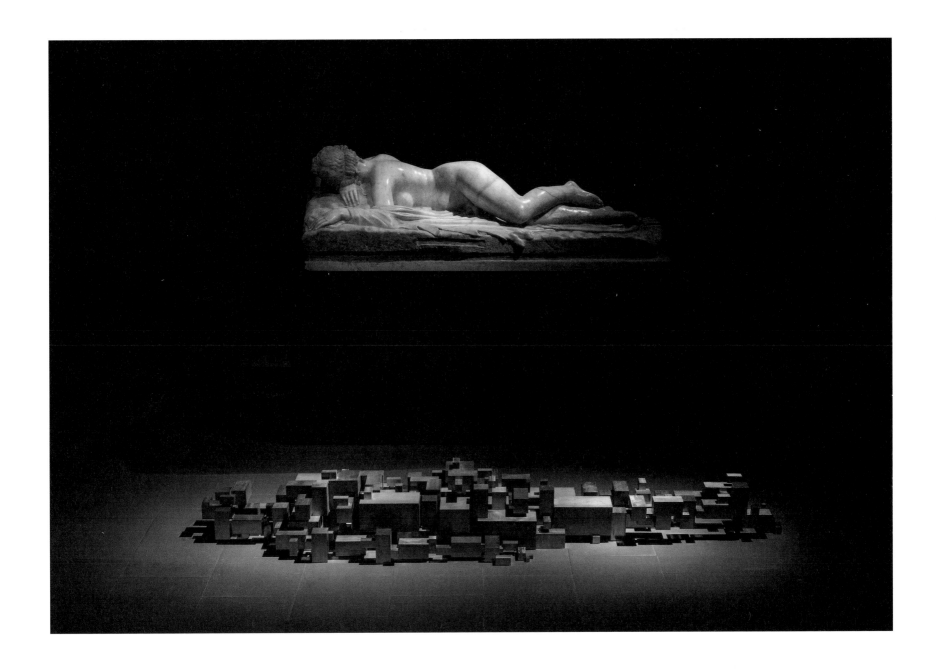

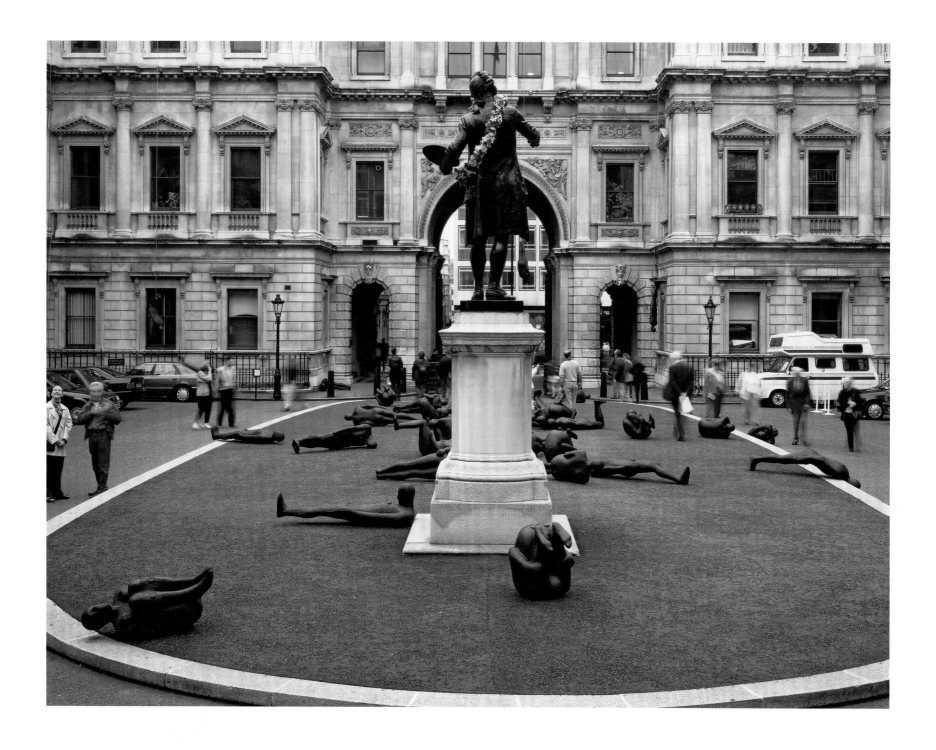

in progress, open-ended; his thoughts run to the future. The exhibition is an exploration of limits and the exhibition space, like the studio, is a laboratory, what Gormley calls a 'test site'.

If this suggests a confrontational attitude, a sense of resistance, it might be seen to extend even to his attitude to the Royal Academy itself. He is an Academician (since 2003), and it is difficult to imagine many artists who could connect with such assurance both with the wilderness and an institution such as this in the middle of Mayfair, but Gormley's stance still suggests an ambivalence to the notion of what the Academy represents. When, in the summer of 1998, he was first called on to propose a work for the Annenberg Courtyard – at the front steps of the Royal Academy – he opted to show *Critical Mass II* (fig. 27), an installation of sixty cast-iron body forms, five examples each of twelve different body positions, a work he first displayed in 1995 in a vast disused tram station in the middle of

Fig. 27 *Critical Mass II*, 1995. Cast iron, 60 life-size elements, dimensions variable.
Installation view, Royal Academy of Arts, London, 1998

Vienna. There, in the middle of Europe, fifty years on from the end of the Second World War, he'd described the work as 'an anti-monument to the victims of the twentieth century'; and the abject single forms and groups of figures fallen or suspended between the tramlines spoke eloquently in their silence of the Holocaust, of the dehumanising onslaught of modern and industrial means of subjugation. Rethinking the work for the Royal Academy's courtyard, three years later, he was inclined to broaden his frame of reference, to see the bodies disoriented, suspended from the buildings and spilled on the cobbles beneath the Palladian façades of the Academy and the six other, centuries-old learned societies all around it, as an implied questioning of the certainties of the Enlightenment, the assurance of the idea – now manifestly discredited – of knowledge as a progress to perfectibility of the human project.

Something of this is evident in the challenge that seems to resonate through Gormley's occupation of the Academy's spaces in this exhibition, not least in his response to the galleries' architecture – the inescapable rhetoric of the Beaux-Arts interior, with its porticos and pediments, ornate ceilings and enfilades. The exhibition has been thought into existence over several years, and has taken shape through long contemplation and consideration of the galleries' resolutely regular and symmetrical floor plan. Interrogation of the space, its potential and its own resistances, has involved model-making, multiple renderings on screen of existing and potential works tried out in different galleries, to assess their capacities, the load-bearing capacity of their floors, their affordance of natural light or of vistas across distance, the different possible routes through the exhibition. All this has to do with more than practicalities: it extends almost to a questioning of the framework of the exhibition itself, and sets the stage for a confrontation between the body of the work and the containing frame of the gallery.

Here, indeed, is the exhibition's central proposition. It is a testing, through sculpture, of the occupation of space: of the experience of the body in the space that surrounds it, and of the body *as* space – of the space that the body itself contains. It is a proposition that fully implicates the viewer too, as another conscious body in space. As ever, Gormley presents his work not as a discrete object of aesthetic contemplation, to be consumed by the eye; not as an object that tells a story, to be explained, but as something to be measured against, something to be negotiated and felt. His work calls for a response – again, here is the big ask – that can lead you to a heightened awareness of your own body in space and in time. And so the exhibition and its terms of engagement unfold as a sequence of discrete and cumulative experiences, from room to room, with assemblages of works or room-sized installations that

ask, or demand, to be occupied as much as viewed, and that accept the architectural frame as (to use Gormley's words) a 'second body'.

The structural language of much of the work in the exhibition is itself architectural, that of the built world, our urban environment. The idea of the body as building has run through Gormley's work for over thirty years; body forms conceived as aggregations of rectangular or cuboid blocks, whether solid masses or open frames defining spatial volumes, have expressed this equation in myriad ways, both simple and complex. The solid blocks that make up the body forms of the recently completed *Slabworks* (all 2019) in the first gallery, the structural principles that govern them – of propping, stacking and distribution of load – announce this right at the outset. And the way in which these fourteen *Slabwork* sculptures are ranged across the space requires that they be approached less as discrete objects to look upon than as a zone – a 'field' to be moved through. This first room of sculptures – setting the course for the exhibition as a whole – reflects the alternating current that has run through Gormley's work for decades. His sculpture proposes two ways in, sets up two modes of engagement: the one through a 'recognition' and an imaginative occupation of the object (this is the proposition of the life-size body cases and body forms – the dark space of the body as 'objective correlative') and the other through an active, bodily engagement. As early as 1994, Gormley announced that he 'didn't want the absolute division between the viewer and the space of art: I wanted a field that you could enter'.

This idea, of the reciprocal relationship between the object, the space in which it is shown and the viewer who enters, reflects back on the sculpture of the 1960s that was so important to Gormley's early formation as an artist – to the installations of Donald Judd, Robert Morris and Bruce Nauman, among others, all of which were predicated on the idea of a 'sited vision', implicating the presence of the viewer as a body moving among the works even if they rejected direct reference to the human body in the objects themselves. And this idea of active engagement holds for the best part of the exhibition, especially with those works made for the show: it is there in the kilometres of steel tube, coiled and looped across an entire gallery, of *Clearing VII* (2019); in the straight lines of *Co-ordinate VI* (2019), with its taut steel wires running vertically and on horizontal axes just above head height across empty space and through wall and ceiling; and – most emphatically – in the constrictive tunnels and shadowy recesses of *Cave* (2019), a building-sized body form that has to be walked into, through which you grope your way in near-darkness towards the light beyond. This cluster of irregular hollow cuboid forms set at angles and bursting the bounds of the gallery is architectural in scale, but its form again derives

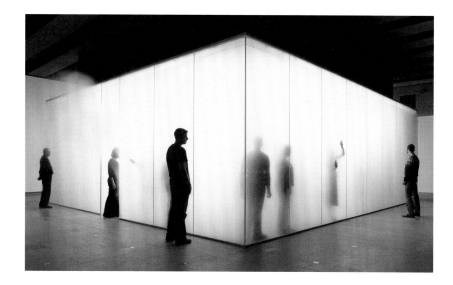

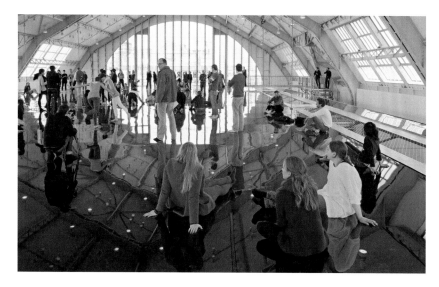

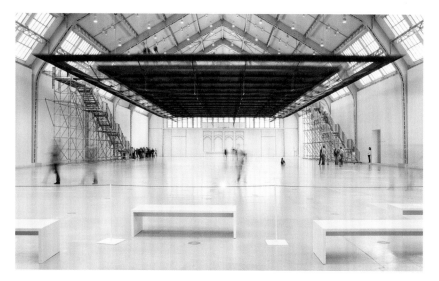

Fig. 28 *Blind Light*, 2007. Fluorescent light, water, ultrasonic humidifiers, toughened low-iron glass and aluminium, 3.2 × 9.78 × 8.56 m. Installation views, 'Antony Gormley: Blind Light', Hayward Gallery, London

(Centre and below) Figs 29 and 30 *Horizon Field Hamburg*, 2012. Steel 355, steel spiral strand cables, stainless steel mesh (safety net), wooden floor, screws and PU resin for top-surface coating, 20.6 × 24.9 × 48.9 m. Installation views, 'Antony Gormley: Horizon Field Hamburg', Deichtorhallen, Hamburg

from the human body, a figure lying on its side, its back hunched against the corner of the gallery. *Cave* acts both as body and as architecture itself, in a dialogue with the building that is joined, or 'completed', to Gormley's mind, by the many bodies that enter it.

Lost Horizon I (2008) seems to combine these two modes of engagement: it allows an encounter with individual, life-size bodies, sculptures that stand upright on the ground before us, but the work as a whole surrounds us, 24 body forms in all orientations – some projecting horizontally from the walls at different heights, others suspended from above, upside down – creating a dizzying, unsettling effect, restating, multiplied, the three axes of *Co-ordinate*. Indeed, both ways, both modes of engagement – with the discrete object and the environment – can constitute a challenge for the viewer, both imaginative and physical; this challenge, for Gormley, is in order to have us sense our own presence, to instill in us a heightened awareness of our own bodies as a focus for consciousness.

We rely on the flat ground on which we stand, the line of the horizon ahead of us, to orient ourselves, recognise our own upright state, our bodies as vertical. *Lost Horizon*, like the environmental installations *Clearing* and *Co-ordinate*, disconcerts by confounding such certainties, prompting that sense of a loss of balance that comes with standing before an abyss, at the edge of the roof. These works set themselves at odds with the building and call from us a different way of moving, of orientating ourselves in space, testing our physical and visual measuring of space and scale and distance. A similar impulse to disconcert in order to prompt a deeper self-awareness has registered in some of Gormley's most striking immersive works over the last decade or more: the brightly lit, glass-walled 'cloud chamber' of *Blind Light* at the Hayward Gallery in London in 2007 (fig. 28), into which bodies walked and disappeared, as if de-materialised; and the black, mirror-like sheet, a trembling membrane stretched taut and high in space, of *Horizon Field Hamburg* (2012; figs 29 and 30), which visitors climbed stairs up to and stepped out on in trepidation, seeing their dark reflections beneath them and sensing through their feet the

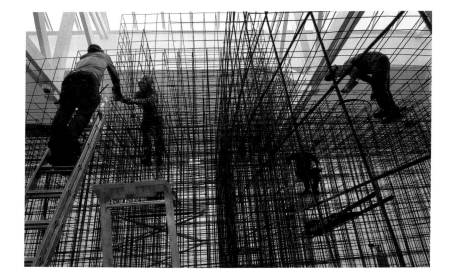

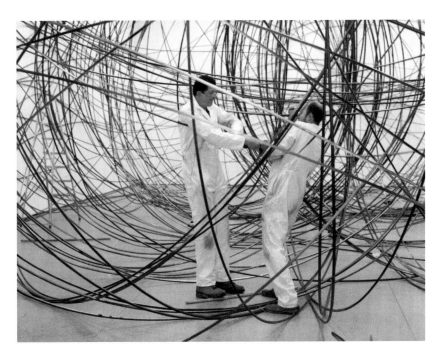

movements of other people all around. *Matrix III* (2019), here at the Royal Academy, cannot be entered in the same manner – it hangs, a vast aggregation of steel mesh space frames, just above head height in the largest gallery space – yet it effects something of the same disorienting effect that elicits both a personal response, an attempt to regain one's bearings in the absence of fixed co-ordinates, and a more communal gathering of bodies, a coming together, beneath its dark, almost impenetrable, shape-shifting mass.

Strategies of concealment and distancing are at play from the earliest works, the lead-wrapped objects Gormley made in the early 1980s, before turning to the body. These works too make an appeal to the imagination, their generalised forms simultaneously presenting and withholding what lies contained within, hidden from view. In the *Slabworks* or the latticed steel-grid construction of *Subject II* (2019), the abstraction of the body and its re-description in the language of architecture can also appear a conscious 'distancing' of the work – almost to the point of perversity – from any effect that might derive from the 'naturalistic' rendering of human appearance. They seem to test the limits of our capacity to empathise, to read a bodily presence into increasingly abstracted form. Their material, their constituent parts and structural principles might have more to do with the building than the human body. And the space of the body itself, as the origin of the form of the work, may also, on occasion, be largely or wholly hidden from view – as with the body voids encased within the geometric concrete works *Flesh* (1990), *Sense* (1991) and *Press* (1993) – or the body positions at the core of the hollow, hermetically sealed iron shells of *Body* and *Fruit* (both 1991–93).

As living, conscious bodies we stand upright and we move forward, seeking security in the level horizon, understanding the space that surrounds us through a sense of our own orientation, gauging distance in relation to our own, human scale. And so the uncertainties of orientation and scale prompted by the work play a part, too, in this unsettling, both of us and of the order of our surroundings. The steel skein of *Clearing* sets up a chaotic challenge to the room it fills; the absolute vertical and horizontals of *Co-ordinate* run askew to the axis of the galleries themselves and the body forms of *Lost Horizon*, life-size, project from walls and hang from the ceiling as well as stand with us on the floor. The works counter the expectations of the building just as they confound our own. The *Slabworks* are pointedly larger than life, with an uncanny 1.25:1 relation to human scale; the intersecting mesh of *Matrix*, suspended from the ceiling, tricks the eye, conflating foreground and back, inside and out, so that the position of its internal volumes can no longer be determined. *Cave* takes on the building in its very scale, and, swallowing us up, threatens to withdraw the last requisite for our ability to locate ourselves securely: light by which to see. Gormley has spoken, often, of the sensations of

Fig. 33 *Earth*, 1994. Carbon and casein on paper, 14 × 19.5 cm

Fig. 34 *Passage*, 1995. Carbon and casein on paper, 14 × 19 cm

(Opposite) Fig. 35 *Host*, 2016. Clay and seawater, overall depth: 23 cm. Installation view, Galleria Continua, Beijing

constriction and release – experienced since childhood and intensified by the practice of the Vipassana method of meditation he learned during his years in India – that come with the closing of the eyes, a turning from real space to the dark indeterminate space of the body. He describes that space as 'a place of possibility'. Each work, in this progression through the exhibition, sets up its own testing proposition in a similar manner. Their combined effect is cumulative, and the response called for is an open one.

Drawings play a crucial role in this exhibition, and in the building of this cumulative effect. In exhibitions in recent years Gormley has come increasingly to set his drawings in counterpoint to the sculpture, as a parallel, independent yet interrelated mode of expression, employing its own particular means in pursuit of the same ends. The drawings are physical evidence of bodily action, and material objects in themselves rather than mere images. In relation to the sculptures they are more immediate, intuitive, exploratory. Gormley speaks of their genesis and their action in the exhibition – as he does of the whole process of conceiving an exhibition in a particular space – in terms of 'dowsing', a searching for something in the ground and a transmission through the body of what lies beneath, invisible – again, a place of possibility, the 'immensity within'.

That Gormley relates this sense to be got from the work – of confinement and release, heightened awareness, connection to the space around us and to each other – fundamentally with a larger sense of our place in the world, our human condition and contemporary predicament, is axiomatic. And yet he has always been reluctant to particularise the work, to identify or align it overtly with specific pressing social or political issues. The 'world view' is there, incontrovertibly, but Gormley would maintain (and he would not be alone in this) that to explain such particularities – or to impose the intention of specific emotional effect – would leave no room for our own, open and personal responses. It is this, the primary unguarded response, that he seeks to prompt – and the conditions for the work that encourage and allow it.

Gormley has followed a singular path over the decades, but all these strategies for involving the viewer – his sensitivity to site and to context, setting his work beyond the bounds of the gallery, moving out of the studio to involve others as co-producers, engaging with entire communities in the conceiving and siting of works, and – not least – installations that confront and challenge and pull the viewers into their orbit – seem prescient at a time when notions of participation and collaboration, the implication of the viewer, have come so much to the fore.

The immersive or spectacular artwork, so prevalent in recent years, can carry with it a certain suggestion of passivity, acceptance, even complicity on the part of the viewer. But if there is spectacle to be found in Gormley's work, it is not spectacle for its own sake, a quick fix of marvel and wonder, rather a means to an end. There is just the physical material of sculpture doing what it does – no trickery or illusion, no smoke or mirrors. Active engagement rather than passive submission is the aim, yet without any sense of coercion. And if there is challenge in this confrontation with the work, there is also an invitation, an invitation to feel. It is a direct appeal, one-to-one, but in the spaces of the Royal Academy and with its broad audience, the orchestrated, at times testing progress through the exhibition is clearly and purposely to be shared with many others, in a co-presence and a sort of co-awareness.

And then, at last, a horizon is restored, and a solitude, of sorts. *Host*, mud and seawater mixed, extends before you across the floor from wall to wall. An organic tang rises from it, and light falls on its surface, dying with the day. The exhibition begins with hard, mechanical, industrially produced metal; it ends with this soft, opaque surface of stilled earth and water, a line dividing the space of the ground below us and the space of the air above. You stand at the threshold as if on a precipice, or at the edge of the ocean. This is the world, again, the outside, brought in. It is a place of origin, another place of possibility, but also something final, wordless.

Human Relations

Michael Newman

Natality and Memory

A baby is in the Annenberg Courtyard in front of the Royal Academy. Visitors will see this as they enter and leave. The baby, in iron, is prone, with head to one side and an ear to the ground. This is not a helpless position. The baby implies beginning, the potential of a life lying ahead. She is crouching, legs splayed, belly down, head to the side as if listening. The suggestion is of independence and possibility combined with connection and dependency. Implied in this gesture, at the very beginning, is a relation to the future, the future of those who are young, who are recently born, and who are yet to be born.[1]

Iron Baby introduces Antony Gormley's exhibition at a moment when the future of the human is very much in question, as we face climate change, the development of artificial intelligence, which in certain of its capacities is already surpassing the human, and the critical questioning of a tradition of thought associated since the Renaissance with humanism, with 'man' as the measure of all things. And this is a time when an older generation is concerned with what the world will be like for their children – whether there will be a world, or continuity of human life – while, if not in denial, having to admit responsibility for where we are now, despite doing very little about it. That task is being left to the young. At such a moment Iron Baby is a call to responsibility.

Twenty-one years ago, in 1999, Gormley showed another, very different work outside the Royal Academy: *Critical Mass II*. Sixty life-size iron body forms made from his own body were placed in the Annenberg Courtyard and hanging from the façades of Burlington House. One of the

figures, as it happens, was crouching, like *Iron Baby*, as if observing the Earth closely (fig. 36). *Critical Mass II* is made up of five casts of twelve positions, including standing and squatting; eleven of the body forms were in a normal position, 'all the rest are tumbled, literally dumped from the back of a truck' (fig. 37); the work is also offered as 'an anti-monument evoking the victims of the twentieth century'.[2]

The figures of *Critical Mass II* were first made for a former tram shed in Vienna, the Remise Transport Museum, in 1995. They were cast in iron from the outside of a plaster mould, and have on them all the signs of their making, such as imperfections from the mould surface, flash lines from between the pieces in the sand mould, and outrunners from the metal-pouring, which are incorporated into their surface. They ally themselves with their industrial means of production just as does another anti-monument of sorts, made just after the First World War, and a key work in the history of sculpture: Constantin Brancusi's *Endless Column* (1918). Gormley points out this preservation of the roughness of production, rare in Brancusi's œuvre, in the radio programme in which he discusses the *Column*, the 'endlessness' of which we might see echoed in the parallel tram lines of the Remise, between which Gormley dug troughs disrupting their continuity when installing *Critical Mass II*.[3] Gormley also speaks

Fig. 36 *Critical Mass II*, 1995 (detail). Cast iron, 60 life-size elements, dimensions variable. Installation view, Changsha Museum of Art, 2017–18

(Overleaf) Fig. 37 *Critical Mass II*, 1995. Cast iron, 60 life-size elements, dimensions variable. Installation view, 'Critical Mass', Remise, Vienna, 1995

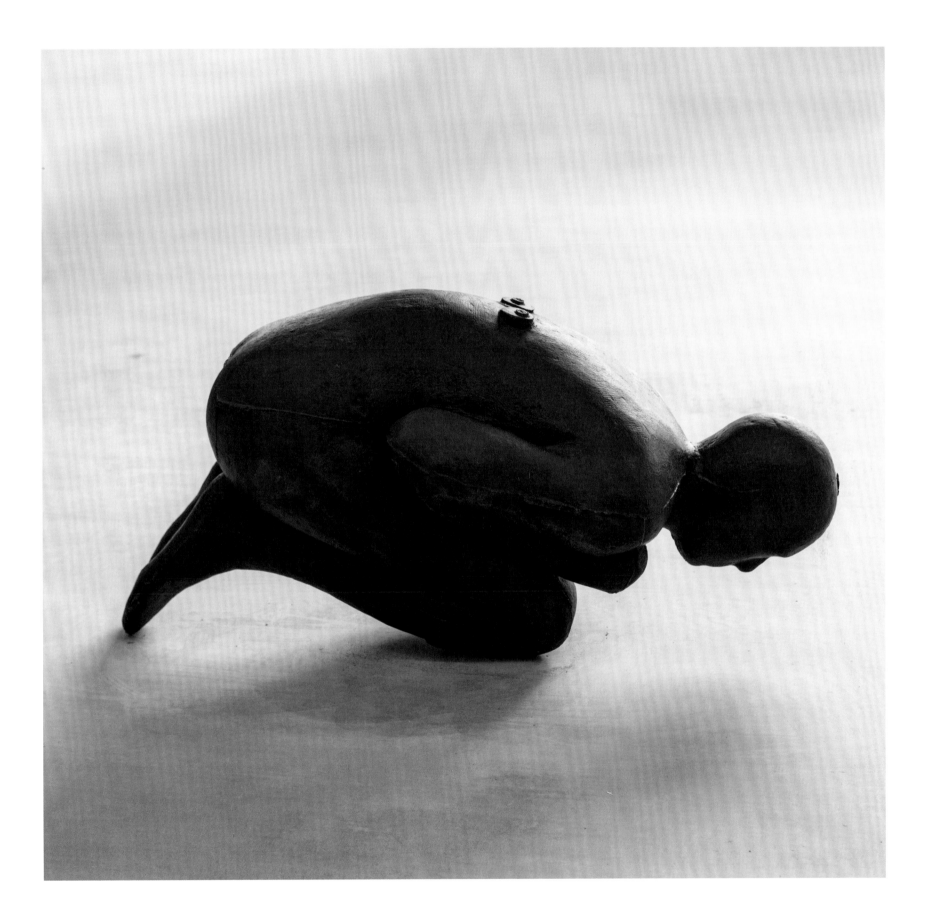

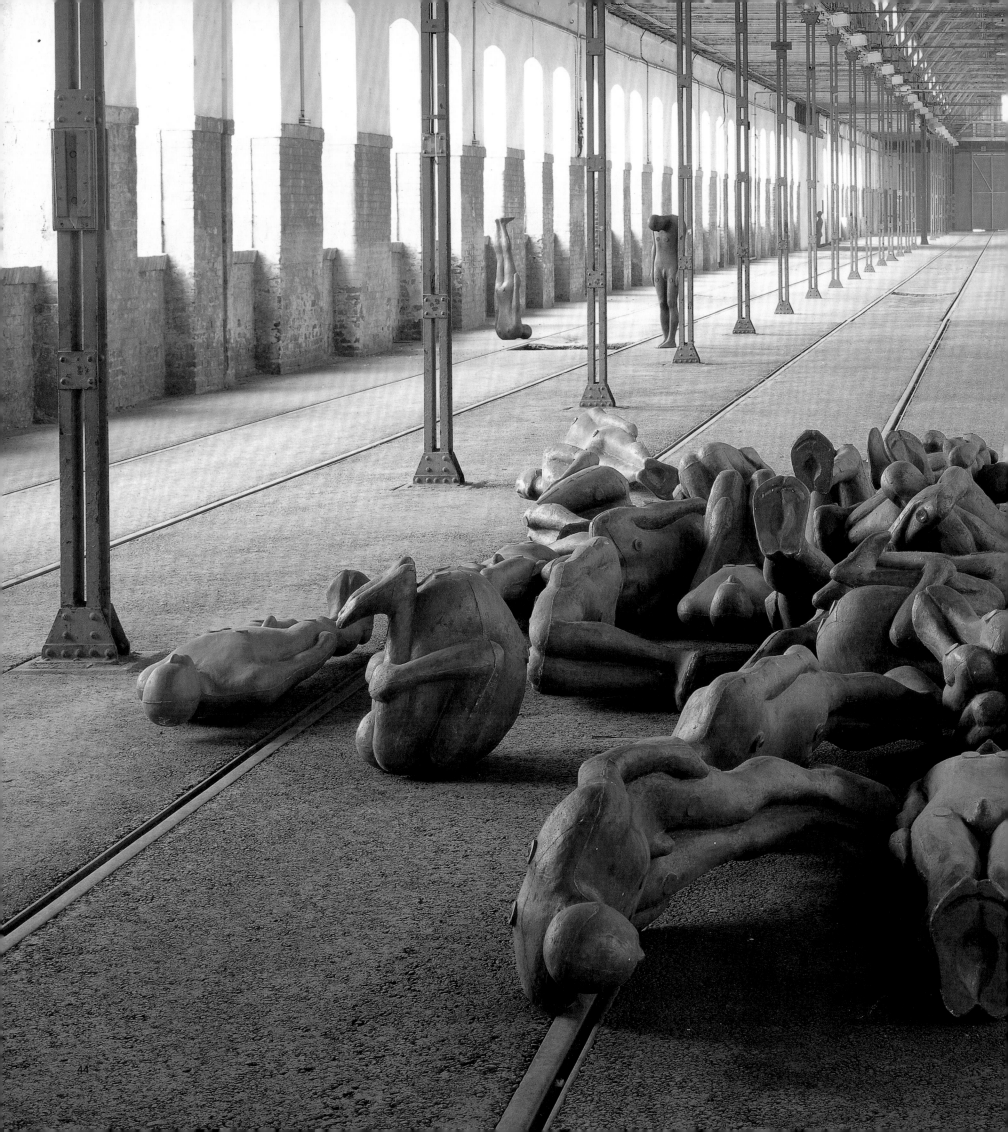

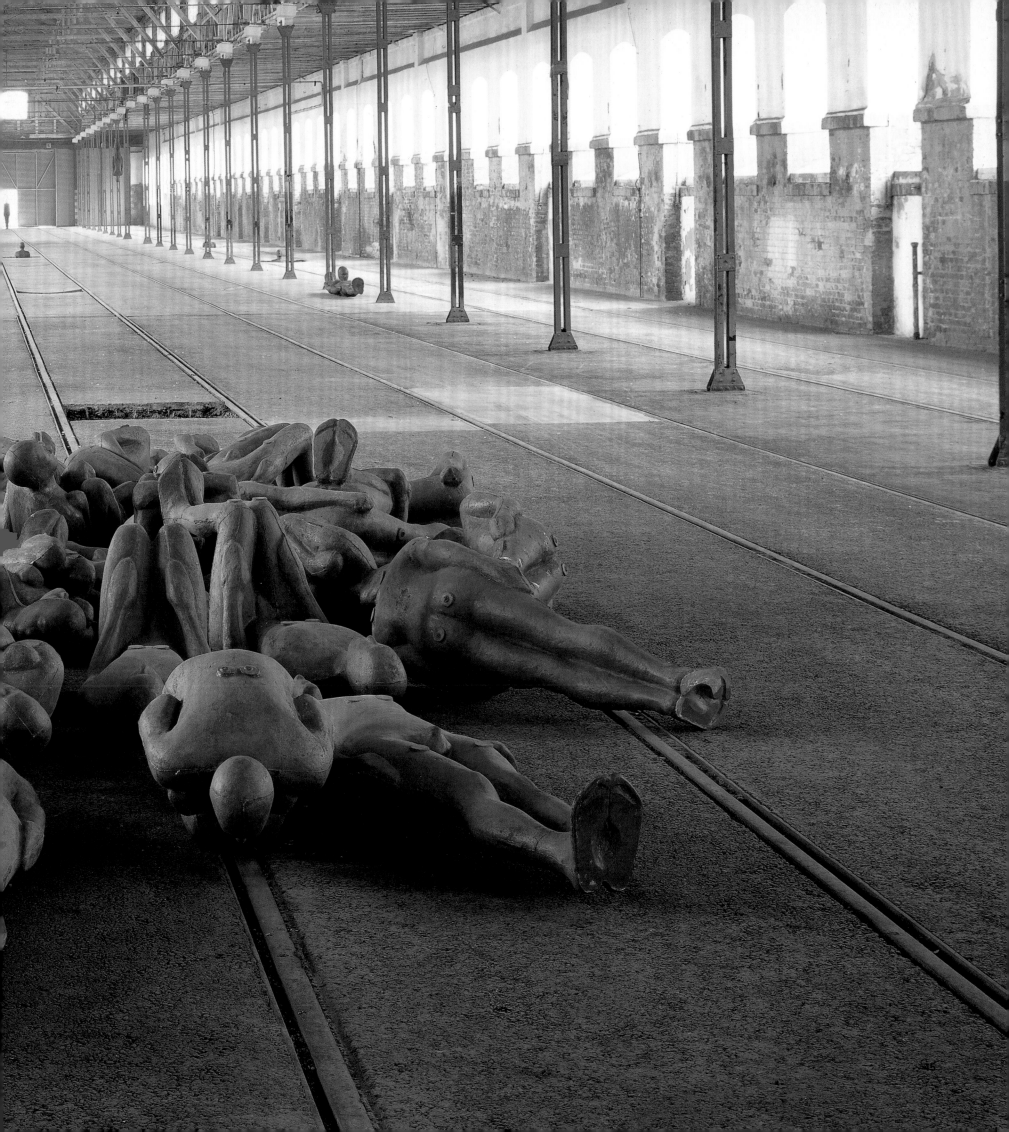

Fig. 38 Constantin Brancusi, *Le Commencement du monde*, 1924. Polished bronze, 19 × 28.5 × 17.5 cm. Centre Pompidou, Paris – Musée national d'art moderne – Centre de création industrielle; rmn 45-000059-02

(Opposite, top) Fig. 39 *Untitled*, 2002. 25 × 25 × 50-mm mild steel blocks, 45 × 189 × 53 cm

(Opposite, below) Fig. 40 Plaster cast of the body of a victim of the eruption of Mount Vesuvius at Pompeii, AD 79

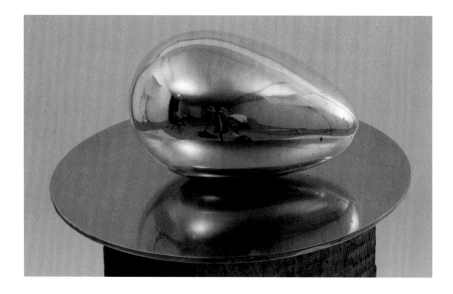

tests have left their mark on the geological record, and they are one of the arguments – together with the burning of fossil fuels since the Industrial Revolution – for the naming of a new geological epoch the 'Anthropocene'.[6]

A work by Gormley from 2002, *Untitled* (fig. 39), was included in the exhibition 'The Last Days of Pompeii' in Los Angeles and Cleveland in 2012. The configuration of *Untitled* resembles the Pompeii casts that were made in the nineteenth century (fig. 40), when it was discovered that the bodies of the Vesuvian eruption's victims had left voids in the solidified ash and pumice, and that these could be filled with plaster. Gormley's sculpture is not produced in this way, but from mild steel blocks welded together within a plaster mould which is then removed. Gormley wrote in a statement for the exhibition:

> The pyroclastic cloud that covered Pompeii in ash, burned all the oxygen in the atmosphere and vaporised the bodies of the inhabitants in poses of fall-out is relevant for my work. The 'lost body' – as the most extreme translation from life to something close to art – is a radical replacement for the lost-wax process and is more direct, more shocking, more about human fragility and our desire for survival. They are shadows that have been made solid, holes that have been filled. I started my work making moulds which were left empty or filled with a darkness which I associated with our experience of the body's darkness. The plaster forms cast from these Pompeian holes are very much masses that materialise a human space in space – a spatial displacement rather than a figural representation. The bodies each lie or crouch in their unique position of facing death but they do not have the morbidity of the mummy, more a direct existential appeal… They are a form of future shock; a premonition of some cataclysmic end whether through lack of air or a nuclear winter. The abstracted bodies of Pompeii AD 79 model the end of the human project and give us a foretaste of our own demise, in the manner of the dinosaur skeleton, but much more immediate. I made three pieces, inspired by a visit in 2002, all of which try to think about a lack of air, fall-out, and the end of time.[7]

of the various versions Brancusi made of an infant's head, including *Le Commencement du monde* (1924; fig. 38), in which the polished bronze head form is placed on a stainless-steel disk, creating a reflection of itself that Gormley envisages as echoing the vertical repetition of the *Endless Column*. Thus, his two works in the Royal Academy's Annenberg Courtyard, separated by over two decades, connect these two works by Brancusi into a meditation on the place and the future of the human.

Gormley's body forms mark a break with the removal of the human body from much of the modernist art that culminates in Minimalism. By placing *Critical Mass II* at the Royal Academy, Gormley questioned how the atrocities of the twentieth century relate to the Enlightenment as represented by the academies of the sciences and the arts founded two centuries earlier.[4] In Claude Lanzmann's *Shoah* (1985), a film about the Holocaust, Filip Müller, a member of the working groups of death-camp prisoners known as the Sonderkommando who were forced to dispose of the bodies at Auschwitz, says: 'The Germans even forbade us to use the words "corpse" or "victim". The dead were blocks of wood, shit, with absolutely no importance. Anyone who said "corpse" or "victim" was beaten. The Germans made us refer to the bodies as *Figuren*, that is, as puppets, as dolls, or as *Schmattes*, which means "rags".'[5] In *Critical Mass II* we were faced with a contrast between the body dumped and the body as a place of potential. The Second World War concluded with the dropping of atomic bombs on Hiroshima and Nagasaki. Nuclear explosions and

Despite Gormley's body form resembling the posture of the Pompeii cast, it no longer gives the impression of being the trace of an absent body, but rather the building blocks suggest both a basic material of which anything could be made – thus by implication connecting the body form with everything else – and a construction oriented not so much to past history as to the future. How does the prospect of the end of the human – figured allegorically in Pompeii, and become an unavoidable part of

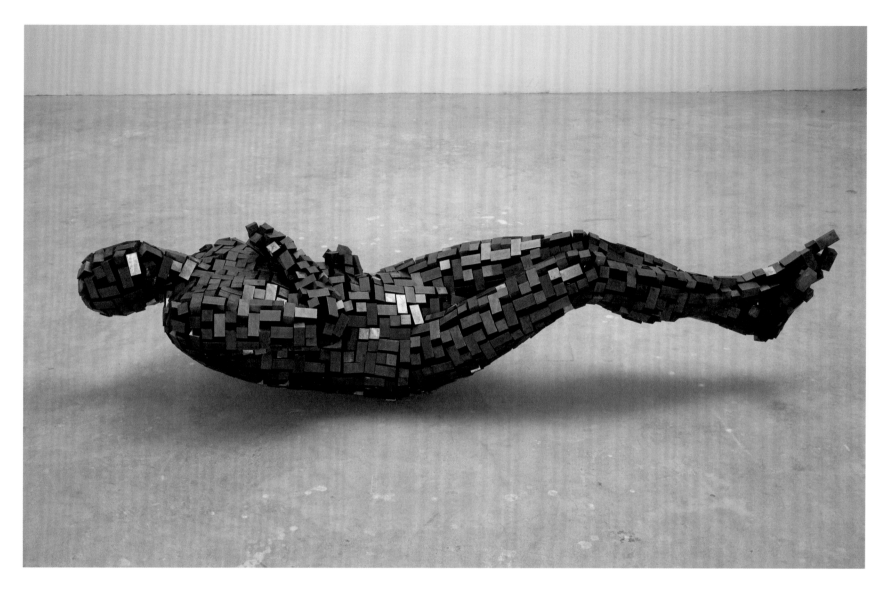

human experience between the emergence of the nuclear threat and the proposal to name our geological epoch the Anthropocene – change how humans envisage their future, which in turn prompts a return to the beginnings of the human?

The atmosphere of Gormley's childhood and youth during the Cold War was affected by anxiety around the nuclear threat. He grew up during the period of nuclear proliferation, with CND protests against missiles in the UK, and the disputed development of nuclear power with its risk of accidents and waste in need of disposal. His school was situated near the RAF Fylingdales Ballistic Missile Early Warning System in North Yorkshire, with its spherical domes covering the rotating radar dishes. The advent of nuclear weapons, particularly after the development of the thermonuclear bomb first tested in 1952, represented the first man-made threat to the continuation of human existence.

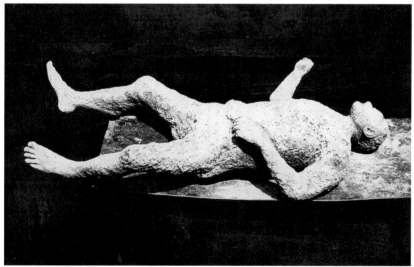

The eruption of Mount Vesuvius was a natural disaster, whereas the use of a nuclear bomb is a human decision. Today the distinction between natural and man-made disaster has been erased by the Anthropocene: 'Nature' is no longer a stable and distinct background to a human foreground. Human activity is causing changes on a geological timescale. The separation between historical time and geological deep time has collapsed, and as change accelerates and extinction becomes a possibility, the human presence on Earth needs to be understood from its beginnings.[8] In a poignant moment in Gormley's BBC film *How Art Began*, the historian of Palaeolithic art Michel Lorblanchet demonstrates how paintings of animals and hand stencils were made in the cave at Pech Merle 28,000 years ago.[9] He chews burnt sticks of wood and blows the ash in little puffs from his mouth onto the surface of the stone. Thus the trace of the living breath of a mortal human is preserved on a rock, which changes according to a completely different timescale – the Palaeolithic humans must have thought the images they left there would leave a permanent mark of their fleeting lives. It is a terrible irony that

the Anthropocene is to be thus named because humans have left traces of their burning of fossil fuels, which will continue to affect the planet according to deep timescales long after humans are extinct.

The possibility of the destruction of all human life by nuclear war is a result of the development of our scientific knowledge. The connection between scientific advancement and nuclear destruction in a work of art can be seen in Henry Moore's *Atom Piece* (1964–65) at the University of Chicago, where it is placed on the site of the Fermilab, where scientists produced the first controlled nuclear chain reaction. As the maquette for *Atom Piece* of 1963 shows, the work grew out of Moore's series of *Helmet Heads*, which emerged as a distinctive form in 1939 and tracked both the war and the rise of the Cold War into the 1960s. The *Helmet Heads* were based on armour and show a concern with the protection of the body, or some kind of homunculus representing both body and spirit. Some, such as the maquette for *Helmet Head No. 1* of 1950 (fig. 41), were made of lead.[10] So the *Atom Piece* maquette both looks back to the destruction of the war, and to Hiroshima and Nagasaki, while also making reference to science

Fig. 41 Henry Moore, *Helmet Head No. 1*, 1950. Lead, artwork (including base), 41 × 26.2 × 26.5 cm. The Henry Moore Foundation

Fig. 42 Germaine Richier, *The Claw*, 1952. Bronze with dark patina, 90.1 × 88.9 × 66 cm. Musée Reattu, Arles

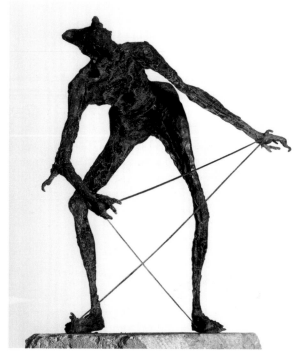

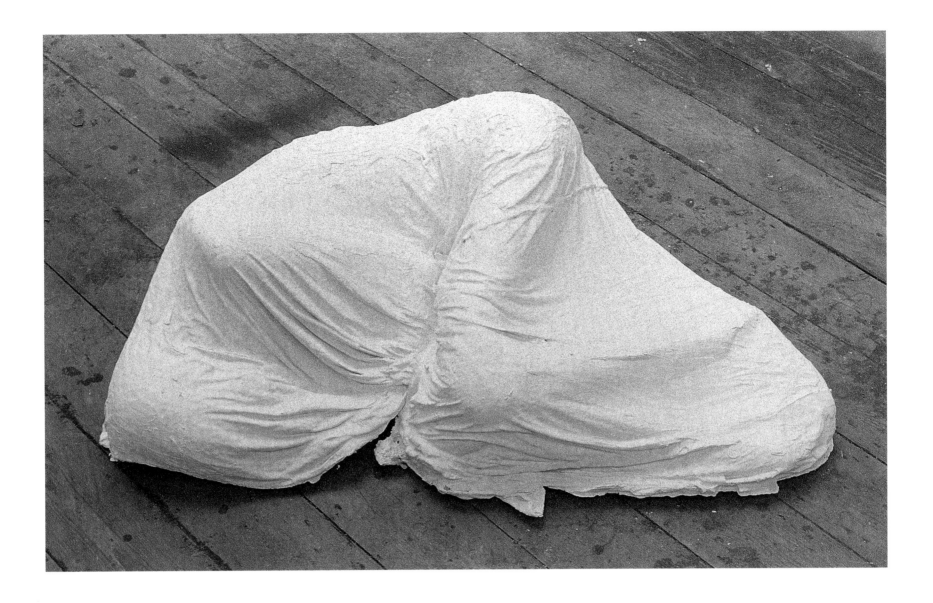

and the advancement of our knowledge of the fundamental constituents of the universe. We see the connection of the body to a diagrammatic linear network in Germaine Richier's 'cat's-cradle' sculptures, such as *The Claw* (1952; fig. 42), in which the 'clawed one', a mixture of animal and human, holds with hands and feet – or perhaps is entangled within – a web of wires. Here the network is outside the representation of the body, whereas the implication of Gormley's body forms is that we are ourselves constituted and affected at a sub-atomic level. Lead may have all sorts of formal properties – malleability and inertness – but it also signifies a protective covering, particularly from radiation. This is to acknowledge the relations of the body with its outside. However, it would be wrong to consider that this is to reduce the body to its atomic or sub-atomic constituents.

After the Second World War the issue for sculpture became not so much the representation of the human – the statue in its classic sense – as of human *existence*. Gormley's work takes a new turn in a development that had already been underway at least since Rodin. Rather than being a question of the representation of the body through formed matter, form realised through skilful moulding in clay, or a body found in a block of marble and released into the world by the action of carving – sculpture for Rodin is the capture of the existence and energy – the life – of a body.

From a prisoner-of-war camp in 1944 the French-Jewish philosopher Emmanuel Levinas described the corporeal self as a 'hypostasis', a Greek word that comes from *hypo*, 'under' or 'beneath', and *stasis*, which means a 'standing' or 'position', referring to 'substance' as both standing and sustaining or underlying. The hypostasis is the event or advent of a bodily existence, or existence as a standing up or taking position. For Levinas that bodily existence is curled in upon itself in darkness as much as it stands in the light – aspects very well reflected in Gormley's early sculptures, such as *Sleeping Place* (1974; fig. 43), in which Gormley, having seen people asleep in public places in India covered by saris or dhotis, placed plastered sheets over friends' bodies to articulate the minimum space required for shelter.

Like Gormley's sculpture, the hypostasis is a place more than it is a being, and therefore it would certainly be wrong to think of it as a statue.

We could, rather, understand the hypostasis reflected in posture. In order to do so we need to distinguish posture from gesture. Gestures are generally movements and attitudes of parts of the body to indicate to others an emotion or a meaning. We may speak of a language of gesture, literally so in the case of signing for the deaf. Although all humans make gestures of some kind, and certain primates arguably do so too, the meaning of particular human gestures is culturally and historically specific, and it is indeed possible to envisage the disappearance of such gestures. The philosopher Giorgio Agamben describes what happens when gestures in modern life become automatic, mechanical and detached from their role in expression.[11]

Although gestures are usually made with the hands or the head, sometimes the whole body becomes a gesture, expressing an attitude. However, I believe it is possible to make a distinction between gesture and posture. Whereas it may, like gesture, be interpreted, and has its own historical and social particularities,[12] posture is closer to the way the body assumes its existence. Stance may involve assertion, acquiescence or anything in between: upright, inclined or lying down.[13] Of course, this means that posture has always been a factor in sculpture of the body. But something changes in the relation of sculpture to posture, first in the late nineteenth century, and secondly in the 1940s and 1950s. The first turn is in relation to narrative and meaning. The question is really whether or not it is subsumed by narrative or the communication of meaning. The transition from gesture to posture, and from narrative to the assertion of the sheer existence of the body, is enacted in the sculpture of Auguste Rodin.[14] This may be seen in his multi-figure bronze sculpture *The Burghers of Calais* (1889; fig. 44). As a sculpture referring to a historical event, the surrender of Calais to the English during the Hundred Years' War, one might expect to find a gesture that sums up the moment when five leaders of the city volunteered to walk out bearing its keys and wearing nooses, as demanded by Edward III. But the burghers are situated between gesture and posture, and the gestures they evoke are concerned with bearing the weighty burden of loss while still holding themselves upright. Perhaps thinking of *The Burghers of Calais*, Levinas writes that in Rodin's sculpture expression does not lie in the face or eyes, nor we might add in the gestures:

> It does not express an event; it is itself this event. This is one of the strongest impressions we get in looking at Rodin's sculpture. His beings are never set on a conventional or abstract pedestal. The event his statues realise is much more in their relationship with the base, in their position, than in their relationship with a soul, a knowing or an essential thought, which they would have to express.[15]

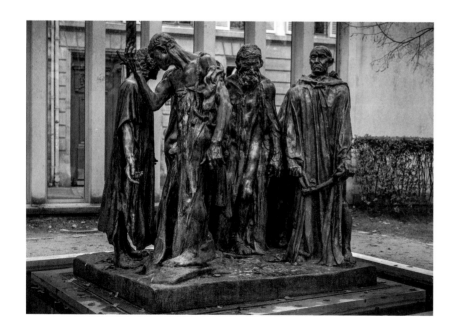

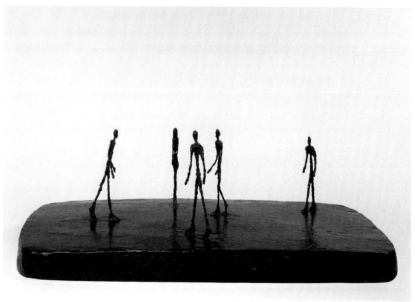

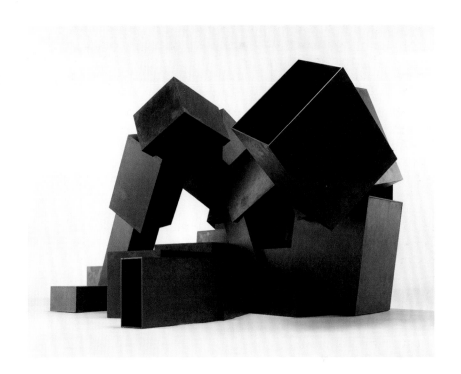

Fig. 46 Exterior view of *Cave*, 2019 (model for the RA). 2-mm Corten steel, 48.5 × 93 × 75 cm

Rodin intended to place his burghers, which are after all sculptures of bodies, directly on the ground, without a plinth, so that they would be on the same level as the public, so that the experience of the sculpture would be one of co-existence.

Gormley effectively carried out Rodin's plan when he placed his own body forms alongside classical sculptures at the State Hermitage Museum, St Petersburg, for the project 'Still Standing' (2011–12). He had the floor raised above the level of the plinths so that the classical figures met the public in a new way. Not only did Gormley's body forms reveal new aspects of the classical sculptures, thus paralleling Rodin's intense study of the Parthenon sculptures at the British Museum,[16] but the movements and positions of members of the public contributed to forming continually changing constellations with the classical sculptures and Gormley's own. The exhibition became an exploration of bodily co-existence.

In order to appreciate the next transformation of posture in relation to the condition of human existence in sculpture from the 1940s, Rodin's *Burghers of Calais* might be compared with a sculpture by Alberto Giacometti from 1948, *Piazza* (fig. 45), which Gormley chose as the subject for one of his 2009 BBC Radio 4 talks. Both sculptures include five figures in a horizontal plane, although the figures of *Piazza* are about nine inches high, compared with Rodin's over-life-size burghers. In this the sculptures separate two aspects that Gormley combines in his own work. In his radio talk, Gormley characterises Giacometti's sculpture as a 'model, not just of a big thing that has been made small, but a model of space-time relations'.[17] Gormley's body forms are often life-size, indexing human existence on a scale of 1:1. Yet in the process of turning existence into sculpture he causes his works also to operate as a model of space-time relations.

Rather than representing or re-creating the figure, Gormley sets up relations between the places of events of existence, which include bodies. However, there is an analogy here to the measurement problem in quantum physics.[18] The question is how measurement affects the ontological state of the entity being observed. To put it in the terms of Gormley's body forms, is it possible simultaneously to measure place and existence? Clearly, existence, once cast or scanned, 'collapses' into an object. The problem then is to create a body form that indicates its own insufficiency, that it is more than that which results from the measuring. In the lead-cased body forms, this is done by rendering the place of the body empty (rather than replacing it with formed matter, as at Pompeii). In the digitally scanned body forms, the notion that there is more to the body and to Gormley's sculpture of the body's place than any reductive account of its ultimate constituents is achieved partly by pushing the

schematic or diagrammatic dimension of the matrix – with wire or blocks, for example, standing in for quanta of energy. Thus in addition to the conception of the work being a model of bodies, the body itself becomes a model, which is both a metaphor and a projection. *Cave* (2019; fig. 46), for the Royal Academy exhibition, is a steel body case, a vessel formed of steel boxes crashed together that fills an entire gallery. Visitors will enter *Cave* and, looking up, see an aperture letting in light. It is as if a life-size sculpture has become a model: the body itself has become a place into which other bodies may enter. It becomes a reminder of where art began, in the Palaeolithic caves, made with and by the human body.

Returning to the condition of modernity, Giacometti used modelling, in *Piazza* as in many other of his sculptures, in clay on a wire armature. His modelling has a tentative quality, with the effect that the existence of the subject modelled by the artist appears to be both coming into being and withdrawing. It must be said that in *Piazza* there is a tension between the anonymity of the field and the minimal designation of the singular humanity of the figures. There is something similar in Gormley's work from 1999 when the body form is opened up and made of some kind of matter that refers to a field, by analogy with electromagnetism or quantum

mechanics. In *Trajectory Field III* (2002; fig. 47) we see the body entirely comprising vector lines. Yet at the same time Gormley is always careful to scan or measure himself and his subjects, and to construct his figures so that they communicate a human feeling, or, perhaps more precisely, the feeling of a human, of a human being. Although the model proposes relations, the inflections of pose imply singularity, that this is the posture of an irreplaceable human individual at an unrepeatable moment.

The singularity and irreplaceability of a human being, that uniqueness, is not something that comes before or is separate from relation, but it does imply a dimension that is irreducible and incomparable. This also means that this aspect of the human is, or should be, immeasurable. Gormley pushes measurement to the limit as the *techne* of his production precisely in order to get us to feel that which in the human does not submit to a metric. The feeling that we sense in relation to his body forms is not the expression of an interiority, but the affect prompted by an inflection in the surface material that conveys that it is a singular body, even if that singularity cannot strictly speaking be represented, since that would require mediation and comparison, by which the singularity would be lost. 'Measure', we might say, is not the standard of a metric or a gauge to be applied, but the need for limits that arises from the acknowledgement of that which exceeds measurement. Measurement renders equivalent: it provides information and generates exchange value. Otherness and values that do not concern measurability don't figure. We live at a time when the future will have to do with how we are able to articulate these two dimensions. While we need to cherish those aspects of the human and the planet that do not submit to a metric, we need measurement to understand climate change and decide what to do. However, measurability and self-preservation are not enough. What is needed is for humans also to sense the non-measurable, non-exploitable value of what we have called 'nature' or the 'Earth'. We need a comportment that we have perhaps not yet, with some exceptions, achieved. Comportment can only start from the body, so a measure would involve a bodily and subjective dimension, which will also be that of the visitor to the gallery. We could see Gormley's work, his projects and exhibitions, as a search for measure in this sense. As he puts it, 'the exhibition is a test site'.[19]

If humanism took the measurement of the white male body as the standard from which to establish the proportionality, the fittingness, of the world, Gormley, starting from his own body, takes that which cannot be measured – which you can only know by trying, or as he might put it 'testing, the feeling of being a body' – as the measure. The danger, of course, is that this might seem a neo-colonialist hubris, to take one's own privileged white male Western body as standing for the body as such or human existence as such. And the issue of male privilege is clear, too, in the work of Rodin and Giacometti. But the problem for them arises because of their attempt to capture the existence of others. Gormley's body forms are premised on the idea that he cannot exist others' existence; that he must start from the existence of his own body. His training in Buddhist meditation in India between university and art school has taught him that existence may become a practice, or that it is possible to work in a disciplined way on one's inner and bodily existence.[20] Posture may have to do with the body understood in terms of energy, where the energy of the body is connected with a general energy in the universe, so that a practice of the body becomes one of connection. Effectively, with the body forms Gormley brought this idea of posture as practice into Western sculpture (as a principle, not as an appropriation). The making of the sculpture could itself be seen as a practice, requiring concentration, endurance and trust. So the body form is the result and indeed the trace of this practice. As a trace, it is the body-left-behind. When Gormley works with other people, it is they who contribute their existence, submitting it to the attempt at measurement, leaving behind the mould or scan, or, in the case of *Field* (1991; fig. 48), multiple hand-modelled clay figurines, each as unique in its individuation as its maker.

Place, Horizon and Field

If Gormley replaces the cast of the body – his body – with *place* as a founding gesture of his *œuvre*, this poses the question: what is the *place* of the human? Further, from where can we even ask this question? Indeed, can 'we' ask this question? Climate change, the extinction event and the Anthropocene compel the need for a standpoint on the human as such, at a time when we envisage its end to re-think its beginning, but can this strictly speaking be a human standpoint? How can we take a standpoint on the human without implicitly transcending the human? For Walter Benjamin, in his interpretation of Paul Klee's painting *Angelus Novus* (1920), it is not a human but an angel who assumes the standpoint – anticipating our own question of standpoint – on the coming-together of history and natural history.[22] This angel, blown by a storm from Paradise, has been turned around and sees only the piling up of ruins and disaster. What does Antony Gormley's *Angel of the North* (1998) see, situated south of an old colliery, and overlooking motorways and a railway line? Its wings reference an industrial history, but 'place' for Gormley has never been retrospective in the sense of Klee's turned-around angel. The 'nothing' of place in the body forms is not so much absence or death, but potential. This is a lesson Gormley learned from the discipline of Buddhist meditation. 'The body' is neither a machine nor an organism exactly, but a practice. It is both where

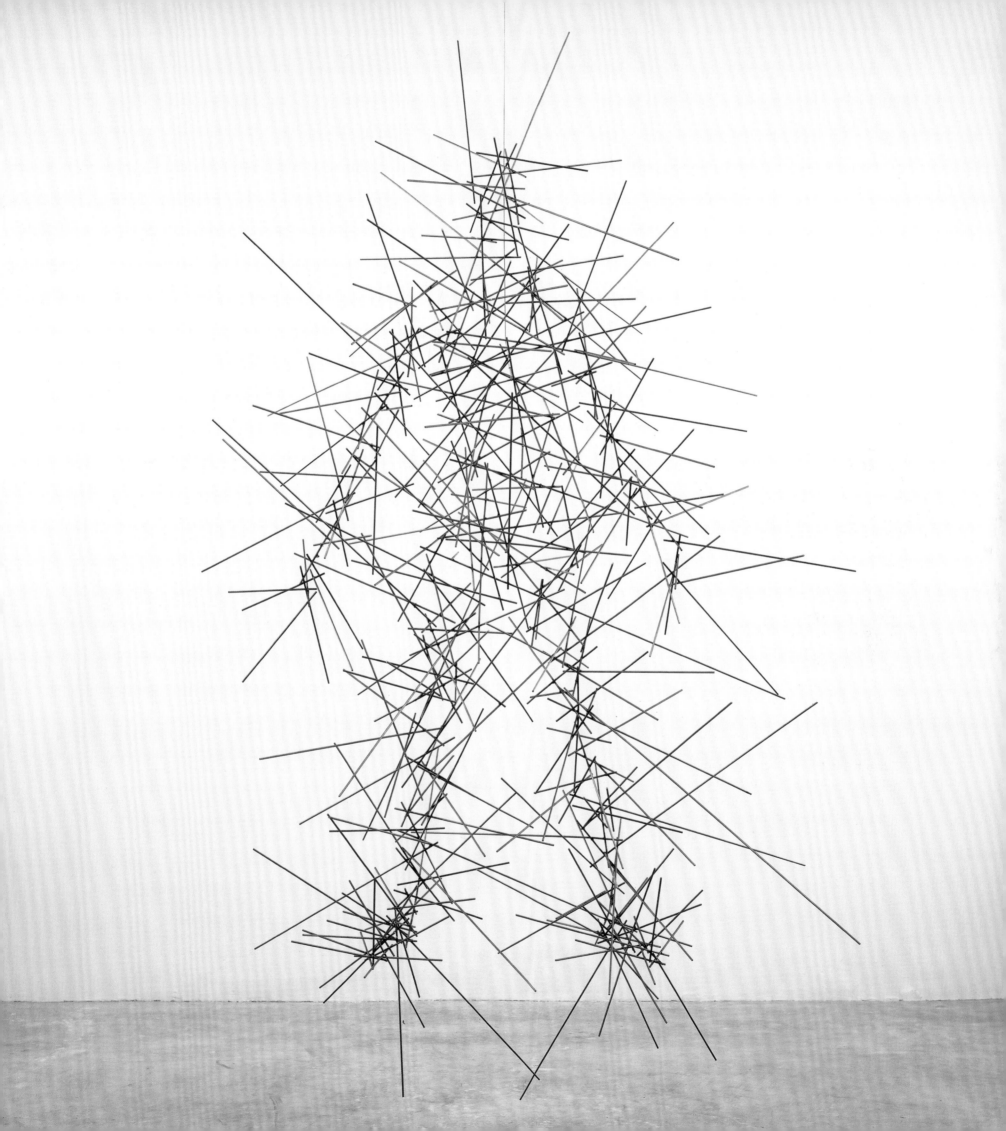

Fig. 48 Forming a figure for *American Field*, 1991

However, there is a further complication to this story. The paradox of modernity is that the more humans lose their place at the centre of the universe (Copernicus), transcending the animal (Darwin) and in relation to their own consciousness (Freud), the more powerful and destructive they become. On the one hand, it seems necessary to understand the universe without privileging the human, while on the other hand, there does seem to be something odd about the human that doesn't fit with anything else and that has a tendency to refuse limitation. The strange relation of the human to place may be seen in a work like *Lost Horizon I* (2008), in which iron body forms not only stand on the ground but also on the walls and ceiling, as if there were no up and no down, defying the pull of gravity towards Earth that we take for granted. In effect, we are reminded that the body is not only on Earth and in a building, but in cosmic space, in which gravity works from all directions. It is as if Gormley is disorienting the visitor in order to reorient her or him, or perhaps to change altogether what 'orientation' might mean. This oddness could be articulated in relation to 'place' as an uncanniness, for which the German word *Unheimlich*, 'unhomely', draws attention also to a certain placelessness. The human at the same time has a need for place, or a body *as* place, and yet acts as if place*less*. This idea of excess, which is the hubris of Greek tragedy, is famously expressed in a chorus of *Antigone*: 'Monstrous, a lot. But nothing / More monstrous than man.'[23]

This combination of place and placelessness,[24] location and excess, is at work in other sculptures by Gormley. Compare *Lost Horizon I* with his works in which multiple body forms are placed on a virtual horizon line, for example *Horizon Field*, whose 100 cast-iron body forms were each positioned in the Austrian Alps at exactly 2,039 metres above sea level, an altitude above everyday life.[25] 'Horizon' here has two senses: as a line that may be mapped, and as a limit. What does it mean, then, to conjoin 'horizon' with 'field'? A horizon in the optical sense is human-centred: it moves with the viewer and has to do with limits and the surpassing of those limits. This centring doesn't mean we are in control – it is in a sense the limit of our control. 'Field', as well as meaning a circumscribed agricultural plot, is a term from physics referring to an object that provides the basis for the understanding of particles and their relations. To apply this concept at a larger scale than the atomic and subatomic is to emphasise uncentred relationships in which objects and bodies are events. Differently from its relation to the optical horizon, the body in this model would be described using categories that do not privilege or distinguish the human, or a human viewpoint, from other things and processes. According to the physicist Carlo Rovelli, quantum mechanics 'does not describe things as they *are*: it describes how things *occur*

and how humans exist. Gormley's art is a practice of the body, which may involve measuring, holding in place, stillness and, indeed, posture. If Rodin's sculptures of dancers capture the practice of others' bodies, Gormley's art comes out of his own. Furthermore, we can see a line of continuity from the idea of the body as a place of potential to that of the quantum field, which is a place of potential encompassing and including all bodies. In *Clearing* (2004–19), which consists of up to seven metres of looping metal tube that fills the room, transforming the Euclidean rectilinear space into a topology of vectors, as if a description of energy, the visitors contribute their bodies in negotiating this three-dimensional drawing in space.

and how they *interact with each other*. It doesn't describe where there is a particle but how the particle *shows itself to others*. The world of existent things is reduced to a realm of possible interactions. Reality is reduced to interaction. Reality is reduced to relation.'[26] Gormley's sculpture participates in this re-orientation from object to relation, where the body, and indeed the human, is to be understood as an occurrence according to various timescales. The human is in relation, emerges at a particular moment, and will disappear. But the question is how this may be understood as fundamental without being a 'reduction'. The approach of the mathematician and philosopher Alfred North Whitehead is helpful here. Instead of feelings being added to the universe through human consciousness, he takes every occurrence to involve feeling insofar as it is relation, so that human feelings are a particular modality of this general process.[27] This is to refuse the distinction between objective and measurable 'primary' qualities and 'secondary' qualities that are attributed to subjective sensation. Sensings are how relations happen. The leaf senses sunlight, the rock senses the water that passes over it. As with Gormley's approach to sculpture from his beginnings, this is not to deny the human relation, but to re-discover its *place* in a much larger field.

With the astrophysicist Priyamvada Natarajan, Gormley has devised a virtual-reality film entitled *Lunatick* (2019), in which we depart the biosphere of an island on Earth – presumably threatened by rising sea levels – for the dark side of the Moon, which, fascinating though it is to experience it in this way, is shown to be utterly uninhabitable. In her 1963 essay 'The Conquest of Space and the Stature of Man' Hannah Arendt wrote: 'We have come to our present capacity to "conquer space" through our new ability to handle nature from a point in the universe outside the earth.'[28] However, it is crucial that we do not take this as a view from above. What we learn is precisely that the 'planetary' is not the planet seen from outside, as some kind of resource we could exhaust and escape. This raises the question: how can we understand what is distinctive about the human without taking humans as those beings who dominate the horizon by overlooking everything else? The human, in other words, as implicated.

Is art able or required to provide a mediation between the presentation of the basis of how things are – building blocks, fields, energy, in a project that goes back to the pre-Socratic philosophers of ancient Greece – and relations of care or obligation? We need some sense in which we are obliged by an otherness that is not a human existence, which would include animals, plants and indeed the 'planetary'.[29] Gormley's sculpture is a practice built on the existence and life of the human body, but a body no longer understood as autonomous or separate from everything else. The human must be shown 'in relation', because ultimately everything is related to everything else, and we cannot excuse ourselves from these relations and the effects that we have on others, on the world. Nor should the human have the privilege to abstract itself. On the other hand, as the horror of treating people like things shows, we have a relation with humans that is different from the relation with objects, and brings with it particular obligations. The point is, though, that not only should we not treat humans as objects, nor as means, but that we also shouldn't treat objects as objects, that is to say first of all as separated, isolated items that only subsequently and secondarily enter into relations. But neither are relations something to which objects in their distinctiveness and people in their singularity are to be reduced so that they lose their individuality and become instrumental in some other purpose. We need to consider relations in a non-reductive way. Gormley took the idea of the 'expanded field' of sculpture[30] as a way of moving from the tradition of sculpture as representation and autonomous object to a sculpture of relation, where it is both the case that relations are explored in and by the sculptures, but also that through installations and exhibitions, relations themselves become the sculpture – relations between the body forms or body matrices and their environment and viewers, and relations between the visitors instigated through conditions created by the works, which become modes of bodily co-existence and intersubjectivity. These experiences are actualisations of potential that model ways of being, experiments both for the artist and for us.

Unravelling the Invisible Universe: Colourless, Soundless, Odourless and Painless but Real

Priyamvada Natarajan

In her philosophical poem *View with a Grain of Sand*,[1] the acclaimed Polish poet Wisława Szymborska addresses the relationship between the real and the unreal, bringing to our attention the essential ambiguity that the sensorially imperceptible could nevertheless exist.

Szymborska could well have been writing about one of the many elusive components of the universe – dark matter, dark energy or black holes. Our cosmic inventory suggests that most of the matter-content of our universe comprises dark matter – composed of an as yet unknown, all-pervasive particle that probably formed soon after the Big Bang. This census has also revealed that our unmoored universe, expanding and discovered recently to be accelerating as well, is powered by yet another mysterious force – dark energy – that countervails the attraction of gravity by providing a kind of cosmic repulsion. Meanwhile, we are also discovering that the near and far universe is littered with some of the most enigmatic astronomical objects of all – black holes, small and large.

With these exotica structuring the universe, all the ordinary matter that is familiar to us contributes a mere four percent of the cosmic inventory. This is the paradox of contemporary cosmology. The most important entities that shape the universe remain invisible, untouchable and essentially unknown, although we infer their omnipresence indirectly. Therefore, in the grand scheme of things, we humans, our bodies constituted of atoms and elements in the periodic table, are made of matter that represents an insignificant fraction of the majestic universe. Yet, our bodies and minds are currently the only known intelligent life-forms with the cognitive capacity to comprehend the universe itself.

This tension between the real, the seemingly real and the unreal potentially plays out on many levels. The combination of the minuteness of our corporeal selves, and the ostensibly unbridled capacity of our minds to unravel the hidden, is at the heart of the paradox. In contemporary cosmology, we are now confronted with a more intricate, tripartite problem of the mind, the body and the cosmos (space) – and how they interact and interrelate. Though it is empirical science that has brought into sharper focus these uncomfortable truths, art offers us a powerful response to bridge and navigate this confounding disconnect. Art is helping us explore more deeply the profound relationships between mind, body and space.

In thinking about how best to shape my contribution to the catalogue for this exhibition, I have decided to focus on subjects and preoccupations common to Antony Gormley's work and my own: mass, space and time. Gormley's work brings into dialogue perceptions of form – in this case that of the human body, its materiality and its position in space – often on a grand scale to produce objects that are hyper-real. In his sculpture, we

Fig. 49 The first image of a black hole, using Event Horizon Telescope observations of the centre of the galaxy M87. The image shows a bright ring formed as light bends due to gravitational lensing by the intense gravity in the vicinity of a black hole that is 6.5 billion times more massive than the Sun. Published in April 2019, this image offers the strongest evidence to date for the existence of supermassive black holes, while also ratifying Einstein's theory of general relativity. Event Horizon Telescope Collaboration

see vividly the interpolation between these truths and the attempt to construct a cosmic identity – one in which the body is an object with mass that carves out space while simultaneously enclosing space. The intellectual and creative process that Gormley's works encode and embody mimics that of cosmologists like me when we construct theories – when our ideas and conceptions collide with observational data. Although these encounters between ideas and instruments generate new discoveries, the provisional nature of science inevitably means that they also serve as sources of consternation to be faced when we attempt to comprehend the deeper nature of true reality. We have to contend simultaneously with the inspiration that leads us to enquire into nature, the exhilaration this brings and the resultant disorientation that arises from our ever-changing conception of our place in the cosmos, even as we remain alert to the limits that our minds impose on our knowledge.

But first, let me take you on a journey to demonstrate how we have scientifically constructed our current cosmological model, a physical and mathematical description of the universe, and made real the elusive entities that we have encountered. Despite our ignorance of the true nature of these invisible constituents of the universe, and fully aware that our own eyes are not attuned to see all that exists, we have been able to develop a detailed theory that is extremely well supported by observational data. And ultimately it is light, dancing through the universe, traversing space and time, that illuminates all, revealing the truth, distinguishing between the real, the seemingly real and the unreal. But does it really? Recently our perception has been extended beyond the visible spectrum, beyond the electromagnetic spectrum even, with the first detection of gravitational waves announced by the LIGO Scientific Collaboration in 2016. These tremors in space-time, gentle convulsions generated when two black holes collide, were measured by the most precise measuring device ever built. We have opened an entirely new window onto the cosmos that will no doubt revolutionise our understanding yet again.

A very significant shift in our cosmic view was catalysed by the astronomer Edwin Hubble's discovery in 1929 that galaxies near our own are hurtling away from us at speeds proportional to their distance from us. Our universe was now untethered, and it was no longer static and stable. This came as a new blow to the comforts of anthropocentrism, which had met a key challenge in Copernicus's reordered view of our local neighbourhood – the solar system. Copernicus radically changed our understanding of the solar system in 1543, shifting the pivot from the Earth to the Sun, and Hubble's finding that our universe is unmoored created another deep fissure in the classical view of a steady universe with us at

its centre. Now we were all drifting into the future with no centre, and by extension originating from a problematic past, one in which the universe arose from a singularity – the Big Bang. Georges Lemaître, Willem de Sitter and Alexander Friedmann successfully interpreted Hubble's observation in the context of Einstein's radical upending of Newton's universal theory of gravitation, and showed that these data unambiguously implied that the universe was expanding. Despite the deep discomfort and initial disbelief that this finding caused, its empirical truth was inescapable. New challenges then arose: what are we expanding into? Where are we expanding from? And what are the initial conditions for our universe that set it adrift on this trajectory? Lemaître was able to show that expansion implied a hot, dense and fiery past that he dubbed 'the primeval fireball' and a 'day without yesterday' – the so-called Big Bang. The discovery of the empirical truth of the expansion inevitably led to an uncomfortable origin story, one in which empiricism eventually appears to falter.

Underpinning all this was Einstein's radical reformulation of Newton's universal theory of gravitation. Newton had provided an explanation for how gravity worked, and described the gravitational force between two bodies but not its origin. He could not account for the way the force of gravity was mediated, and instantly at that. Einstein's profound insight lies in his conception of how gravity arises and that it is a consequence of the interplay between the shape of space (geometry), the distribution of matter (mass), and motion (dynamics). His mathematical description that now integrated the shape of space as the arena where gravity manifested itself was truly remarkable. His re-conception held deep consequences for our understanding of how gravity operates and how the gravitational field is generated. The evolution of the universe over cosmic time, with all the concomitant implications for the changing geometry of space, has since formed the basis, the essential scaffolding, of our cosmological model. Although we have been able successfully to chart the evolution of the early universe – its cooling and expansion from its initial hot state – many questions still remain open: why and what causes our universe to follow this particular evolutionary track, why does it have this very specific set of initial conditions, and of course what are the nature and origins of the principal invisible constituents of our universe: dark matter, dark energy and black holes.

Dark matter, though ubiquitous in the universe, does not emit, reflect or absorb light, hence our use of the adjective 'dark'. Nor does it appear to interact noticeably with any force other than gravity. Since dark-matter particles have mass, their presence is revealed by the gravitational force that they experience and exert in the cosmos. Similarly, dark energy is indirectly measured from its impact on the measurable expansion history

of the universe. And the presence of black holes, of course, is revealed by the dying gasps of matter that falls into them.

The essential invisibility of dark matter, dark energy and black holes is a challenge for an empirical science based, as astronomy is, on direct observation. Indirect inference adds to the other epistemic difficulties of cosmology. Philosophically, our inability to perform controlled experiments on the universe, and the fact that we have only one universe to measure and study, mean that cosmology does not strictly conform to our notion of a scientific discipline. The nature of cosmology calls into question our ability to derive general principles or universal laws from the study of a single object – one 'control' universe! Intellectually, in the discipline, we have surmounted this limitation by resorting to large-scale numerical simulations, which enable us to perform multiple realisations of the formation and evolution of the universe, and to make 'mock' observations in these simulated universes and compare them with observational data to test and validate theoretical ideas. Simulations serve as the intellectual intermediary between observational data and models, offering a powerful tool for understanding and visualising complex phenomena. Models, meanwhile, encapsulate theoretical understanding and serve as vehicles for descriptive transcription – much the same purpose that models serve in sculpture. Ideas and laws that define order and causality are embodied in models that are then confronted with both observational data and simulations.

Unseen entities have often played an important if ad-hoc explanatory role in science. Supposed invisible fluids, such as ether, phlogiston and miasma, were variously ascribed magical properties in the pre-scientific Dark Ages. Often used as a stand-in for our ignorance, these ghostly entities were invoked to account for phenomena that seemed inexplicable at the time, but were eventually all conclusively disproved with experimental evidence. In science, empirical inference establishes reality. In that sense, dark matter is reminiscent of ether, the substance thought in the nineteenth century to be the omnipresent medium for the propagation of light, but which was later shown to be non-existent by the famous Michaelson–Morley experiment.[2]

The propagation of sound requires a medium: air. Analogously it was believed that light, too, needed a medium. The idea of an all-pervasive luminiferous ether was postulated as the medium that facilitated the propagation of light waves in the cosmos. Experimental evidence for the existence of ether was lacking, however. If a static distribution of ether existed, it would have to be dragged along with our motion around the Sun and around the centre of our galaxy. Two American physicists, Albert Michaelson and Edward Morley, devised an ingenious set-up in 1887 – an interferometer experiment to measure the relative motion of light waves with respect to this fluid (ether). If ether existed, the measured speed of light would vary along two perpendicular directions due to the

differing components of the motion of the Earth – thereby providing definitive proof for the motion of light aided and diminished by ether in the two respective orthogonal directions. Michaelson and Morley found no difference between the speeds of light along these two directions, thereby demonstrating that ether simply did not exist. This seemingly innocuous null result was pivotal in the re-thinking of the relationship between particles and waves. It was the catalyst for the birth of quantum mechanics, which postulates that things are not quite as they seem to be, that all particles can be thought of as waves and vice versa. The uncovering of this fundamental duality – between matter and waves – caused a radical disruption of our cosmic view yet again. Quantum mechanics, the realm of experience in which this duality is manifest, provides us with a deeper view of reality, one in which the autonomy of, and the separation between, the observer and the observed are no longer tenable. In the quantum regime, the very act of observing and measuring alters the observed, consequently imposing a limit on the precision of the measurement of any physical quantity. This revolution in physics completely altered our conception of the real and material, and the seemingly unreal and immaterial – such as waves – in the universe. It also heralded a major shift and a transformation of the relation between the object and the viewer – from one of passivity to active engagement. This altered perspective – one in which the distinction between the viewer and viewed is dissolved – has served as inspiration for Gormley, who deliberately invites the projection of the viewer to occupy the space offered by his voided moulds or displaced by his body forms.

Let us take the example of dark matter to see what counts as proof and examine why we astrophysicists believe it is real despite not having yet found the particle. Evidence supporting the dark-matter hypothesis comes principally from two classes of observation of the gravitational effect exerted by this invisible component: one inferred from the application of Newton's laws and another that is predicted by Einstein's theory of general relativity. The evidence for dark matter comes from our observations of celestial motions on a range of physical scales: the measured motion of stars in galaxies and of galaxies in clusters (the largest assemblages in the universe, consisting of about a thousand galaxies strongly held together by gravity) is derived from straightforward application of Newton's force laws to these systems. The measured speeds of stars moving around in individual galaxies and of galaxies in clusters are so high that these bodies cannot be held together merely by the gravity supplied by just the visible matter within them. Unseen matter (roughly ten times more than the visible matter) providing additional gravitational force to hold these cosmic objects together is required to

explain their motions. This invisible aggregation of matter is postulated to be dark matter, and must thus be ubiquitous in the universe to structure everything that is visible. The second, independent line of evidence comes from another manifestation of the presence of matter – gravitational lensing of light in the universe – an effect predicted by the theory of general relativity. This results from the postulated relationship between gravity and the shape of space that is at the core of Einstein's theory of general relativity. Space and matter interact and have an impact on each other in a geometrical way. Space and time are intertwined geometrically into a sheet, and matter in the universe generates potholes that curve or, more multi-dimensionally, deform, indent this sheet. Therefore, a universe replete with matter – both visible and invisible – would be pockmarked with potholes. The motions of bodies in the universe, including the propagation of light, are confined to this sheet. Therefore, the path of light from distant galaxies will be deflected by the many potholes it encounters on its way to us. This deflection, known as gravitational lensing, induces distortions in images of distant sources of light when we view them. The strength of this bending of light depends on the number and the depth of the potholes it traverses. Extreme distortions in the shapes of distant galaxies have been observed, allowing us to infer that invisible matter must be distributed along the line of sight that causes this gravitational lensing (fig. 52). The degree of observed lensing in the exquisite images taken by the Hubble Space Telescope, for instance, indicates that there must be almost ten times more matter than can be seen to account for the distortions. My own work has involved using data from the Hubble Space Telescope to reconstruct the detailed distribution of intervening dark matter (figs 50 and 53).

However, although we can map dark matter in space, the particle itself remains elusive. Many experiments operating over several decades have actively searched for the putative dark-matter particle and returned no results. The current state of our understanding poses many challenging questions: are our assumptions about the nature of the particle robust or do they require revision? Do our search strategies need to be overhauled? Do we need to stress-test the dark-matter paradigm further with higher-quality data to see if any cracks emerge? And of course, as good scientists we must always keep an open mind about alternatives. If truth be told, we are at a bit of an intellectual impasse at the moment. Key elements of the cold dark-matter model that best seems to describe our universe have been confirmed by observations of ancient light – relic radiation from early epochs of the universe 400,000 years after the Big Bang – the cosmic microwave background radiation first mapped out by NASA's Cosmic Background Explorer (COBE) satellite in the early

Fig. 53 Cartography of dark matter obtained from the lensing analysis. Published by the Natarajan research group in 2017. Image published in the Monthly Notices of the Royal Astronomical Society

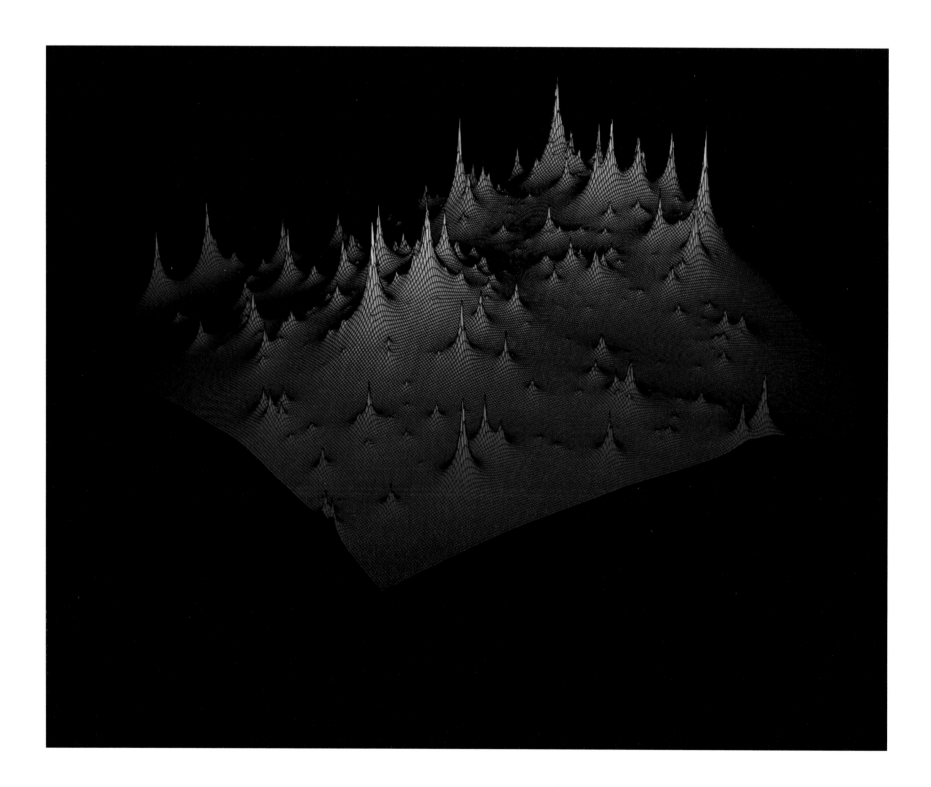

1990s. High-precision data of this cosmic background radiation, and the measured inhomogeneities in it that harbour the imprint of the assembling dark-matter structure and the galaxies they encounter *en route*, offer incontrovertible evidence for the existence of dark matter and the current storyline for the formation history of our universe.

Recently, another spectacular manifestation of gravitational lensing provided us with a first glimpse of the silhouette of a black hole, the closest that we can dare approach to the sacred boundary that encases everything and nothing – a singularity. This now-iconic image of the event horizon of a black hole (fig. 49) once again serves as a marker of how far we have come as humans grappling with and unravelling cosmic mysteries, and how we are relentlessly pushing at the limits of what is mappable and hence knowable.

Modern cosmologists constantly wrestle with this essential tension between what is directly seen and the indirectly inferred, between continuity and change. Gormley similarly explores the connection between the tangible and intangible nature of what it is to exist as a body in the world. His work interrogating these questions by using our senses resonates with our experience of sensing the universe using light. And just as dark matter is invisible but exerts perceptible influences on the position and motion of things we can see, Gormley's work helps us perceive the body's own tension between visibility and marginalisation, and the effects our bodies can have on the space around them. His work challenges the senses just as we work to comprehend the universe by taking its measure.

Focused on the human body and using Gormley's own as a template, his sculptures play with and confront our perception of scale, and in using the casing of the body, they examine the tension between the interior and exterior, the stance of the observer and the observed. Gormley captures and often transmutes the complexity of the body and its form into abstract geometric forms. It may seem a paradox – such a transmutation would surely denature the object and denude it – but he excels precisely by reconceptualising the emotional interaction between the subject and the viewer. It is clear that his hope for art and for art's purpose is somehow to make the unknowable, ineffable and impalpable deeply felt. Gormley's sculptures leap further in providing us with a haptic experience of space.

His art comprises experiments that uniquely explore the shape of space. Gormley's choice of materials is salient – solid cast iron, steel, stone and lead – all deeply connected to the core of the Earth, and considered the most stable and resilient elements. Though the Earth's core consists of molten iron, it was synthesised elsewhere in the universe and expelled during violent supernovae explosions. Its origins are truly cosmic, a resilient material that yet gets imprinted and transformed over

time with exposure to the elements – air, water and light. Gormley offers us a new modality in which to experiment and explore the relationship between matter and space, one that is precise like the world of theories that cosmologist inhabit, and yet not mathematical. Despite this, however, there is a deep synergy in our quests – we strive to unravel the nature of reality and find the idiom to describe it. And there is a surprising alignment of aspirations in our work: we are searching to comprehend and imaginatively inhabit our conceptions of the cosmos, whether we are using poetry, mathematics or sculpture.

As a species we occupy a paradoxical place in the universe: we are simultaneously significant and insignificant. Our insignificance in the grand scheme of things is an inescapable feeling when we see the pale blue dot of Earth suspended in the darkness of space, one among the multitude of heavenly bodies that comprise this vast, boundless universe. Or perhaps a multitude, even an infinite number, of other universes exist – the multiverse – in which every version of our past and future selves gets played out. Part of the appeal of the concept of the multiverse is that we get to circumvent the thorny issue of an explanation for the special initial conditions required for our universe and the awkward singularity of the Big Bang. The multiverse hypothesis postulates the existence of an infinite number of universes in which every possible set of initial conditions is manifested. In this event, our universe just happens to be one instantiation and is not physically special per se. Hence, our uniqueness in terms of life is entirely random – this particular universe happened to give rise to a habitable planet on which our particular version of life arose. Diluting our special status by relegating us to one of the many possibilities serves yet again to temper our significance in the grand cosmic scheme.

Regardless, our species is significant, as the fragile fate of our current habitat lies in our hands and depends upon our sense of cosmic stewardship. Strangely, it is the dizzying pace of our scientific progress that has brought this into sharper focus better than any other medium. Maybe ultimately science will help us find our place in the universe, by extending our cosmic consciousness imaginatively and simultaneously inspiring us to become more responsible guardians of our precious home. After all, given our spectacular success in unravelling the mysteries of the universe thus far, tackling this challenge must surely be well within our grasp if we act now.

(Overleaf) Fig. 54 The cosmic web: a section of the virtual universe, a billion light years across, showing how dark matter is distributed in space, as filaments and blobs. Dark-matter halos, the sites that will seed the formation of visible galaxies, are seen as yellow clumps, interconnected by dark-matter filaments. Cosmic voids, the white areas, are the lowest density, nearly empty regions of the universe. Joachim Stadel, University of Zurich

Seeing Inside the Outside

Jeanette Winterson

How will you write about an exhibition you haven't seen?

Tamara works at the Gormley studio in London. We were looking at the model and the drawings of the exhibition, while Antony explained the concept of each room and how each room links to its neighbours.

Tamara asked a good question – and like all good questions, it proved to be bigger than its surface area.

I thought about Gertrude Stein, saying to Picasso when he was painting her portrait, 'Paint what is really there – not what you can see, but what is really there.'

I thought about Anaïs Nin, 'We don't see the world as it is but as we are.'

I thought about John Berger's classic essay, *Ways of Seeing*: 'To look is an act of choice. We only see what we look at.'

Throughout his working life Antony Gormley has asked us to look at the human form. He has asked us to look at it so that we are able to see it, because we spend most of our lives not looking at things, and therefore not seeing them at all.

As we go about our everyday life, unless we are children, unless we are in a strange place, unless we are puzzled or threatened, unless we have just bought a new toy, unless it snows, unless we are in love, we are not looking.

One of the saddest statements of long-term partnerships is this: *You don't notice me anymore.*

So what do we look at?

Consumer capitalism bombards us with visual advertising and we are adept at blanking it out. At the same time, we are searching for something, searching for anything, that will hold our distracted attention for more than two minutes. YouTube channels and social media allow us to move rapidly across content – videos that go viral, uploads of other people's experiences, the Instagram Snapchattery of Tumblr, Tinder, Buzzfeed, Twitter, vlogs, dancing dogs, the penny arcades and distorting mirrors of the competing claims on our retinas.

Pornography and violence will always get our attention. Both happen at the site of the human body. The body, more than anywhere else, more than anything else, is what we simultaneously long for and flee from. The animal simplicity of our baby-body is soon replaced by a lengthening series of unsatisfactory bodies. Now that our bodies have been colonised by consumerism, not even the young and beautiful can love themselves for what they are.

For many of us, the daily encounter with the mirror in the morning is enough to convince us that our bodies can only be ignored or despaired over. How we look. How we don't look. How we look to others is a problematic negotiation between what we see, what we wish we could see, what we don't want to see, and what we want to hide.

Women especially suffer from the schizophrenia of *Display versus Disappear*. Women are brought up to believe that they are on display at all times – as well as being groomed to take up no physical space in the world. Young women are relentlessly judged on their looks. Older women are invisible.

How can we see the world around us when we can't see ourselves? (When you are obsessed with your image you can never see your real self.)

And this is where Antony Gormley seems to me to be a shaman of the corporeal dystopia where we live.

The job of the shaman is to identify the ills of his or her tribe and find medicines that will heal. One of the ways in which the shaman does this is by re-casting the ground-down isolation of our personal agony into its mythic dimensions.

We are not so small, not so alone, not so blind or so blindfolded.

———————

Picture a Gormley body form standing on top of a building.

We look up. We see it. Now we can see the building too. Now we notice the skyscape. And we see other people looking. And we see ourselves. We see the figure of man but the man made of metal sees us too. We are witnessed. We are known.

The city feels less impersonal. We feel less anonymous.

———————

One of the many beautiful things about a Gormley body form is the sense of being seen without being under surveillance. The figures are as stark and certain as just-landed angels. They have authority and power – yet they are benign. This is no sniper on the roof. This is not Big Brother watching you. This is the antithesis of CCTV – this is a way of seeing yourself, of seeing *for* yourself, and of being recognised for what we are: human imprints passing through time. Capsules of history.

The statues of great men we all hurry past as we travel through the cities of the world are unrelated to the work that Antony Gormley is doing with his body forms. Public monuments are memorials to the past – and yes we should remember our history, and sometimes we do – but this is not the energetic Reiki that happens with a Gormley.

First there is the position – always unexpected. Top of a building, in the sea, outside the train window, visible on a promontory. Even in an expected place, such as an exhibition space, the position within the space, and the spatial relations of object to environment, cause the viewer to pay attention. To pause. To be affected.

Once we have paused enough to look, then we can experience the energy exchange between the Gormley life form and our own life form. Body to body.

This matters. Before the brain kicks in there is the body experience. Our minds can't help but categorise and catalogue; and then we start talking (arguing, criticising, filing away the experience). But before we start talking, notice the body language: How do people stand? Do they sit? One foot on one side? Head to one side? Arms folded? Slack? Are you comfortable? Frowning?

And what about the object? The thing in itself that is really there. Not virtual. Not imaginary. Not pornographic. Not violent. Look. Do you see it? Yes you do. And when you do, then there is an encounter. You position yourself. Literally.

The body forms that Antony Gormley makes don't move; their job is to move us.

A body that's not sexualised or selling something, that is neither at work nor at rest, that carries no freight of assumption, that is not wounded, nor clothed in power. A body that is undressed and unafraid. How do we position ourselves in relation to such a body?

That question has to be asked twice – physically and psychologically.

In Pilates we are asked to learn where our body is in space. Children find this easy – adults less so, unless we are dancers or physically aware. The strange thing about the human body is that it is our coordinate in space – we can't go anywhere without it – and yet most of us act like we are a brain on wheels. Body dysmorphia is common enough, but also we misjudge scale and distance – probably because we no longer use our body as measurement. Traces are still there in our speech: feet and inches, a handful, rule of thumb, head height, neck and neck. Horses are measured in hands.

Our clothes are not usually made for us; our bodies must fit the clothes. We have become approximate to ourselves and this makes us uneasy – not always at a conscious level, but where it does more damage, unconsciously, in the breakdown of our relationship with our bodies. I include here eating disorders and cosmetic surgery.

Antony Gormley has always used his own body as his measure for his work. This is not the narcissistic copying of your own programme to make unlimited selves – like Agent Smith in *The Matrix*, it is the human body as Everyman. Here we are, vertical bipeds, temporary imprints in a temporary place. Sometimes, the Gormley body is free from the problems of gravity, and we'd all like to walk on the ceiling and the wall. Sometimes the bodies are submerged by the tides or battered by the weather. Often birds perch there, as the body becomes part of the landscape.

Observing these bodies that are as unselfconscious as the natural world, and yet seem as knowing as the human world, we reflect on the maddening glory of our nature; so fragile and transitory, so stubborn and enduring, markers through time, both at one with and at odds with the world that is our home.

———

Our home. The first thing that a visitor to this exhibition will see is the tiny form of a baby lying asleep in the courtyard. This is Paloma, Antony's daughter, when she was a few days old.

She is beautiful, vulnerable, upsetting, and contradictory. When I saw this shape in the studio I wanted to put a blanket over her.

At the same time, she is like an arrival from a spaceship, shiny and self-contained. An emblem of the future.

This is a wonderful moment of beginning. No trumpets, no wow, nothing grand in the grand scale of the Royal Academy courtyard. Instead, here is how we all begin, as babies, rich or poor, privileged or not, the ordinary miracle, and the sense of our migrant souls.

————

Towards the end of the exhibition is a sleeping giant – a thing out of fairytales and myth. This vast body is there for us to enter, as he lies curled up, knees bent. Many homeless people lie like this and we walk past them every day. Today we can't walk past, we must walk through; this is our only way out.

There are multiple meanings in this and they needn't be spelled out. The immigrant, the refugee, the outcast, lie here in the cast form whose spell is in his silence. Not what is said but what need not be said. We know what we have done. We know how many times we have crossed to the other side of the street.

We know too, that the human body is where we land and where we live. All of us. The religious hope of life after death declares that the body is not our only home; we are camping here. That doctrine has worked well with neoliberal capitalism to evict us from our bodies. We are landless. The throw-away body, the throw-away world.

Antony Gormley's body forms are witness to this deception and loss. They stand as a rebuttal. This is who we are. This is our home.

————

Very soon we shall be sharing the planet with non-biological life forms created by us. Robots and interactive artificial intelligence. Such life forms won't need food or fancy cars, won't sleep, get sick, decay or die. Perhaps we will upload the contents of our brains to something more permanent than a substrate made of meat.

And then we shall be like the gods – immortal and capable of creating life.

Along the way we will enhance our own bodies with smart implants, and delay or reverse the ageing process.

Our relationship to our bodies is about to undergo a radical reformation – and in any case, what will male and female mean when there is no necessary biological basis for procreation?

I have thought about this a great deal and often in the company of an abstract Gormley figure, blocky and geometric, clearly human, but clearly something else too. The next stage of the human journey.

And I'm back to Tamara's question: How will you write about an exhibition you haven't seen?

The answer is to keep looking and to remember what the philosopher Emmanuel Kant said about the stars.

What you see in them depends on who you are.

Map of the Exhibition, Royal Academy of Arts

Iron Baby

The Annenberg Courtyard, fronting the Royal Academy at Burlington House and overlooked by a range of learned societies, is a place of comings and goings, of traffic wheeled and on foot. Centre-stage on a plinth with his back to the Academy's portico stands Alfred Drury's bronze, full-length statue of the Academy's first President, the painter Sir Joshua Reynolds, standing as if caught in action, looking up and regarding his own creation, arm outstretched, gesturing grandly, brush in hand. He has stood here for nearly ninety years. Gormley's *Iron Baby* is a quiet riposte, easily overlooked; a temporary presence, it rests on the ground beneath the plinth, almost out of place.

An uncharacteristic work for an artist best known for the use of his own body both as subject and material, it is a tiny human form, hunched and compact, showing its back to the world, arms and legs drawn up under its body, head tilted to one side. The figure, modelled on Gormley's six-day-old daughter, is a solid iron cast (Gormley describes iron as 'concentrated earth'); the seams of the cast are plainly visible on its surface. The form is itself dark, concentrated: the shape of a new life, naked and unknowing. The pose carries a sense of both composure and vulnerability. Set down here, for Gormley *Iron Baby* acts as a preface to the exhibition's central concerns: the space of the body, the state of becoming, and our place in nature and in the world we have constructed around us.

Iron Baby, 1999 (opposite and overleaf)
Cast iron, 12 × 28 × 17 cm
Private collection

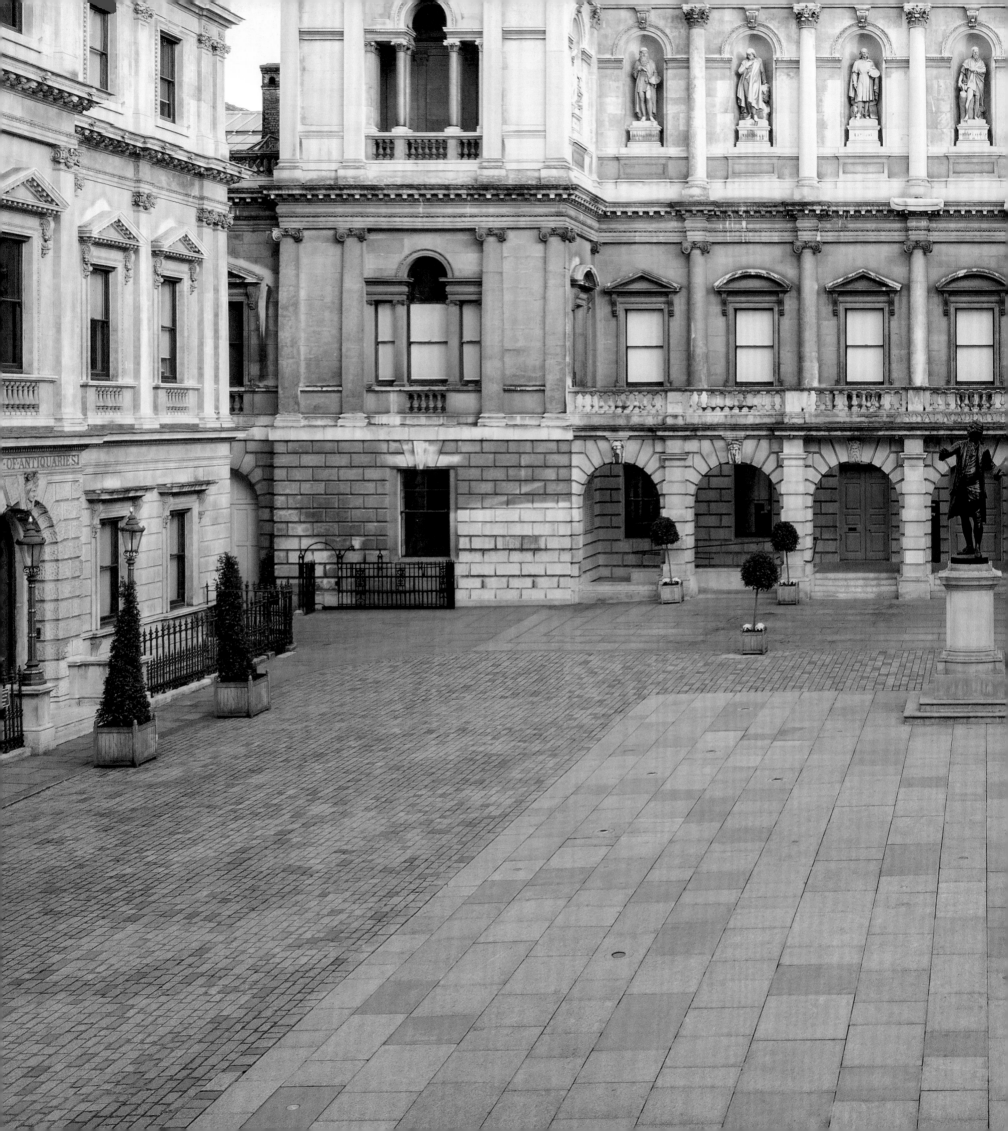

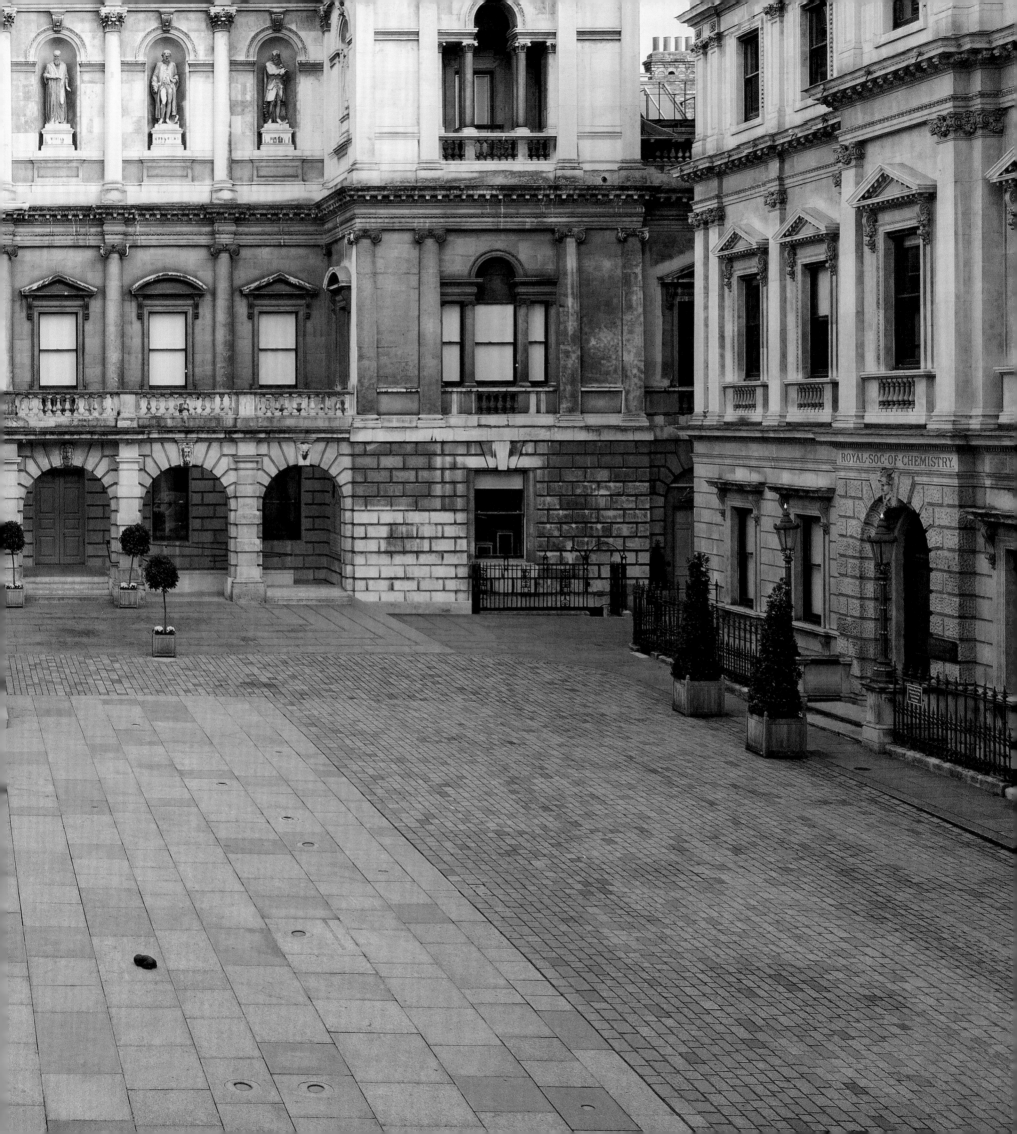

Slabworks

Fourteen *Slabworks* present at first view a random field of related forms or figures. Arranged on the same axis as the gallery, they spread across the floor from wall to wall, standing separate, one from another, or – depending on your viewpoint – coming together in groups. Each form is a rendering, more or less life-size, of the body's space, or the 'place' of the body, as Gormley sees it. The positions the sculptures describe are some of those that have served as points of origin for Gormley's work for decades, all derived from his own body. One is standing, another upright but leaning against the wall; most of them are close to the ground, sitting, kneeling, lying. They do not seem to address an audience or invite an approach. Some are condensed and compact, others extended, but all describe undemonstrative, static, 'whole-body' poses rather than registering expansive gestures – positions, perhaps, of abjection or helplessness, sleep or even death.

Gormley's *Slabworks* describe the body not in terms of flesh and bone and sinew, but according to the language of building: at its most basic, the structural logic of load and support. Each of this family of forms is an assemblage of separate structural elements: of iron, the stuff of the earth, smelted into steel and shaped by mechanical processes, then gas-cut into slabs by precision tools. In each form, solid slabs of different proportion are set in line or at right angles one to another, on end or on their sides, disposed as if propped, stacked, cantilevered. Relying on gravity alone to stand, they convey a sense of precarious balance. Forms on a human scale abstracted to the very limits of recognition, they manage even so to retain a sense of *being*, of individual awareness or attitude, that seems to call for some sort of recognition – even, despite their estrangement, of fellow feeling?

Stop II, 2019 (opposite)
90 mm weathering steel slab, 51.7 × 95.8 × 47.9 cm

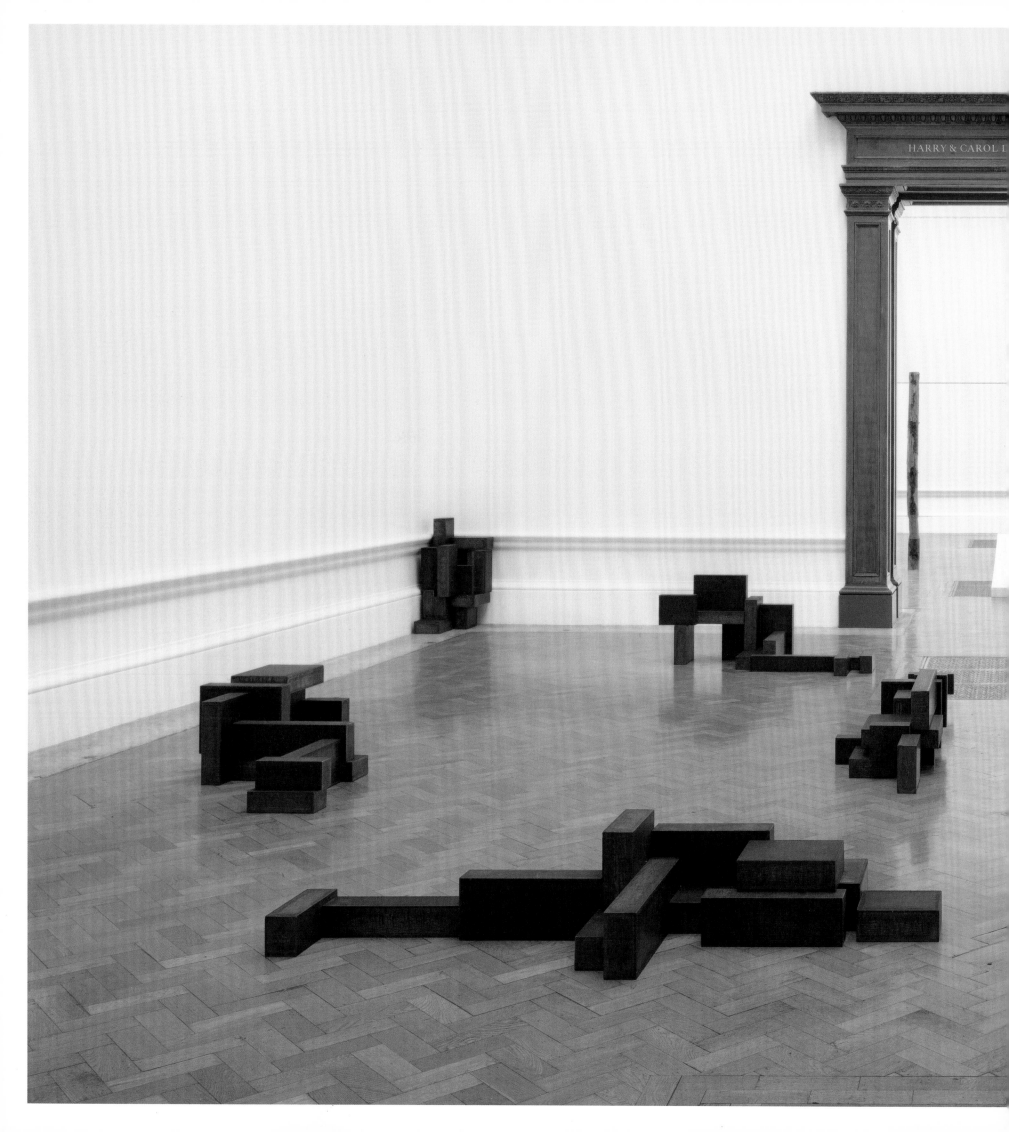

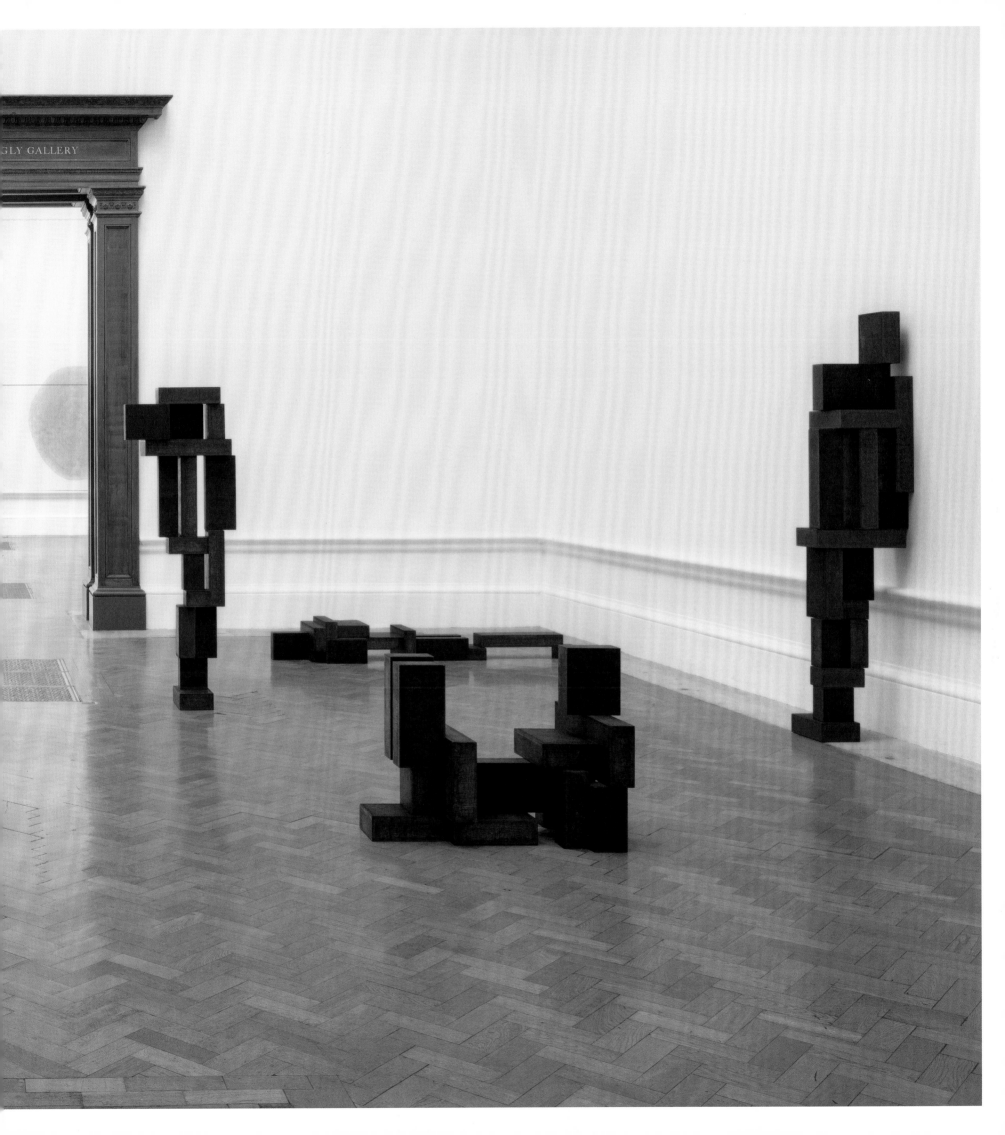

Slabworks, 2019 (pages 78–79)
Clockwise from bottom left: *Settle*, *Fold*, *Corner V*, *Prop*, *Resort V*, *Lean*, *Lie*, *Border VII* and *Tuck*

Corner V, 2019 (opposite, left)
90 mm weathering steel slab, 83.1 × 43.6 × 63 cm

Prop, 2019 (opposite, right)
80 mm weathering steel slab, 56.1 × 143.9 × 83.6 cm

Slabworks, 2019 (pages 82–83)
Clockwise from bottom left: *Border VII*, *Pleat II*, *Stack*, *Tuck*, *Stop II*, *Lay II*, *Settle*, *Slump*, *Fold*, *Resort V* and *Lean*

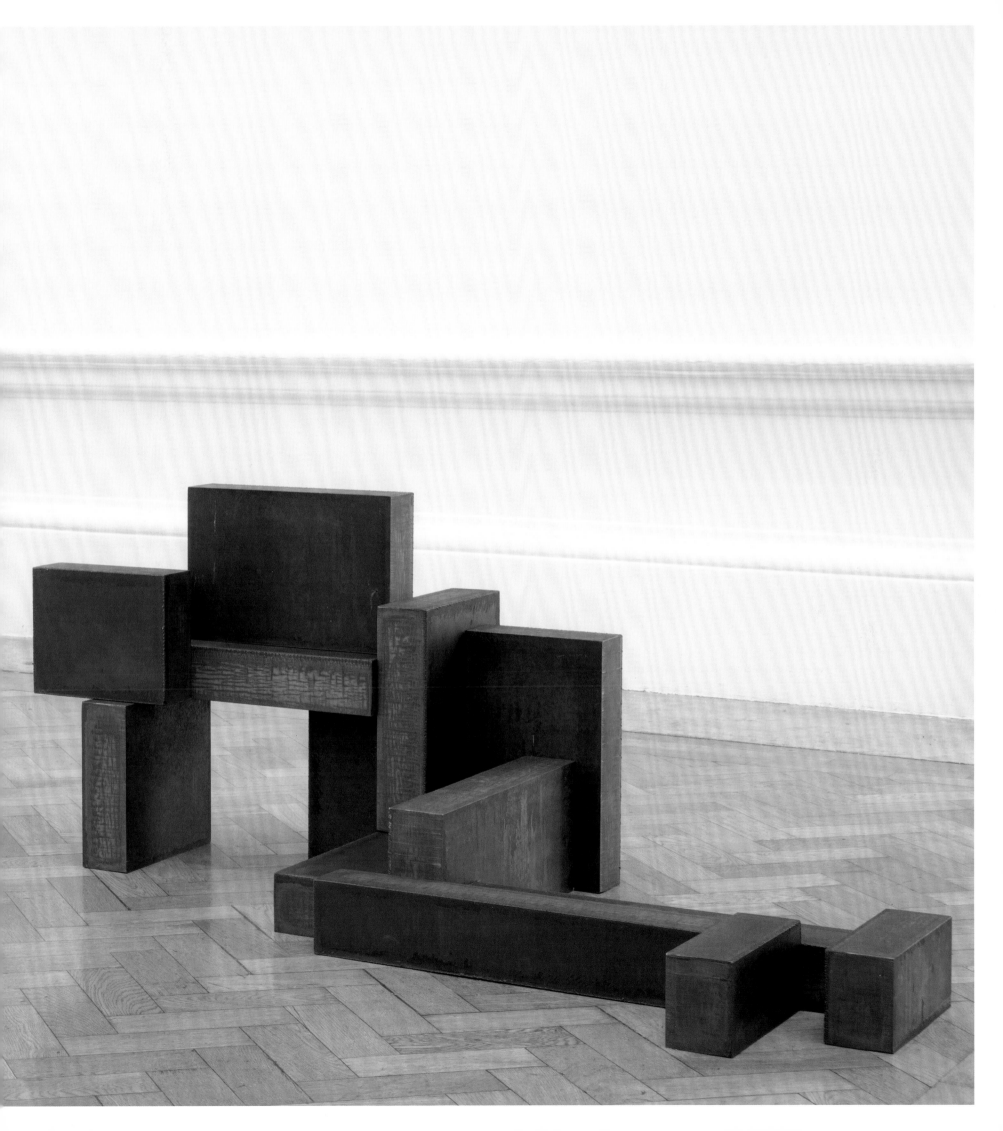

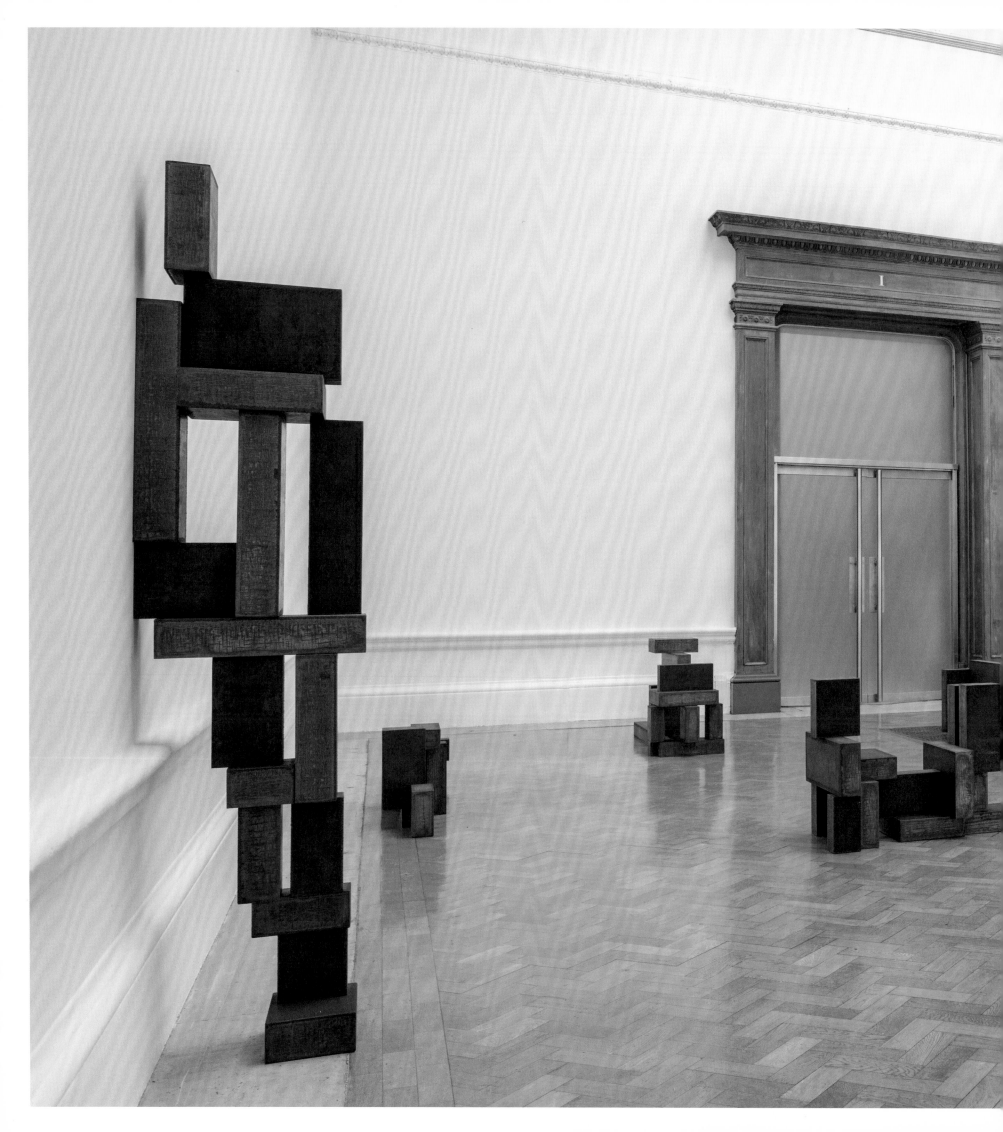

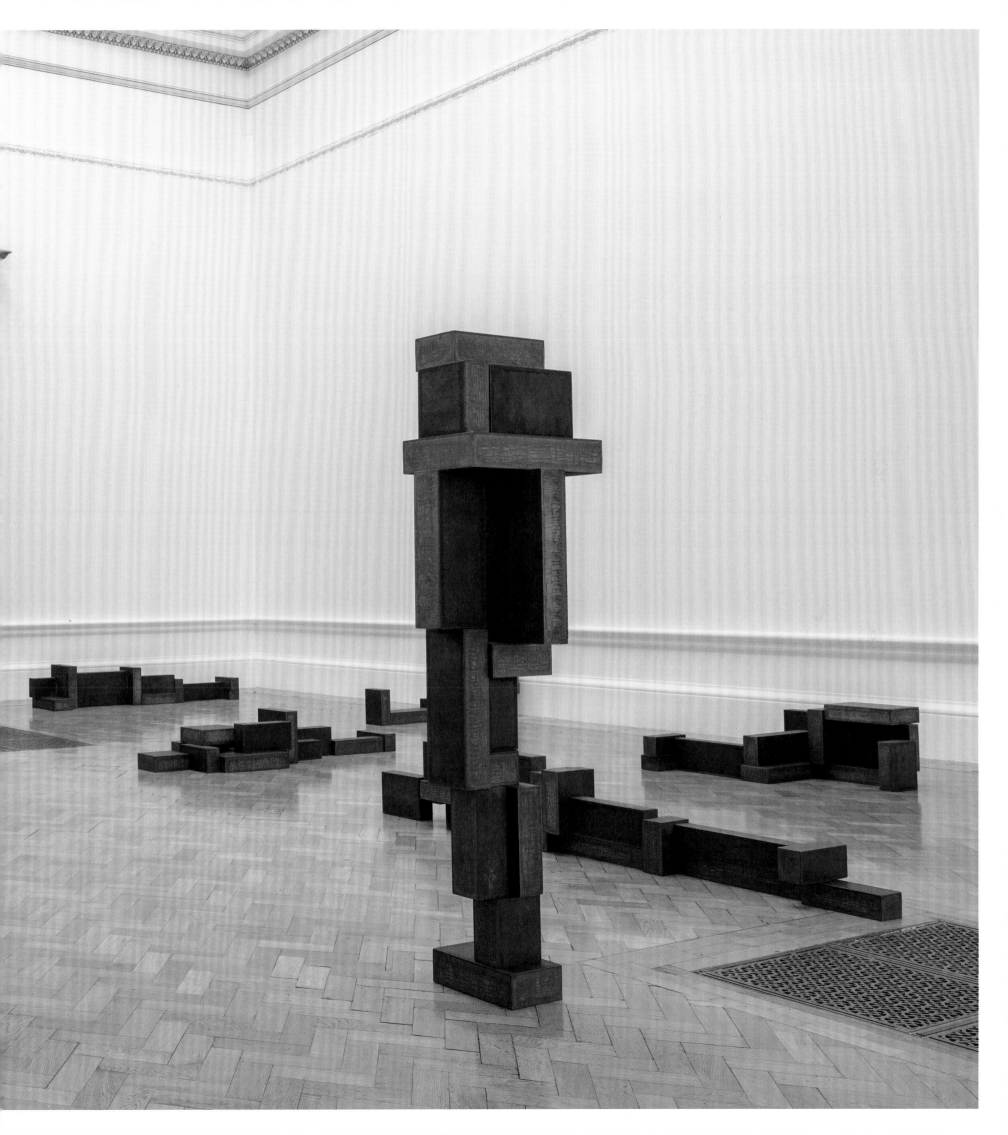

Early Works

From his time at the Slade School of Fine Art (1977–79) Gormley set out to explore 'what sculpture could do' from first principles, using different materials to consider their nature, explore their potential, and find the most appropriate ways to manipulate and transform them.

Working directly with natural objects, lines are scored on stone, layers are stripped from the trunk of a tree; materials from rubber to bread, and most consistently lead, are used. Lead, beaten around forms, is folded and soldered around 'found' objects, exploiting the softness of the metal and its dull, impenetrable surface to conceal these objects beneath a 'second skin'. Singly, in triads, or in extended series, these things, removed from view, are consigned to the work's dark core and to the viewer's imagination – as forms concealed and presented anew, as ideas to be rethought. Forms rearranged in series or created through repetitive actions reveal the artist's interest in the potential for growth and evolution, and expansion in time and space. By 1980 the human body begins to appear in his work, as a void, an absent presence, or as a core of energy extending into surrounding space.

Upright Tree, 1978 (overleaf, foreground)
Larch wood, 230 × 15 × 15 cm

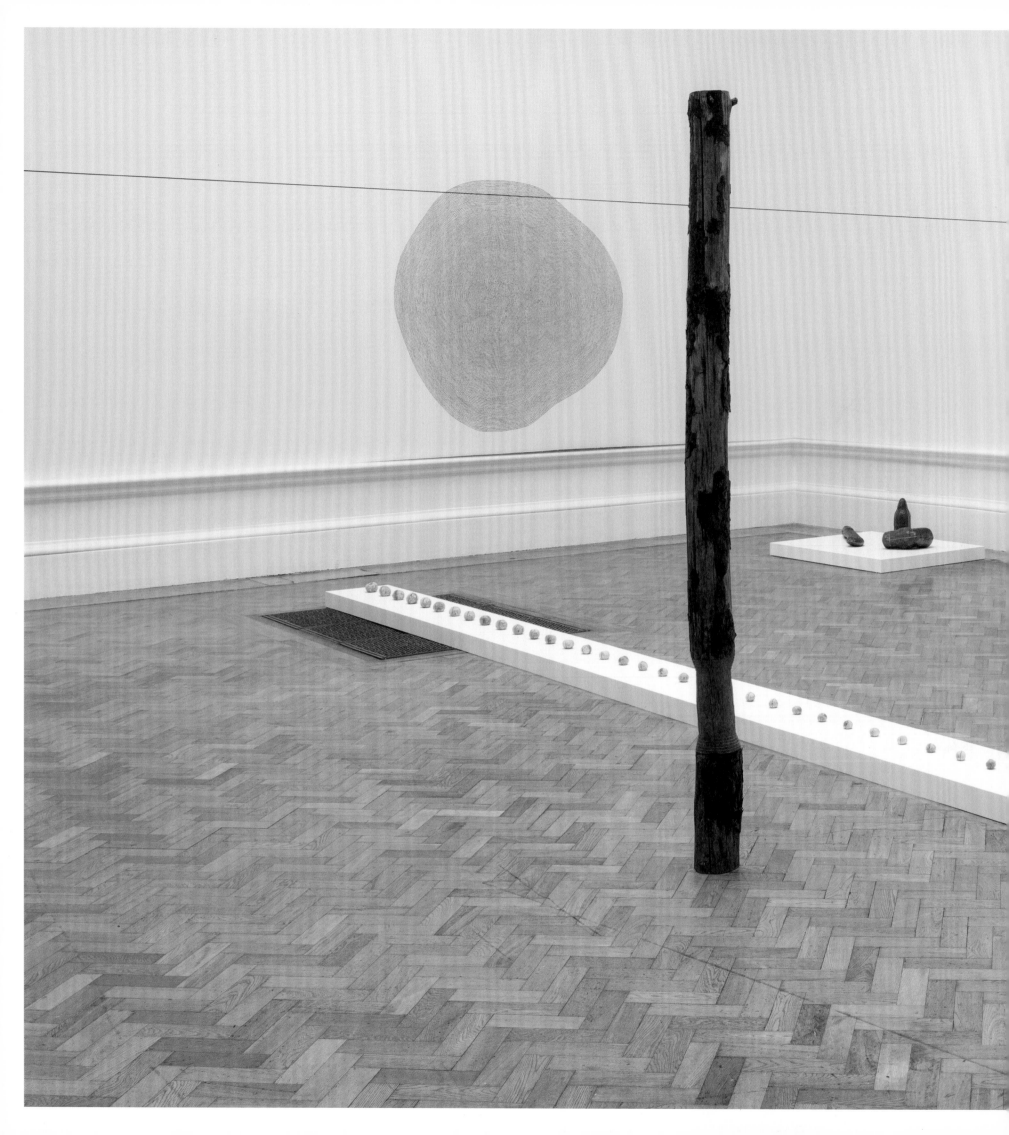

Full Bowl, 1977–78
Lead, 6 × 17 × 17 cm
Private collection, Vienna

One Apple, 1982 (detail opposite,
complete work pages 86–87)
Apples, lead and air, 53 pieces,
7 × 1,110 × 7 cm

Land Sea and Air I, 1977–79
Lead, stone, water and air,
three elements, each 20 × 31 × 20 cm

Fruits of the Earth, 1978–79
Lead, revolver, bottle of wine and machete,
largest element approx. 60 cm

Floor, 1981
Rubber, 0.6 × 122 × 134 cm

Exercise Between Blood and Earth, 2019 (opposite, detail on page 85)
Chalk on wall, d. 1.96 m

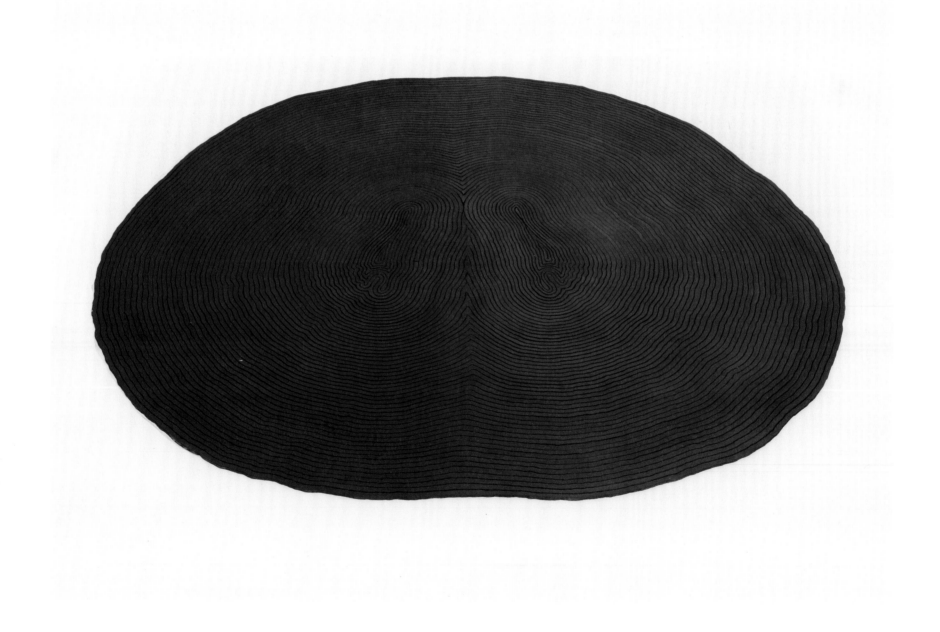

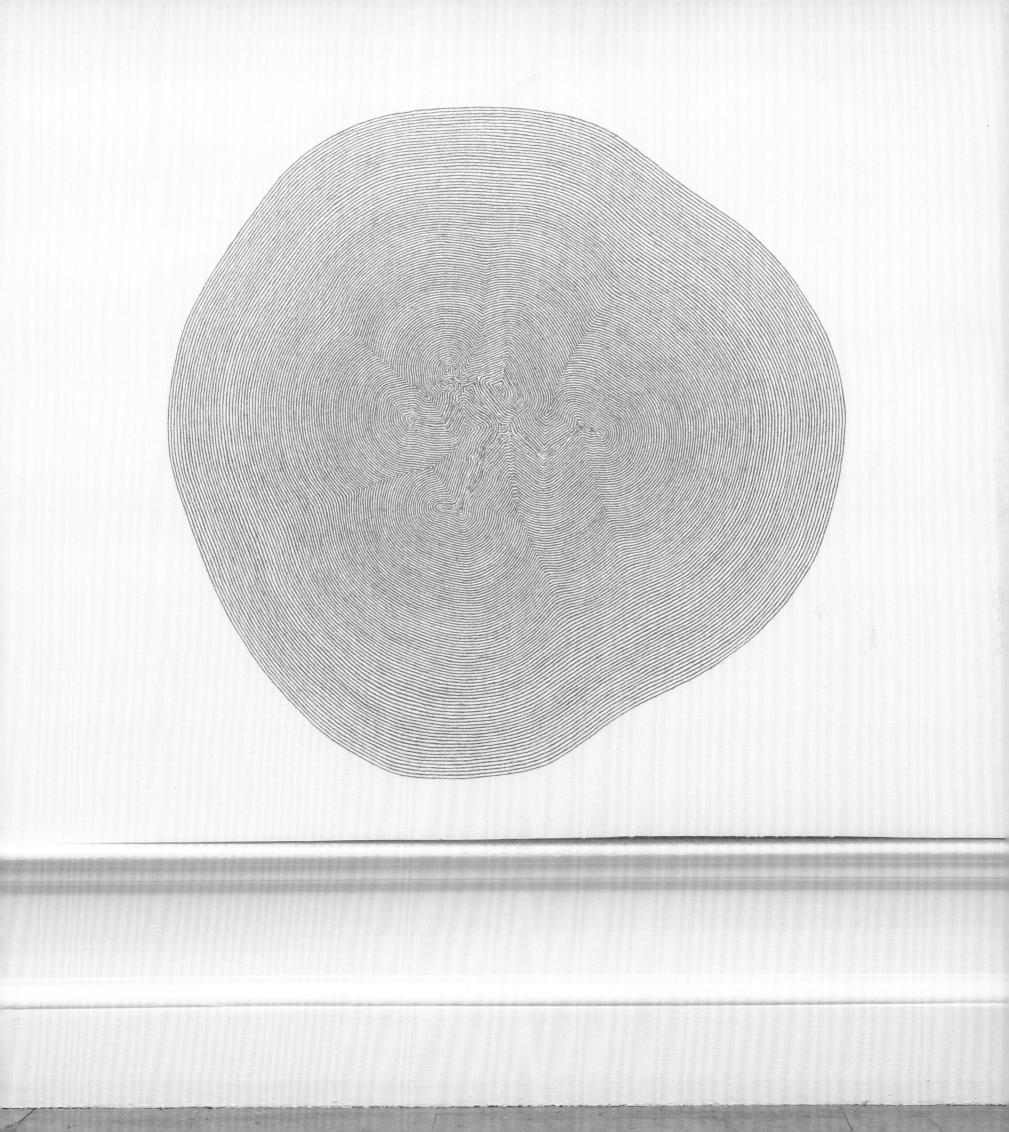

Grasp, 1982 (below)
Blackstone, 8 × 8 × 8 cm
Private collection

Mask, 1978 (opposite)
Lead, 18 × 72 × 3.3 cm

Blanket Drawing V, 1983 (page 98)
Clay and blanket, 170 × 226 × 0.6 cm

Mother's Pride V, 2019 (page 99)
Bread and wax, 306 × 209.5 × 2 cm

Clearing

Viewed from the entrance to the gallery, *Clearing* appears as a chaotic explosion of line. Though the work has almost no mass, it takes on the full expanse of the room. Over seven kilometres of thin, flexible square-section aluminium tube, a length without beginning or end, it presses in arcs and loops against the confines of the space. It seems to speak a different, contradictory language to the gallery's formal architecture, yet its form remains defined, its energy contained and trapped by the floor, ceiling and walls. And still it acts against the simple right-angled geometry of the space, defying the rules of perspective that allow a measure of distance, ordered recession, a vanishing point. There is no focal point here: *Clearing* is a dynamic field of visible energy, a shifting interplay of dark and reflected light. It has often been described as a 'drawing in space'; Gormley has spoken of it as 'a nest, a trap, to ensnare the viewer'.

Clearing draws you into its skeletal caverns, offering the possibility of a path, a passage through its field that involves an effort of the whole body as you push past or step through, parting the swaying coils that tremble to the touch and clank as they meet or separate, setting off a resonance that travels along the line. Entangled, your body becomes part of the work, you feel it, and others see it as such, whether they're in there with you or outside, viewing you from the entrance.

Clearing VII, 2019 (details on pages 101–07)
Approximately 8 km of 12.7 mm square-section 16-swg aluminium tube, dimensions variable

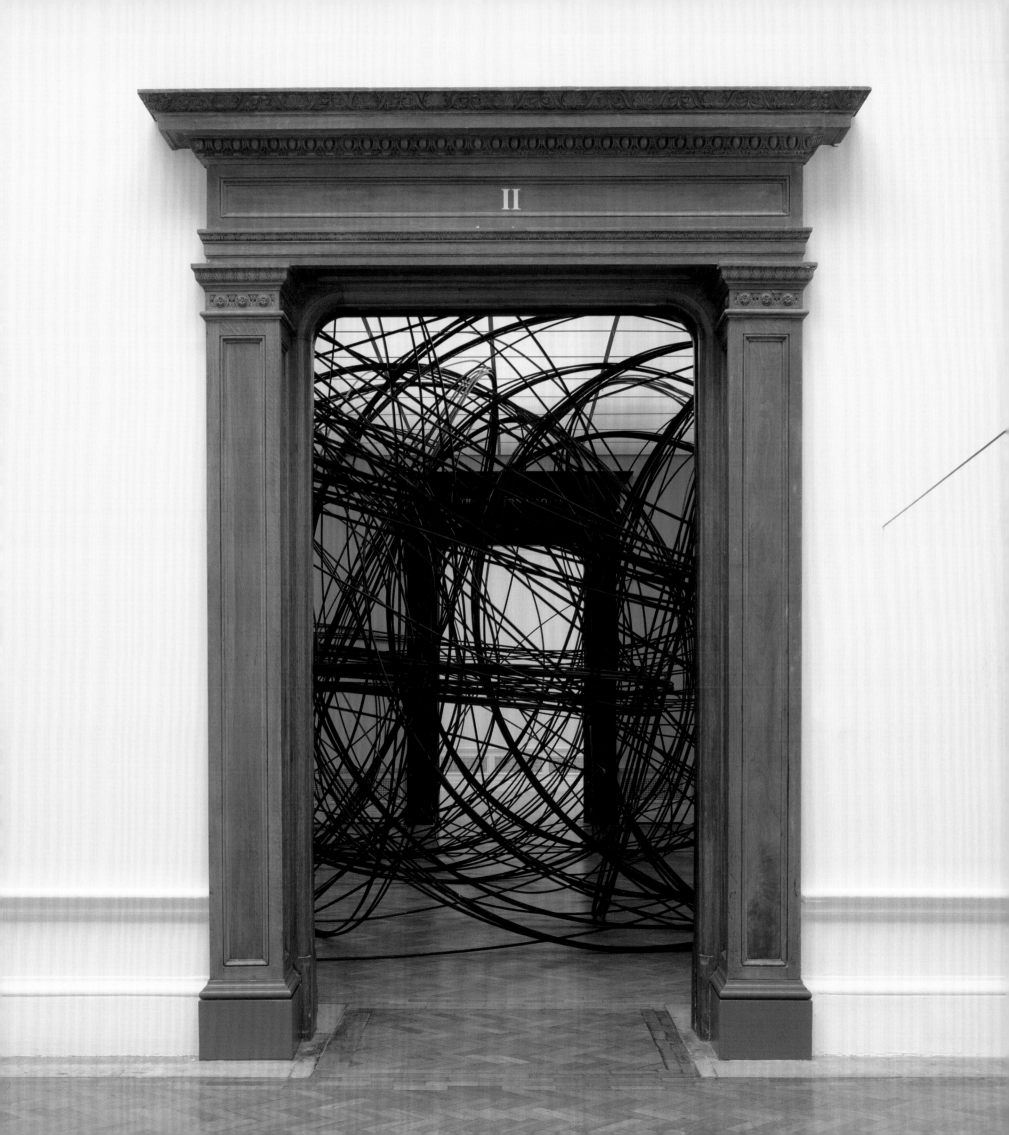

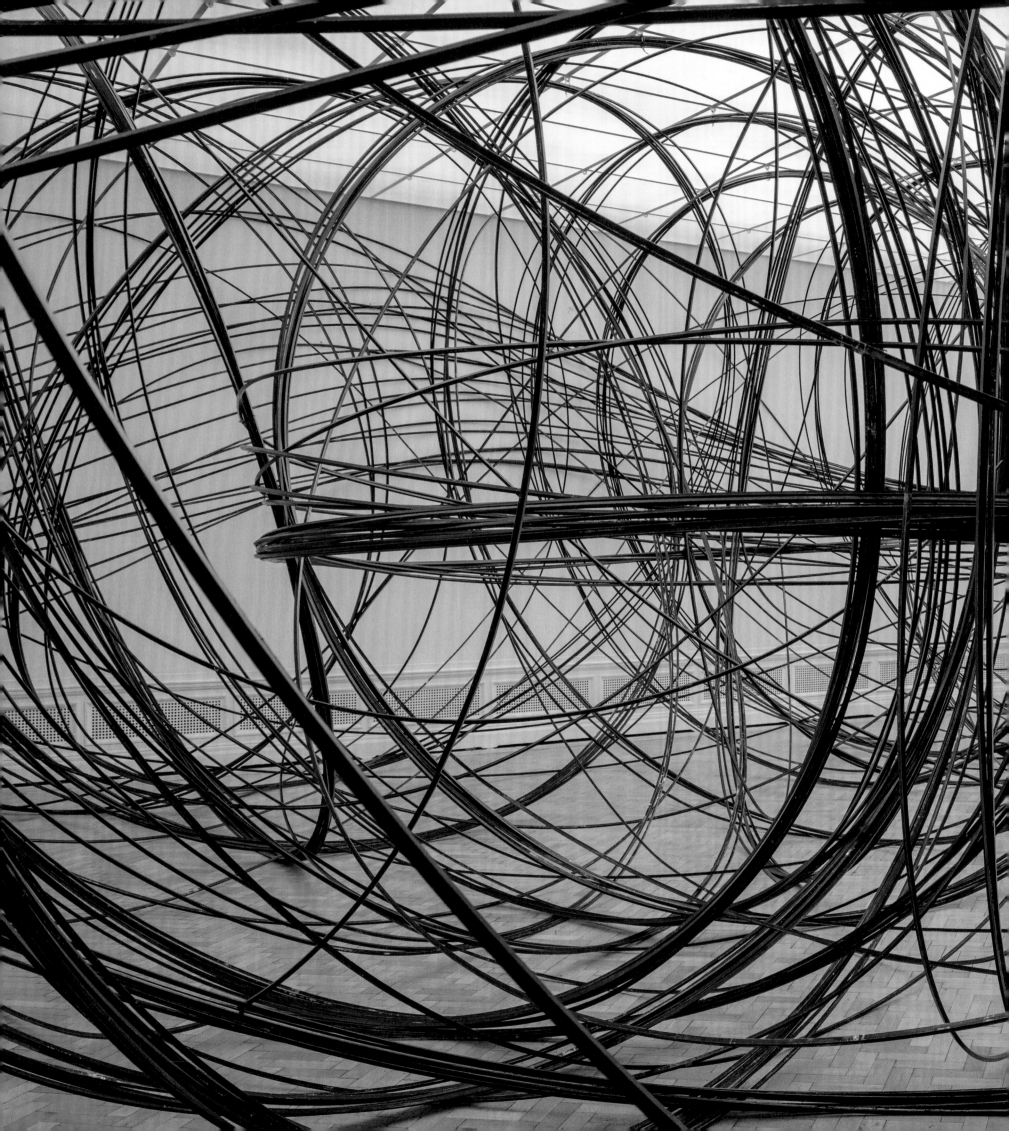

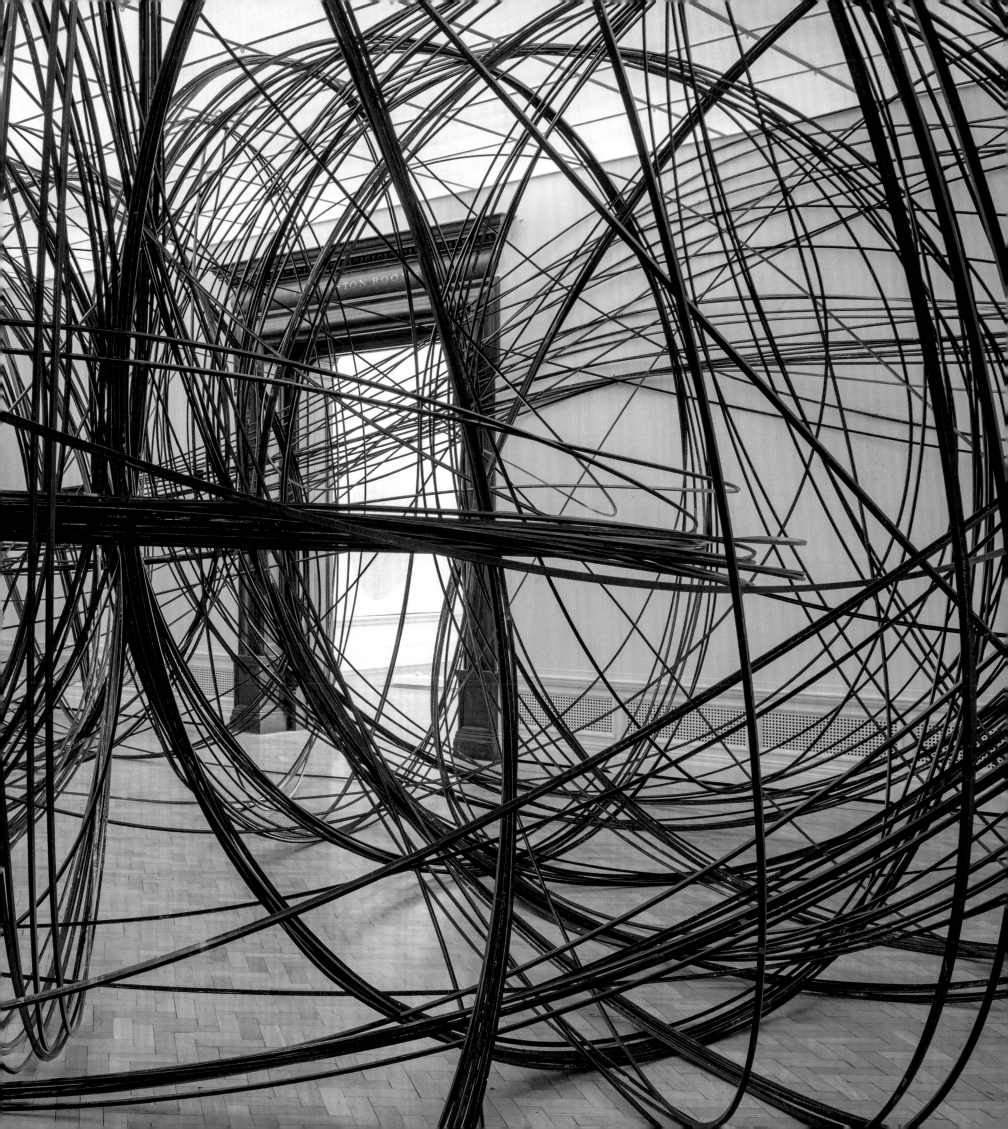

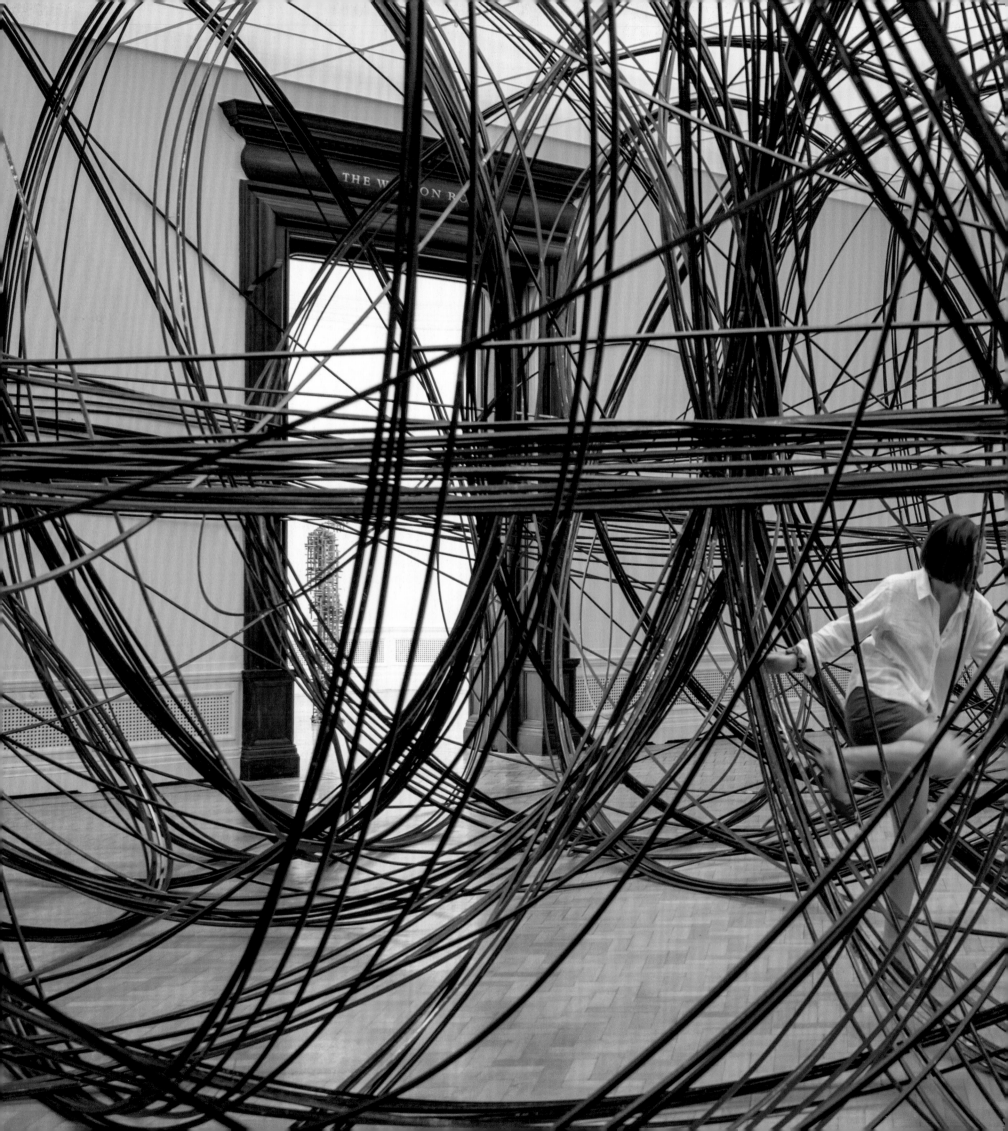

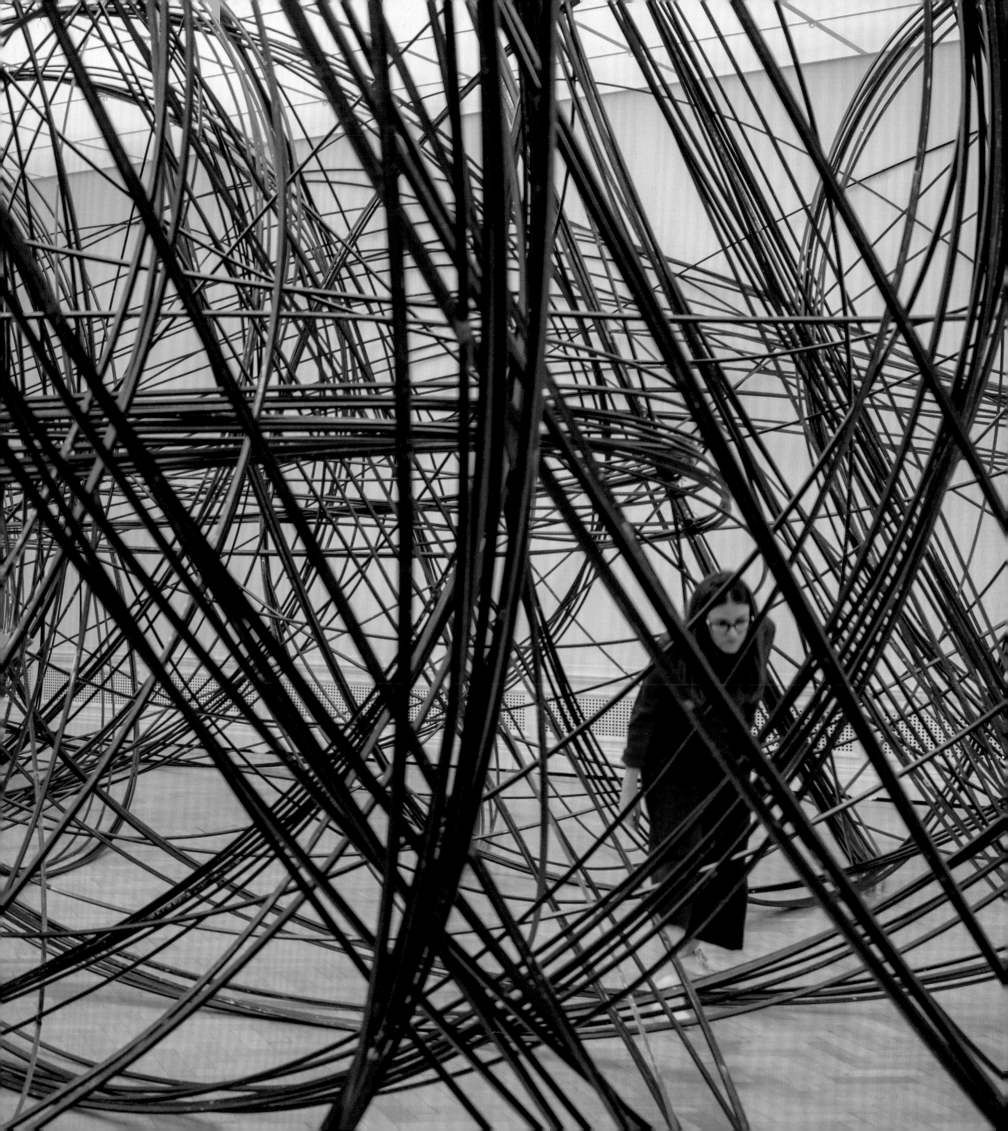

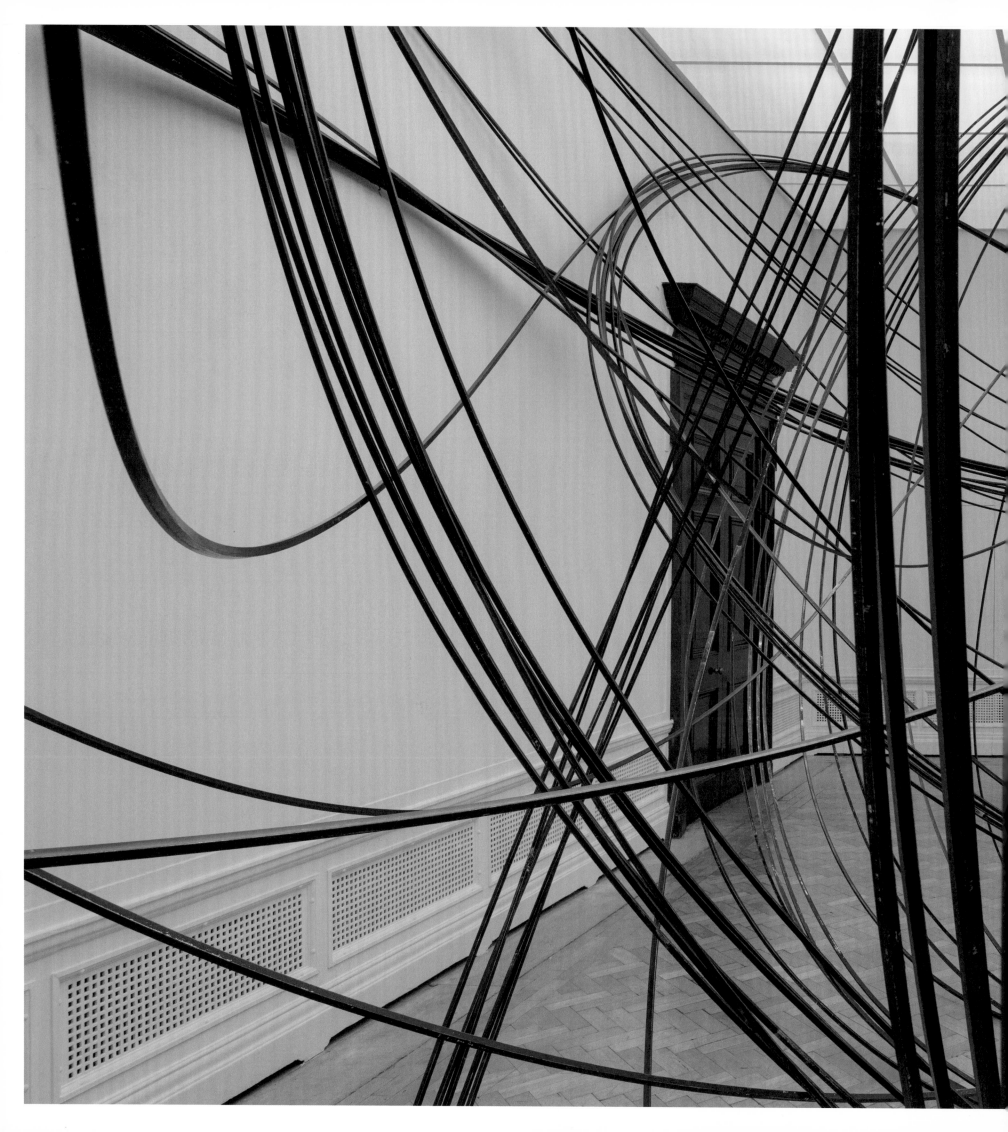

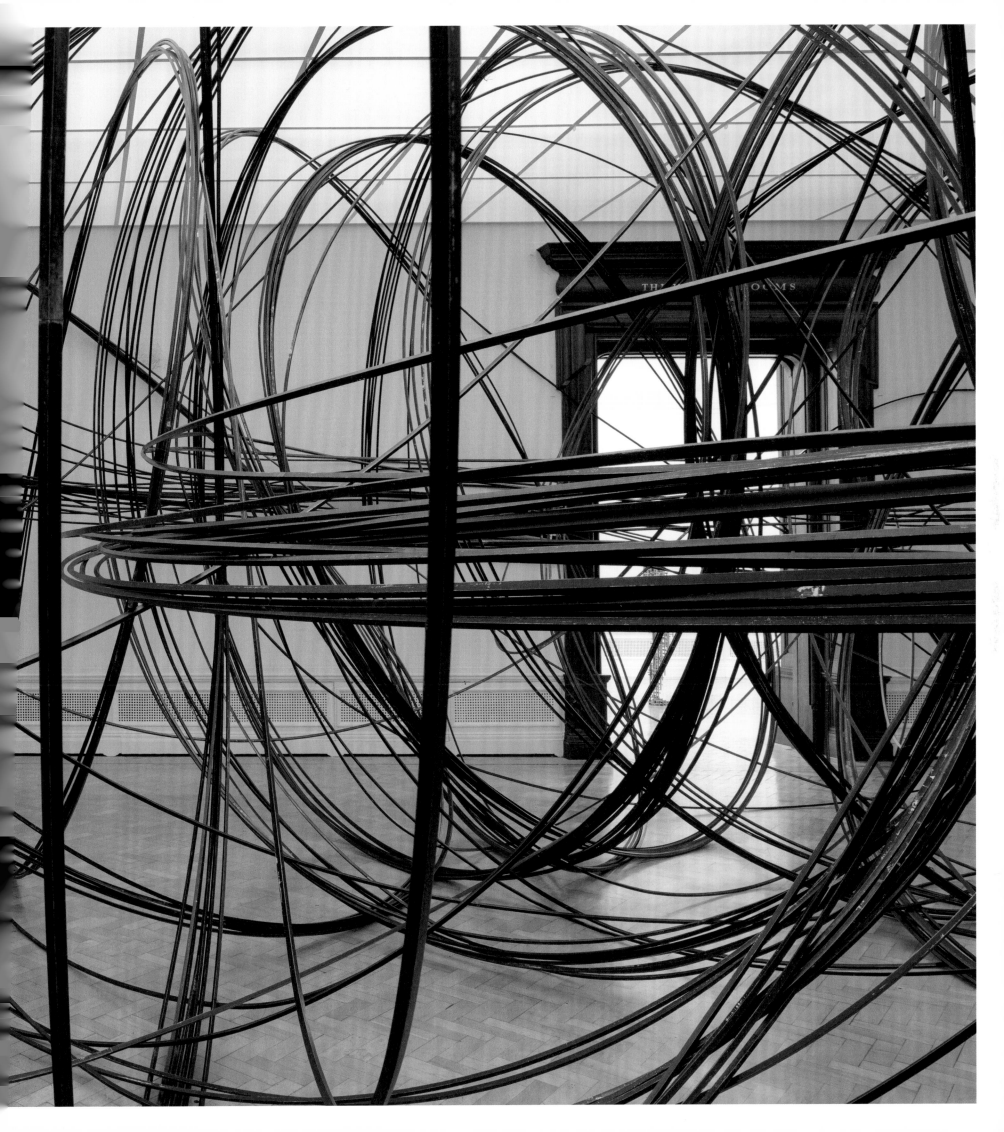

Subject

The pose is of a type familiar within Gormley's repertoire of body forms since the 1980s: an upright body, arms held in line with the torso, neck inclined forwards and head tilted, looking down towards the ground. Like the *Slabworks*, what is presented here is the space of a body, the rendering of a 'lived moment of time' as Gormley describes it. *Subject* is life-size; unlike the *Slabworks*, its structure is neither solid nor load-bearing. The body space is described as a dense, irregular three-dimensional lattice of straight square-section steel bars, with lines running as if randomly on three axes, intersecting at right angles, yet seemingly without structural support. Space permeates the work: most of the bars are truncated at the point of the body's invisible surface but indicate the potential for a continuity out into space beyond, while some are withdrawn, suggesting a shift of density at the core.

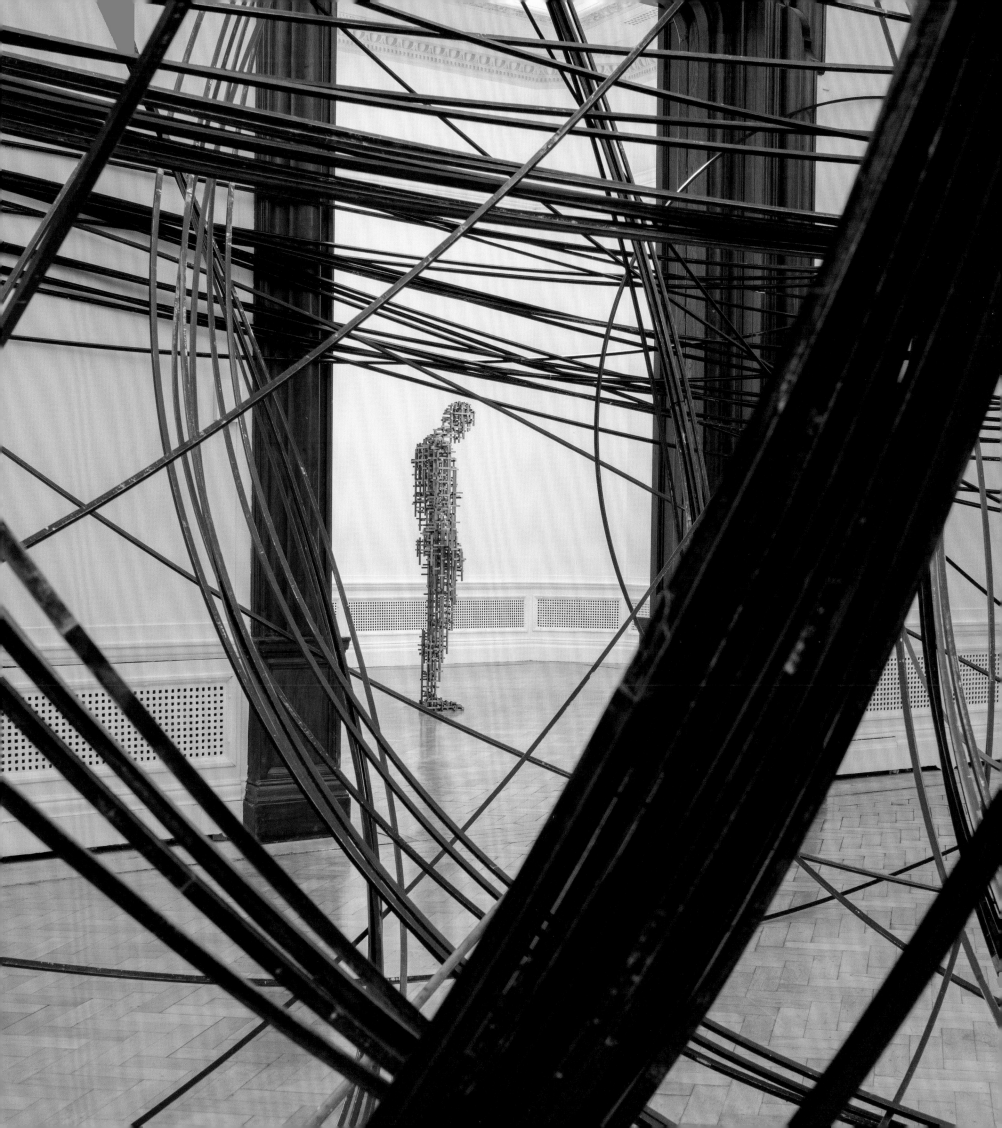

Subject II, 2019 (details on pages 109 and 113)
10-mm square-section mild steel bar,
189 × 51.5 × 37.5 cm

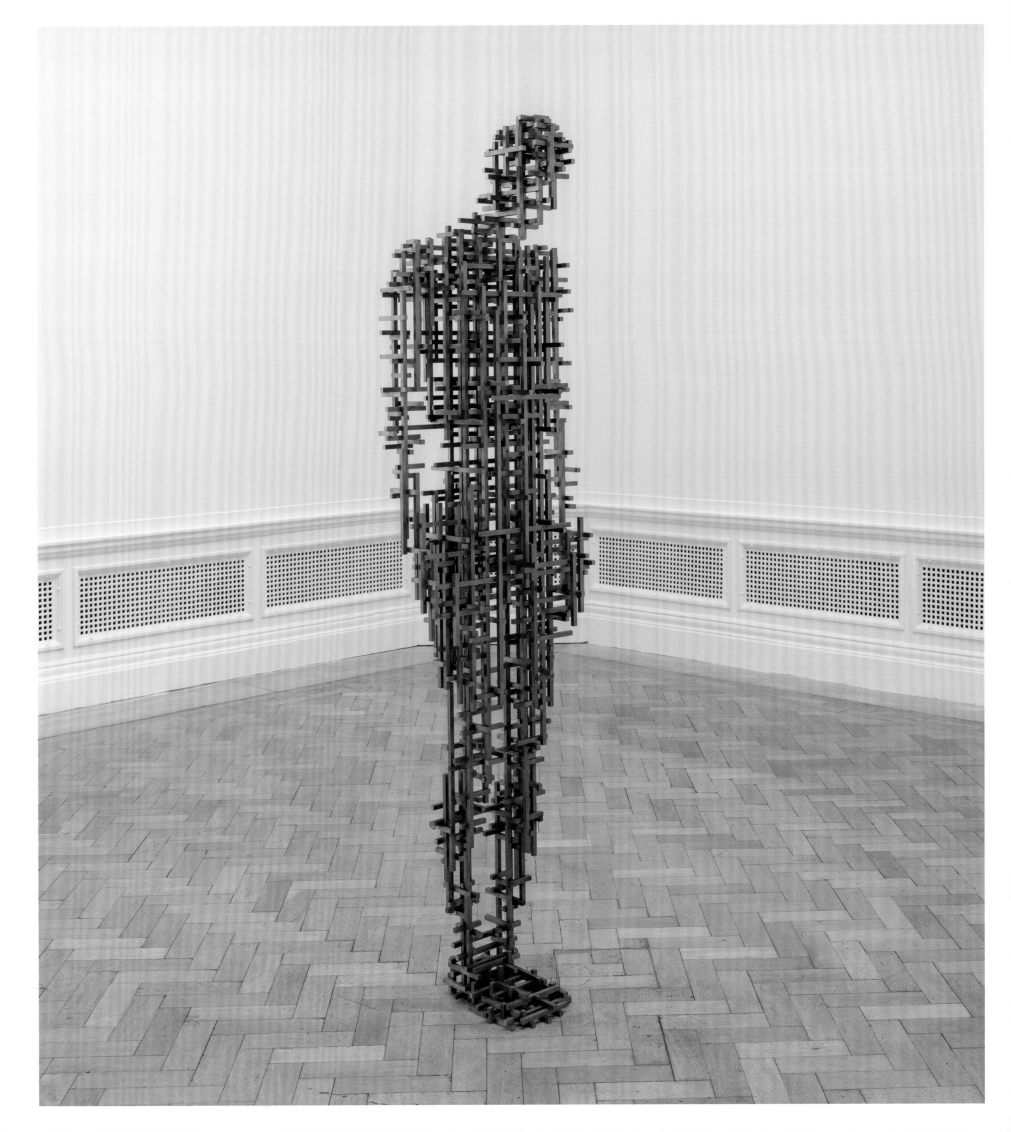

Early Drawings

Gormley's drawings of the early 1980s, the first he had made that were not mere recordings of the appearance of things, people and places, reflect the decisive turn in his work from dealing with objects in real space to considering the dark space of the body, as a site of feeling and experience and a place of transformation. They were made shortly after his marriage to the artist Vicken Parsons, around the time of the birth of their elder son, on paper pinned to the wall of their London home, with charcoal and with thick black pigment mixed with linseed oil, applied by brush.

In these investigations of inside and out, and the points of connection between the two, the interior of the body is rendered as white – blank paper – and surrounding space as dark, black ink, in a reversal of figure and ground. These drawings reveal the lasting influence of Gormley's experiences in India, of Buddhist meditation, as well his deep interest at this time in alchemy. They can be seen as attempts to describe how something feels, rather than how it appears – and as mental diagrams, mapping out the territory for the work to come.

Mould, 1981 (detail on page 135)
Black pigment, linseed oil and
charcoal on paper, 60 × 84 cm
Private collection

Untitled, 1981
Black pigment, linseed oil and
charcoal on paper, 64.7 × 49.7 cm

Mansion, 1982
Black pigment, linseed oil and
charcoal on paper, 84 × 60 cm

Untitled, 1982
Black pigment, linseed oil and
charcoal on paper, 64.7 × 49.7 cm

Landscape Drawings

Made mostly at night, and setting darkness against light, these drawings mark a withdrawal into an inner realm of imagination and memory. Gormley has spoken of 'going places in the drawing which are not possible in life or sculpture'. The drawings record sensations of being in a body, and being in the world – of immersion in the immensity of elemental nature, and of containment within the warmth of sheltering architecture. Many call upon remembered direct experiences of the landscape, looking out to sea on the west coast of Scotland, or sinking deep below the surface of Coniston Water in the Lake District – with the body depicted as an upright form set against the line of the horizon, or as floating above or below ground in fathomless space.

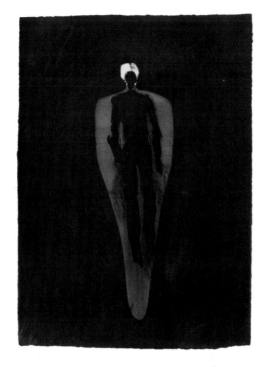
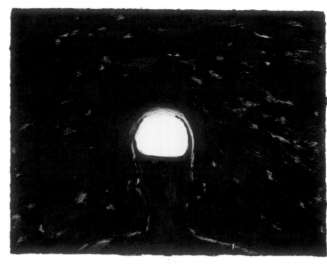

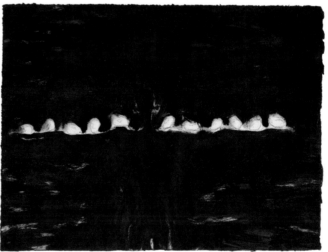

(Top row) *Suspension*, 1990
Black pigment and linseed oil
on paper, 38 × 29 cm

(Bottom row) *Lesion*, 1986
Black pigment, linseed oil and
charcoal on paper, 28 × 38 cm

Venture, 1986
Black pigment, linseed oil and
charcoal on paper, 28 × 38 cm

Light Burden, 1986
Black pigment, linseed oil and
charcoal on paper, 28 × 38 cm

Seascape, 1987
Black pigment, linseed oil and
charcoal on paper, 38 × 28 cm

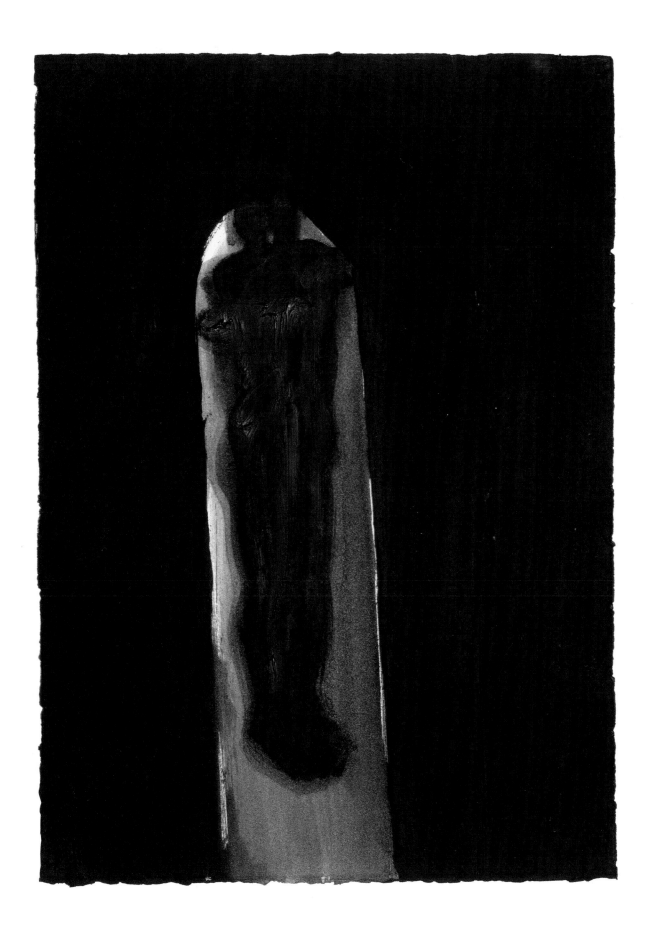

Landing, 1988
Black pigment, linseed oil and
charcoal on paper, 40 × 30 cm
Collection of Dr Michael Gormley

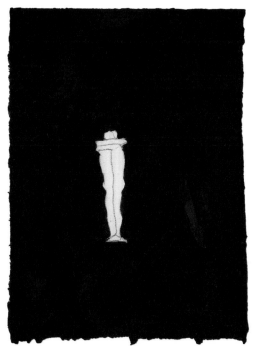

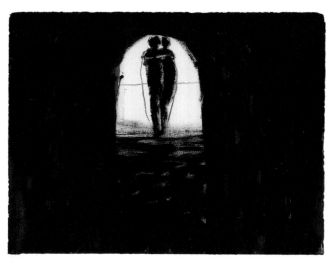

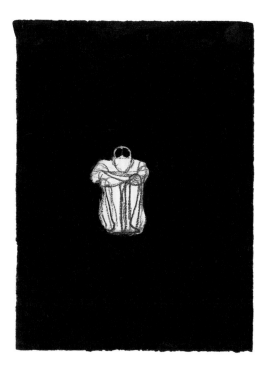

Twin Bodies/Dark Star
Light Star, 1986 (detail on page 139)
Black pigment, linseed oil and
charcoal on paper, 28 × 38 cm

Place, 1986
Black pigment, linseed oil and
charcoal on paper, 38 × 28 cm

Meeting, 1987
Black pigment, linseed oil and
charcoal on paper, 28 × 38 cm

Witness, 1988
Black pigment, linseed oil
and charcoal on paper, 38 × 28 cm

Home and the World, 1986
Black pigment, linseed oil and
charcoal on paper, 26 × 34 cm
Private collection

Soul and Search, 1988
Black pigment, linseed oil and
charcoal on paper, 39 × 28 cm
Private collection, London

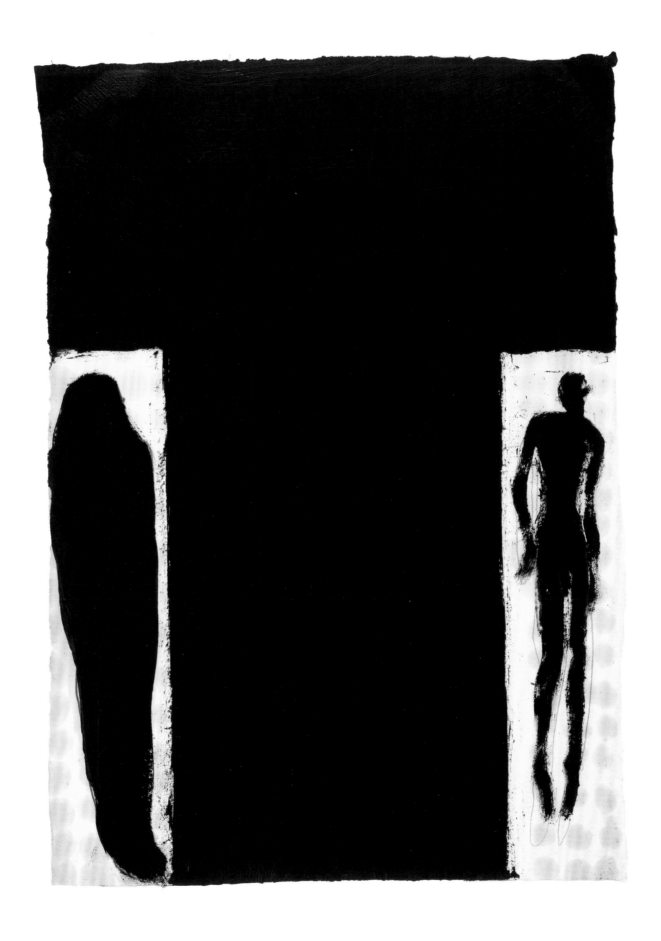

Testament Drawings

The later 1980s were busy and highly productive years for Gormley. The sculptures he was making at the time involved the laborious procedures of the body casting process and long hours beating lead around moulds. The drawings he produced during these years, in the studio and at his home in south London, usually at the end of the day, were in contrast free, immediate and rough. They were made standing up, working with charcoal and black oil paint on paper pinned to the wall. They show Gormley's continuing interest in the nature and properties of different materials; at this time, in works such as *Light*, he began to make works using his own blood.

Although they are not illustrational, the drawings deal with the same concerns as were emerging in his sculpture, collectively forming a sort of manifesto or testament to the work as a whole. They explore themes of sexuality and fecundity, and the union of opposites: presence and absence, body and earth, past and future, body and spirit, darkness and light. They evoke feelings of claustrophobia and extension into space: the darkness of the body, and the mind as a source of illumination. Some, like *Room*, clearly reflect the direction of his sculpture, the encasement of the body as in his concrete works; others, such as *Territory*, recall experiences of being in or floating above the landscape (here, flying over Japan). All the drawings express, in some way, Gormley's sense of his own passage through life as an artist, looking back and looking forward: his search for a way of making art that touches on life itself, its continuance and also its jeopardy.

(Opposite, clockwise from top left)
To the Ends of the Earth, 1987
Black pigment, linseed oil and
charcoal on paper, 53.8 × 40.6 cm
Private collection

Room, 1987
Black pigment, linseed oil and
charcoal on paper, 38 × 28 cm

Open, 1985
Black pigment, linseed oil and
charcoal on paper, 38 × 28 cm

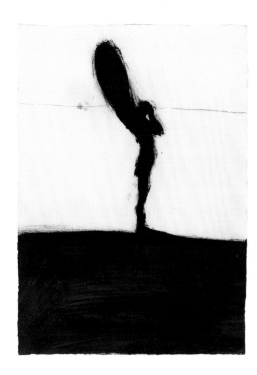

Apart, 1986
Black pigment, linseed oil and
charcoal on paper, 38 × 28 cm

Territory, 1985 (detail on page 147)
Black pigment, linseed oil and
charcoal on paper, 25 × 34 cm

Thermometer, 1989
Black pigment, linseed oil and
charcoal on paper, 38 × 28 cm

Fold, 1987
Black pigment, linseed oil and
charcoal on paper, 38 × 28 cm

Presence, 1989
Black pigment, linseed oil and
charcoal on paper, 28 × 38 cm

To the Ends of the Earth II, 1987
Charcoal and linseed oil on paper,
38 × 28 cm

Reach, 1988
Linseed oil and charcoal on paper,
30 × 40 cm

Light, 1987
Linseed oil and pencil on paper,
37.7 × 27.5 cm

Headway, 1989
Black pigment, linseed oil and glue on
paper, 77 × 111 cm
Private collection

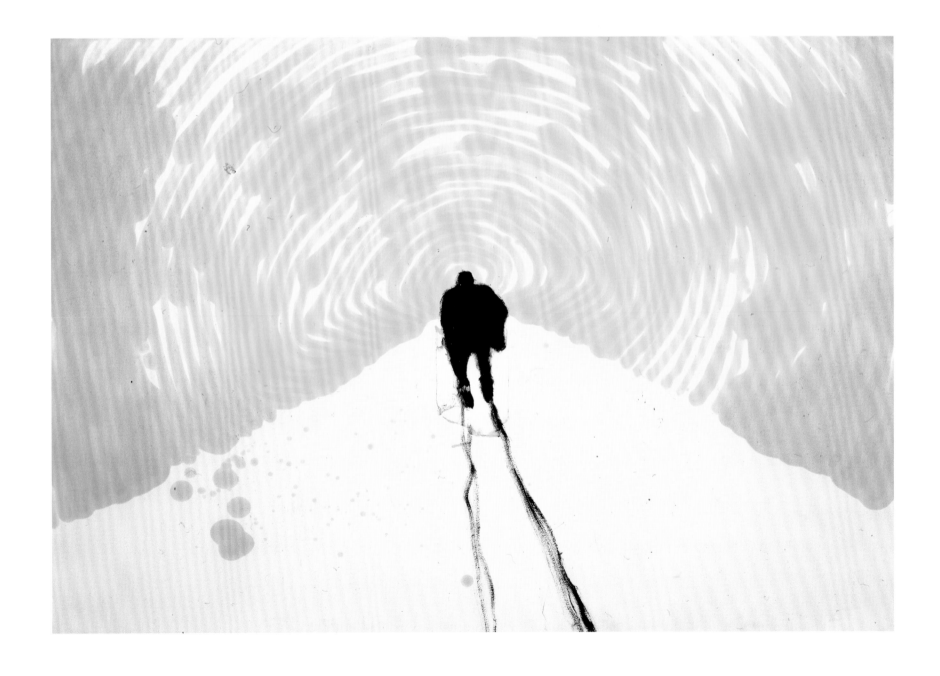

Sympathy, 1987
Black pigment, linseed oil and
charcoal on paper, 38 × 28 cm

Untitled, 1987
Black pigment, linseed oil and
charcoal on paper, 28 × 38 cm

Plant, 1987
Black pigment, linseed oil and
charcoal on paper, 28 × 38 cm

Double Moment, 1987
Black pigment, linseed oil and
charcoal on paper, 38 × 28 cm

(Opposite, left) *Journey*, 1986
Black pigment, linseed oil and
charcoal on paper, 38 × 28 cm

Threshold II, 1986
Black pigment, linseed oil and
charcoal on paper, 34.5 × 25.4 cm

Enlighten, 1988
Black pigment, linseed oil and
blood on paper, 38 × 28 cm

Woodblocks and Body Prints

Two series of large-scale prints present a polar contrast in their different transcriptions of the body in two dimensions on paper. Each unique *Body Print* derives from a single moment where the artist's body, coated in crude oil and petroleum jelly, falls onto the paper, leaving its imprint in the crude oil (Gormley describes oil as 'the blood of the earth'). This indexical mark sinks into the weave of the paper, the varying density of the oil reading like the contour shades on a map that designate the rise and fall of the land. The physical act of the body's impress – simple, straightforward – and the resulting instantaneous imprint relate directly to Paleolithic traces on rock and in caves of body drawings, among the first marks made by man, in pigment on stone.

In contrast, the *Woodblock* prints reinterpret the body in the language of modern architecture, of block superimposed on block. The natural grain and semi-transparency of each successive overlay allows an interpenetration of planes, and a build-up of density around the body's dark internal core. Both the *Body Prints* and *Woodblocks* are registers of the absence and presence of the body, the one resolutely indicating the body's surface, the skin, and the other evoking a deeper, more indeterminate internal depth, the void within.

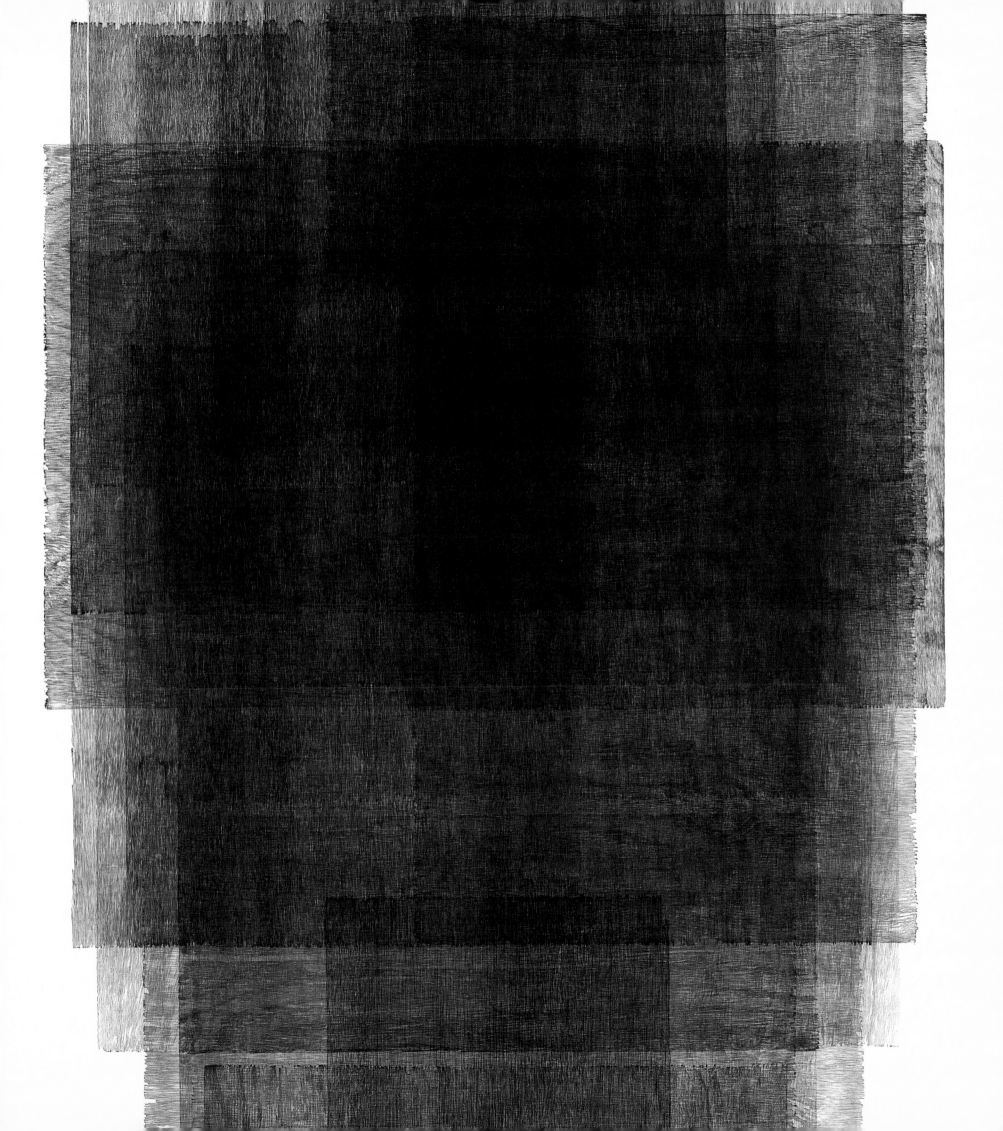

Feel III, 2016
Crude oil, linseed oil and petroleum jelly
on paper, 249 × 153.5 cm

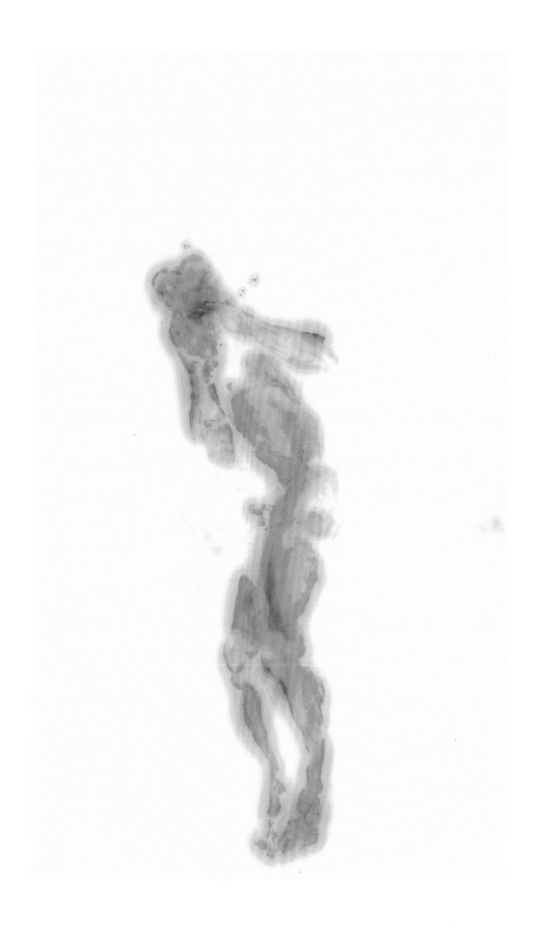

Fall, 2016 (detail on page 157)
Woodcut on Saunders 190 gsm
smooth paper, 237.1 × 134 cm

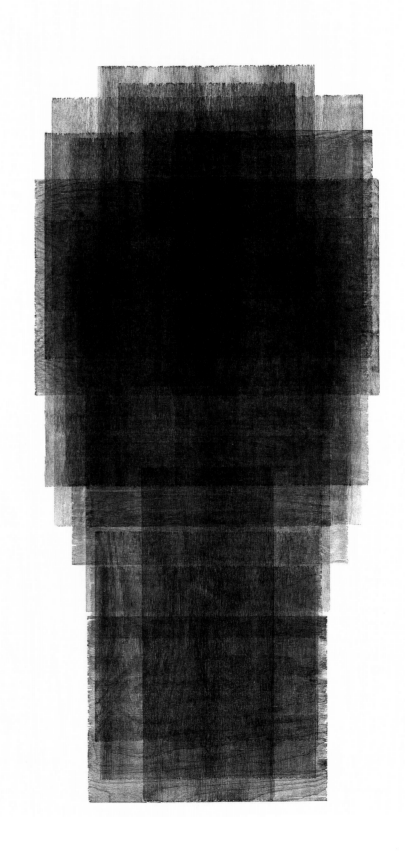

Body and Light Drawings

In the 1990s Gormley seemed to be forever flying, making and showing work on every continent. The drawings he made at this time – out of London, mostly on holidays in the Lake District – evoke feelings of floating, of exposure to the elements, of displacement and disorientation. There is in them a sense of freedom but also of searching for refuge, a place of safety: much of his work at this time gives witness to world events (the first Earth Summit, the Gulf War) and, mindful of the global predicament, is imbued with rival emotions of hope and foreboding.

The drawings were made at speed: the pigment, a mixture of carbon and casein, spread fast and freely across wet paper. Gormley likens the process of making the drawings to that of dowsing: following the material and being somehow at one with it; he sees how it evolves and allows the emergent forms to carry different feelings and thoughts.

Brink, 1992
Carbon and casein on paper,
19 × 14 cm

Attempting Re-entry, 1991
(detail on page 161)
Carbon and casein on paper,
12.5 × 17.5 cm

Structure/Road, 1996
Carbon and casein on paper,
14 × 18.5 cm

Body Light Weight Water, 1991
Carbon and casein on paper,
14 × 19 cm

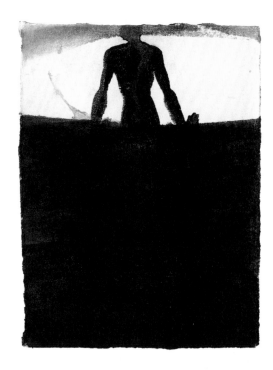

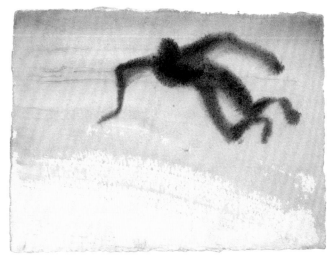

Future Time, 1990
Carbon and casein on paper,
15.5 × 21.5 cm

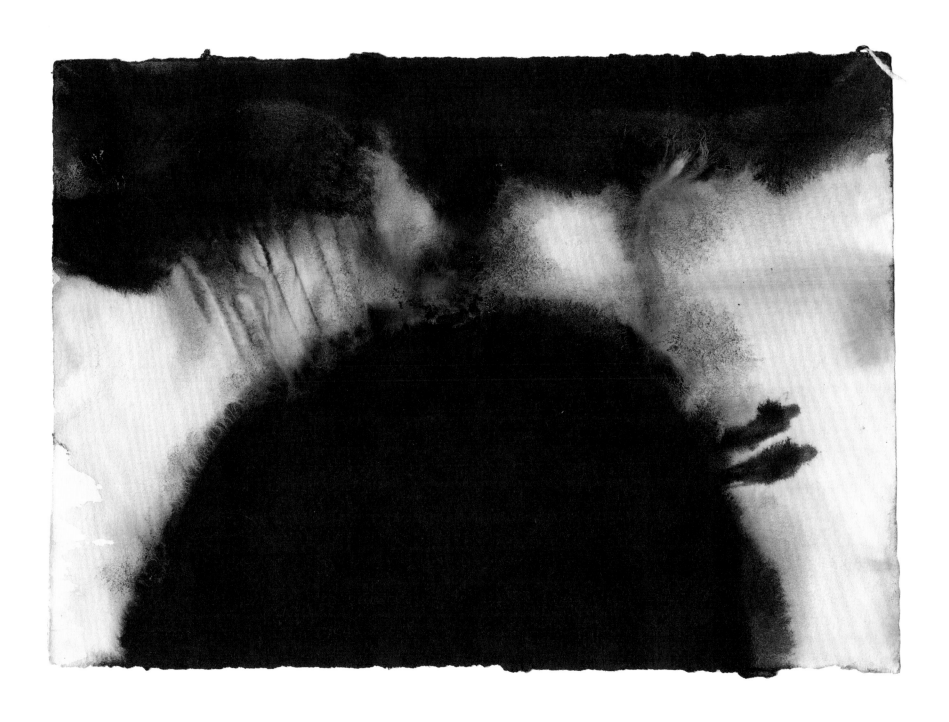

Stretch II, 1991
Carbon and casein on paper,
14 × 19 cm

North, 1991
Carbon and casein on paper,
14 × 19 cm

Baobab II, 1991
Carbon and casein on paper,
12.6 × 17.5 cm

Body and Light, 1990
Carbon and casein on paper,
15.5 × 21.5 cm

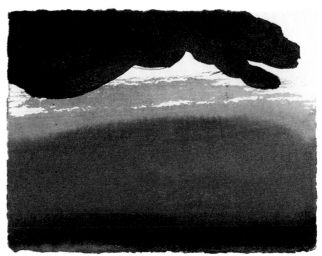

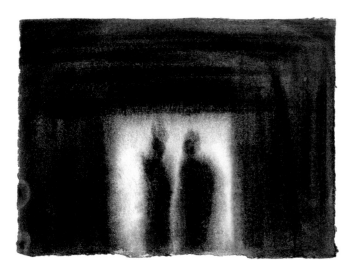

Signal I, 1991
Carbon and casein on paper,
19.5 × 14 cm

Draw, 1991
Carbon and casein on paper,
12.5 × 17.5 cm

Between People Between Worlds, 1991
Carbon and casein on paper, 14 × 19 cm
Private collection

Commune II, 1991
Carbon and casein on paper,
13 × 17.5 cm

Hand over Water, 1996
Carbon and casein on paper,
14 × 19 cm

Open Window, 1991
Carbon and casein on paper,
12.5 × 17.5 cm

Present Time, 1990
Carbon and casein on paper,
15.5 × 21.5 cm

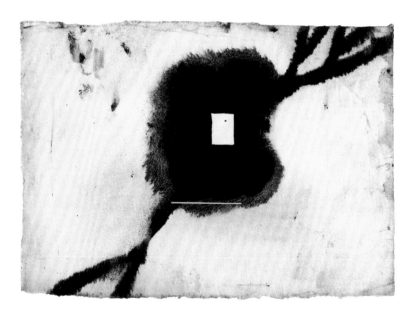

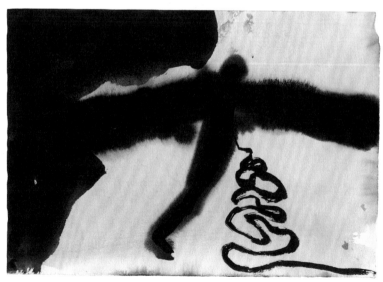

Nerve, 1993
Carbon and casein on paper,
diptych, each 19 × 14 cm
Private collection

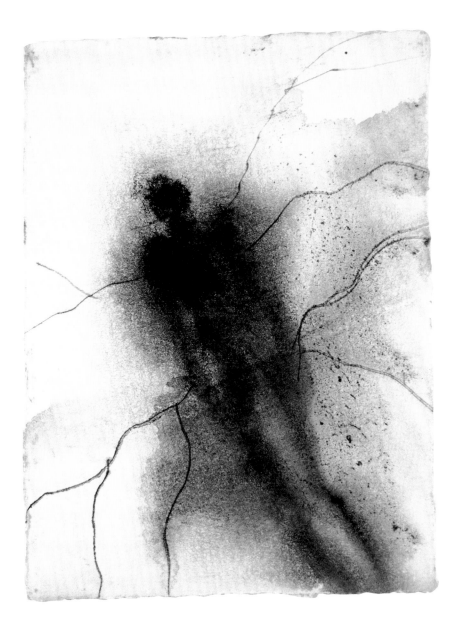
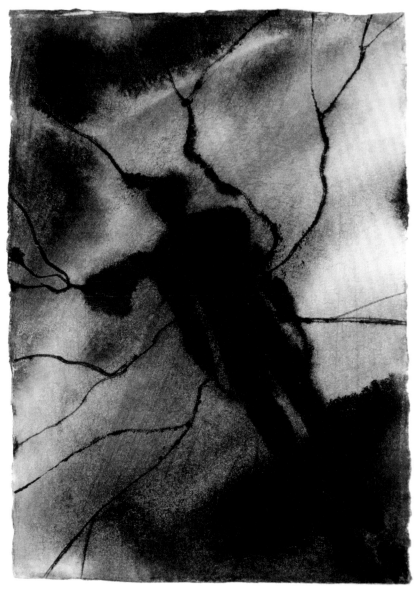

Clearing Drawings

If the sculptural installation *Clearing* can be thought of as a 'drawing in space', the drawings in the *Clearing* series convey something of the same energy, their loops and arcs at times contained by, at times extending beyond the paper's edge. Inscribed with an etching tool into casein coated paper, the lines register the sweep of the artist's arm (or on occasion both arms simultaneously) moving at full stretch, in a fluid, orbital gesture that returns on itself and repeats, time and again.

These drawings are non-figurative and intensely physical works – marks of a sort of choreography with the mind and body engaged as one. Those entitled *Rain*, a parallel series in which the paper is scored with a thicket of vertical incised lines, again mark the parameters of the arm's reach, creating an enigmatic spatial field for the eye somewhere between two and three dimensions.

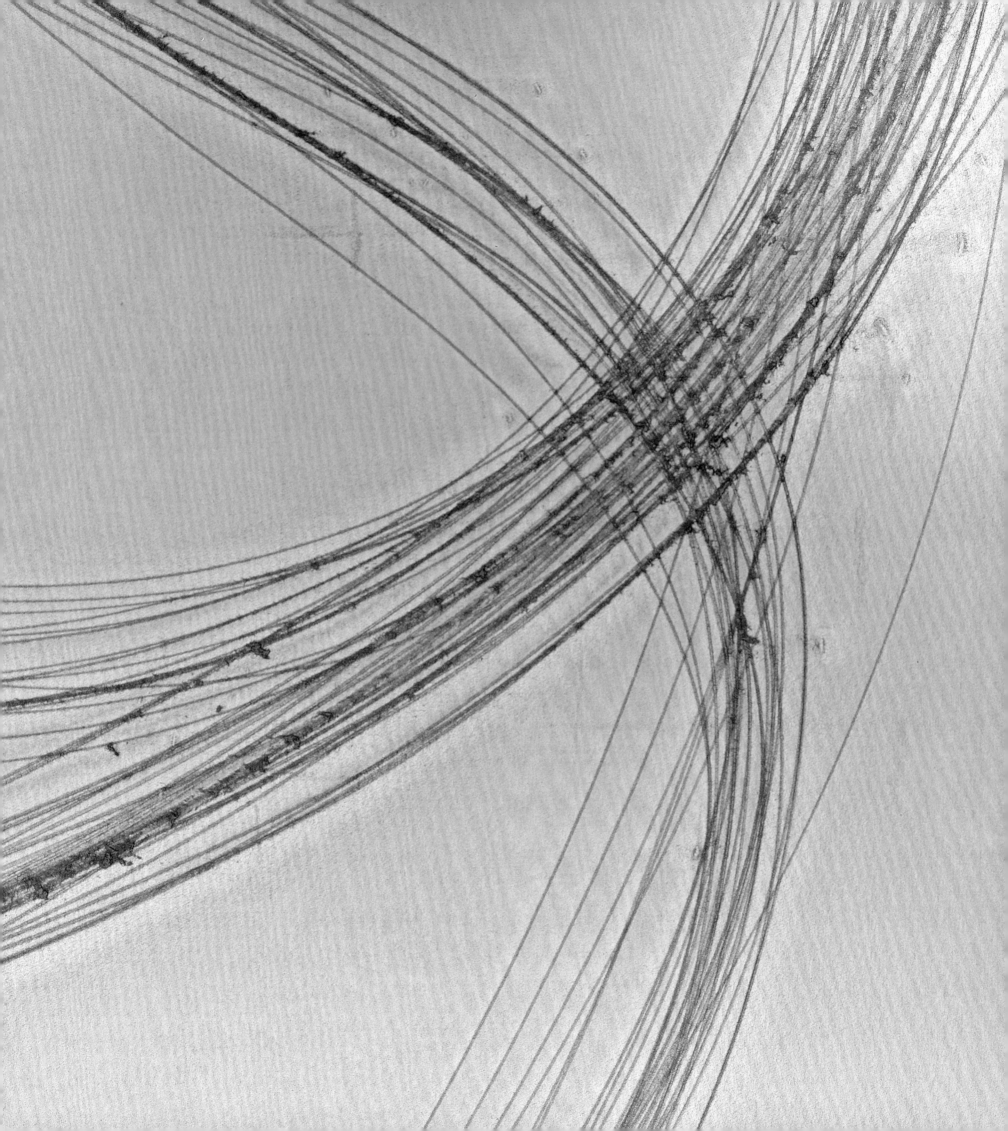

Clearing 57, 2007
Carbon and casein
on paper, 77 × 111 cm

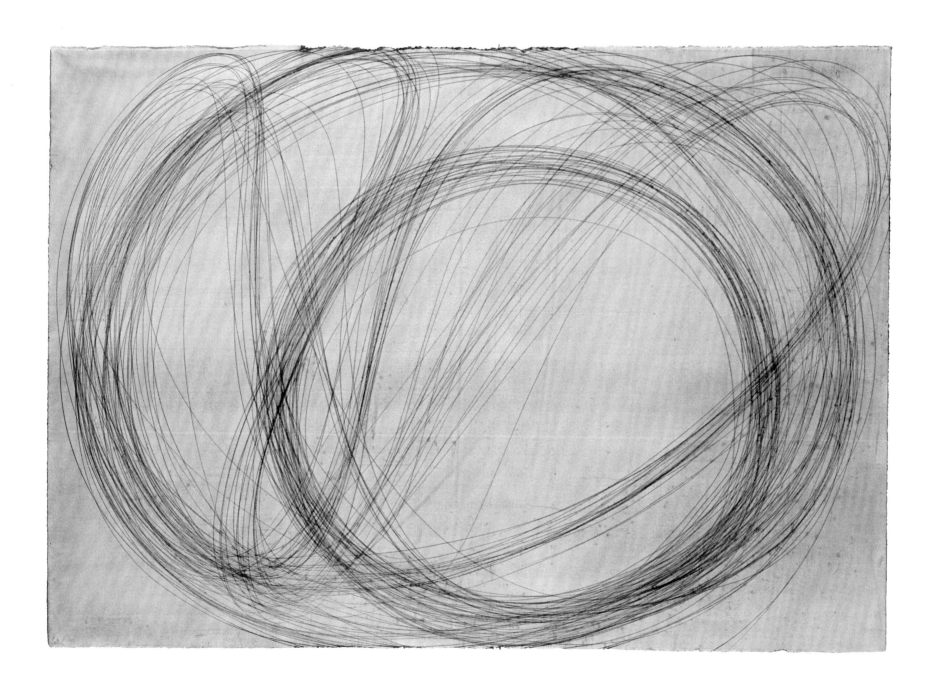

Wild Orbit I, 2006
Carbon and casein on paper,
76 × 111 cm

Clearing L, 2006
Carbon and casein on paper,
77 × 111 cm

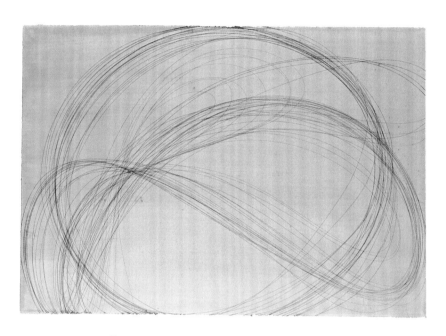

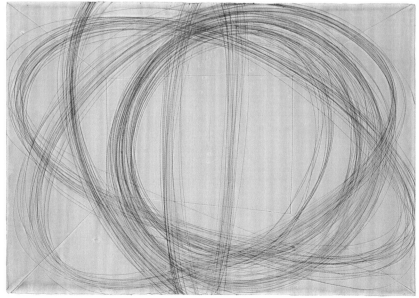

Rain III, 2008
Carbon and casein on paper,
77 × 111 cm

Rain VII, 2009
Carbon and casein on paper,
77 × 111 cm

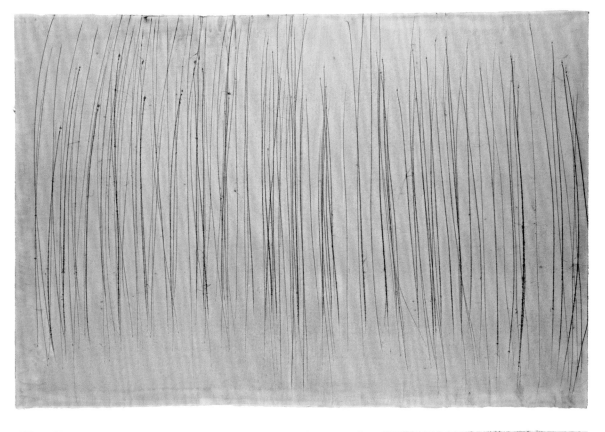

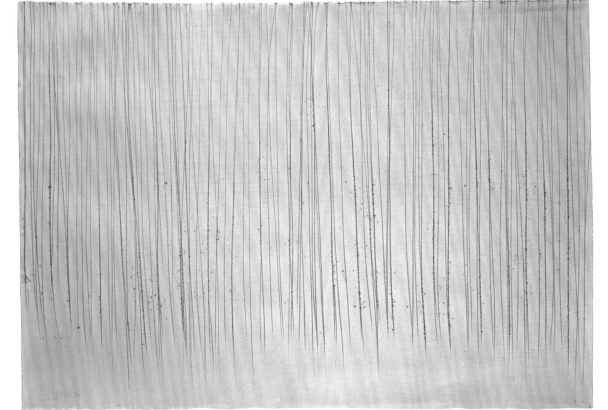

Workbooks

The small workbooks Gormley has always carried with him record his thoughts and ideas for future works and projects. More broadly, drawing is an everyday activity for Gormley; he describes it as the foundation of his sculpture. His drawings run parallel to the sculptural work, exploring the same concerns. Unlike the lengthy and often laborious practical procedures involved in making sculpture, notation and drawing offer an internalised, intimate and immediate process. Like the dark interior of the body, too, a drawing can offer a space of indeterminate scale. Gormley wrote once of drawing as 'a kind of magic, a kind of necessity … an attempt to fix the world, not as it is, but as it exists inside me'.

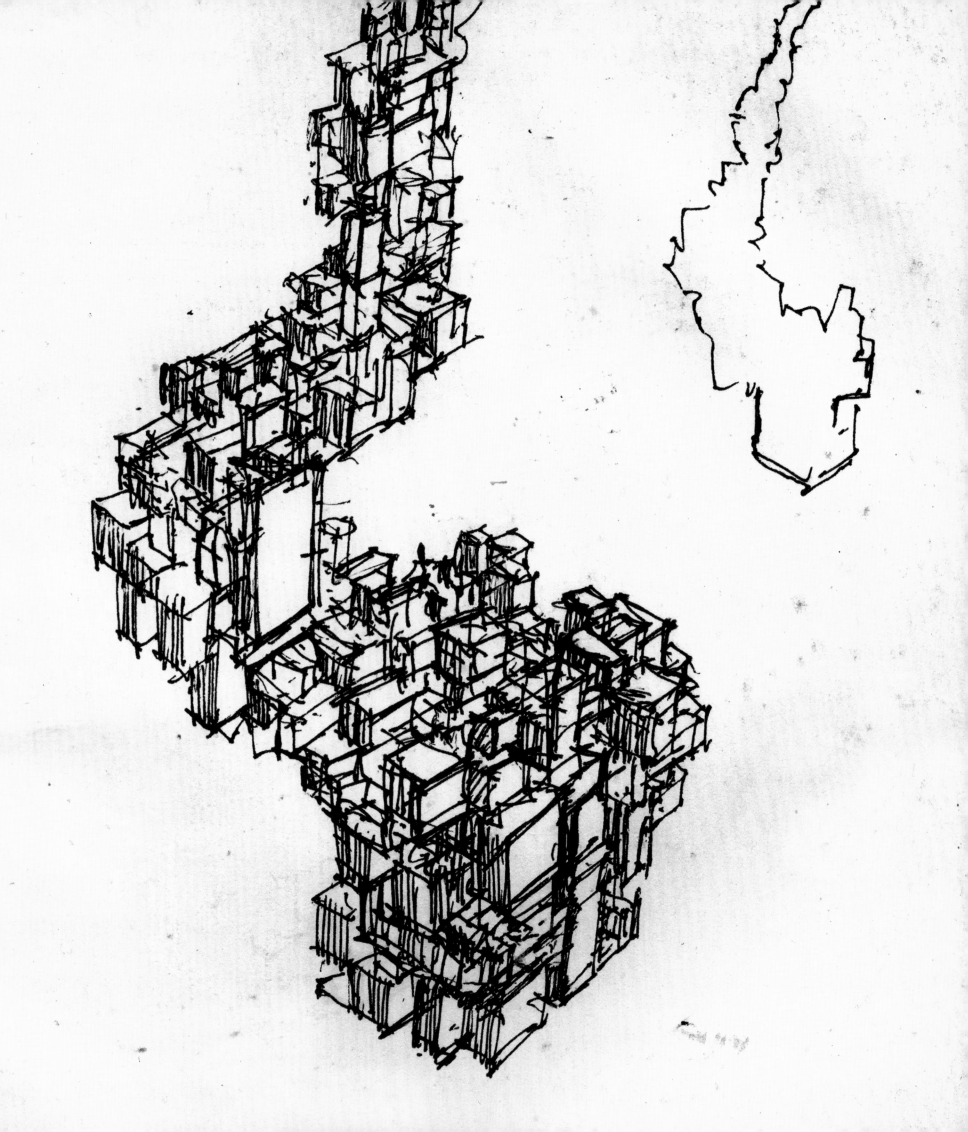

Workbooks, 2017–19 (pages 175–83)

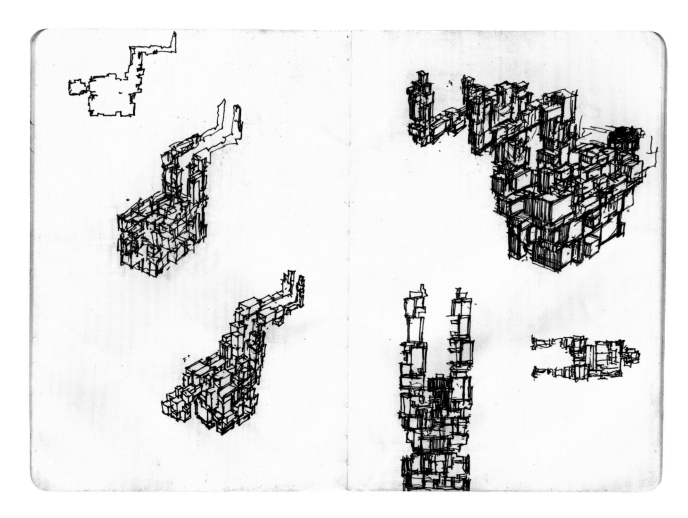

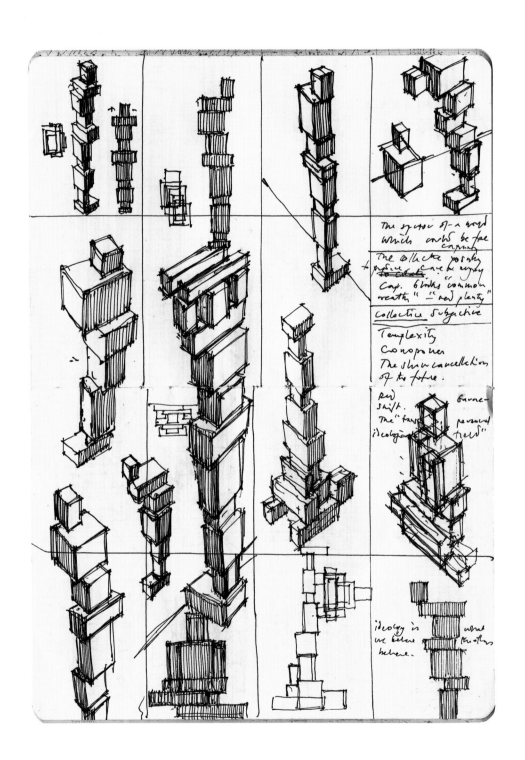

The syntax of a word
which could be free
expression

The collective possibly
produce — could be usefuly
to create, or
Cap. blocks common
wealth " — red plenty"

Collective subjective

Templexity
Cronoprener
The slow cancellation
of the future.

red
shift. Garner
The "trans personal
ideological field"

ideology is what
we believe others
believe.

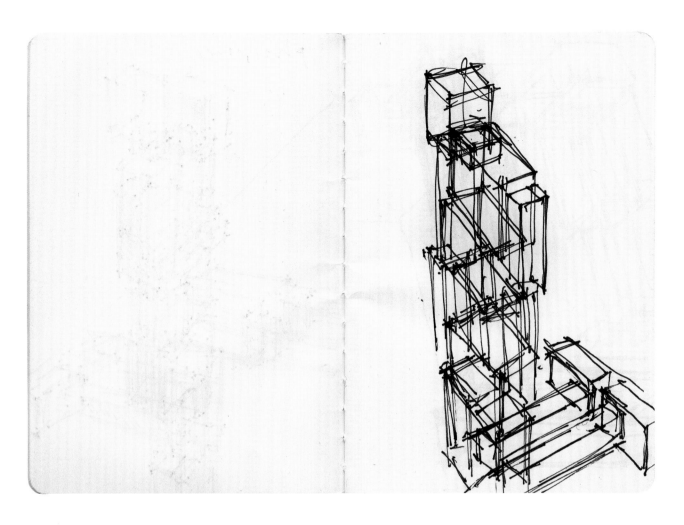

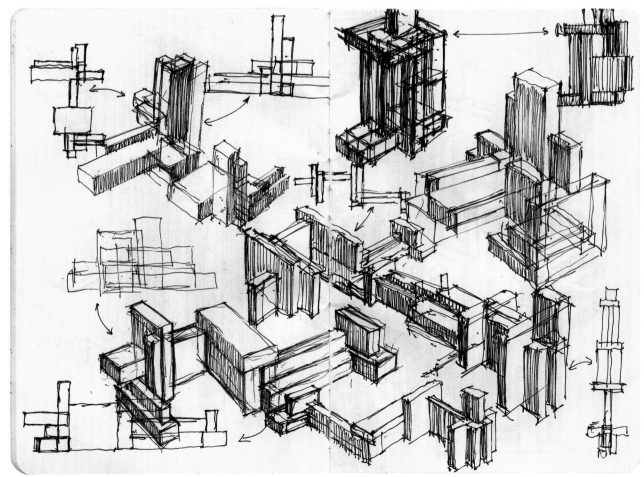

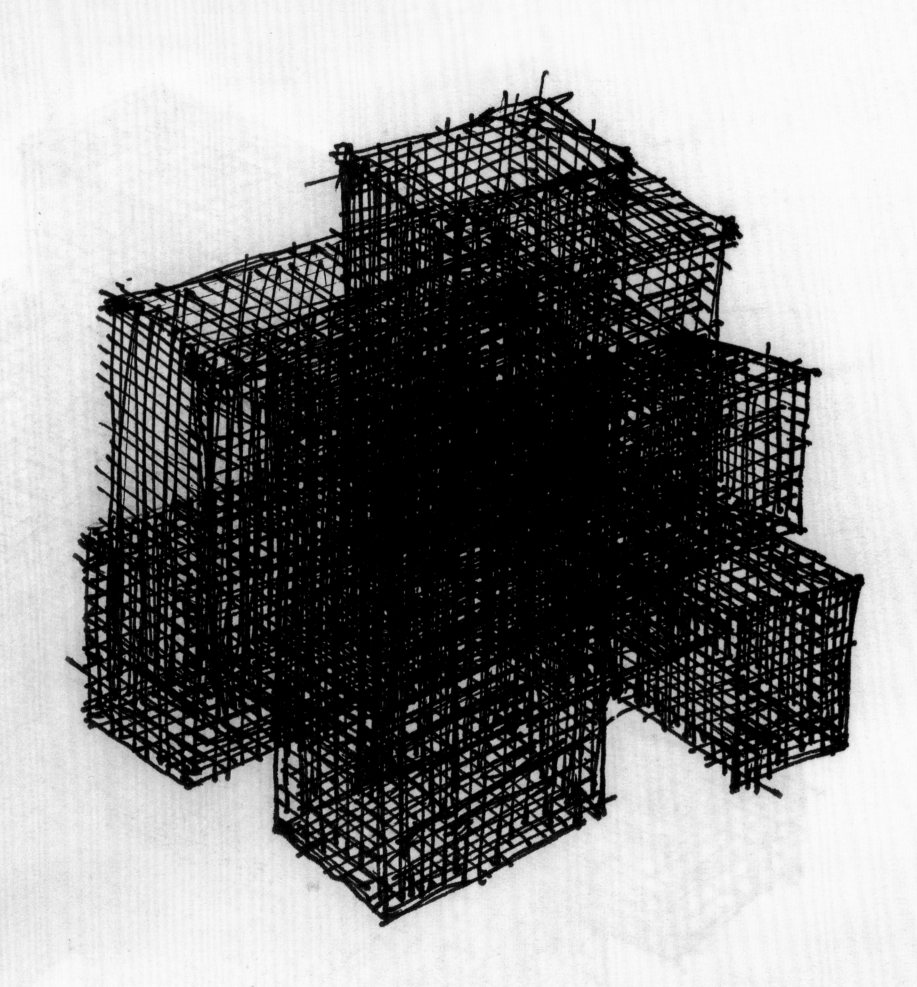

Lost Horizon

The horizon is a constant presence in Gormley's work. An unreachable boundary, it stands at the limit of our field of vision, the fundamental reference point that grounds and orients us, inseparable from our experience of space. In *Event Horizon*, an outdoor installation in London in 2007, Gormley positioned life-size figures across the city in all directions to the furthest visible rooftops, all oriented towards a central viewpoint. *Lost Horizon I*, made the following year, is conceived as an 'internalised' version of *Event Horizon*, and turns the idea on its head, almost literally. Since the 1980s, Gormley has presented individual body forms in orientations counter to our own upright bodies: projecting from the wall horizontally into space, or suspended upside down. Here, in a single installation, a proliferation of these body forms, set every which way, pits the body against its architectural 'container' and disrupts the stability of the regular gallery space in which they are all set – unsettling, again, our position in space, our sense of ground and measure of distance, emphasising the simple fact that the body is both the space we occupy and the means by which we experience all other space around.

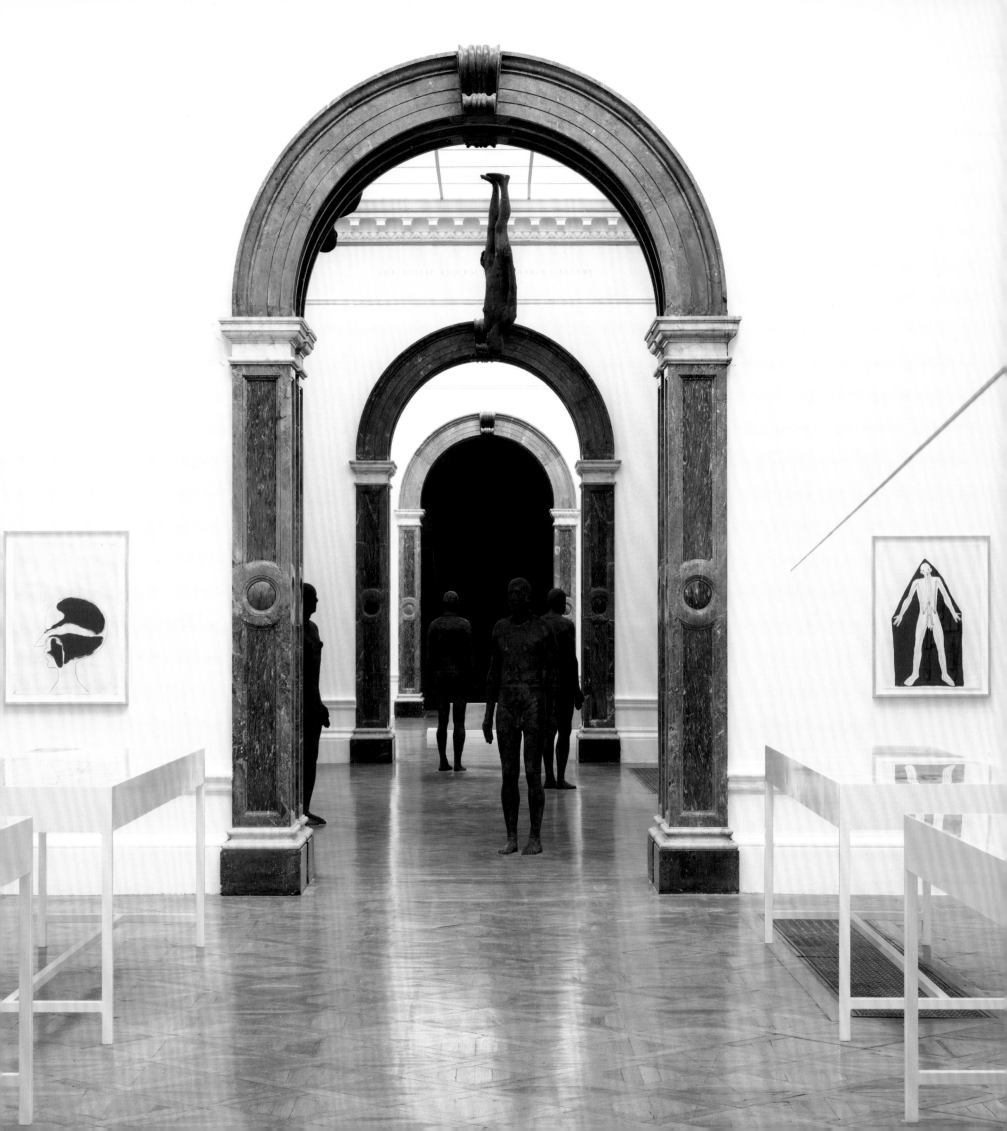

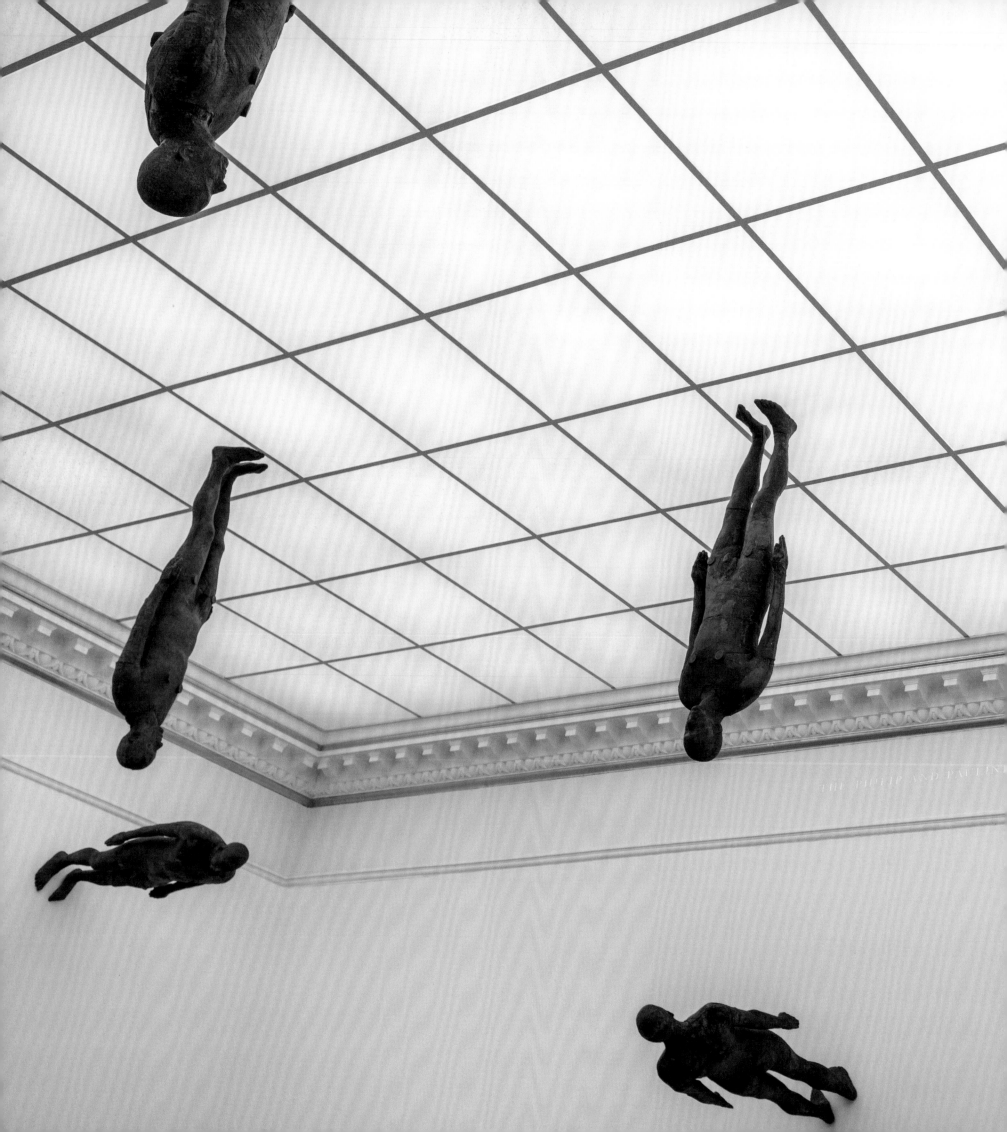

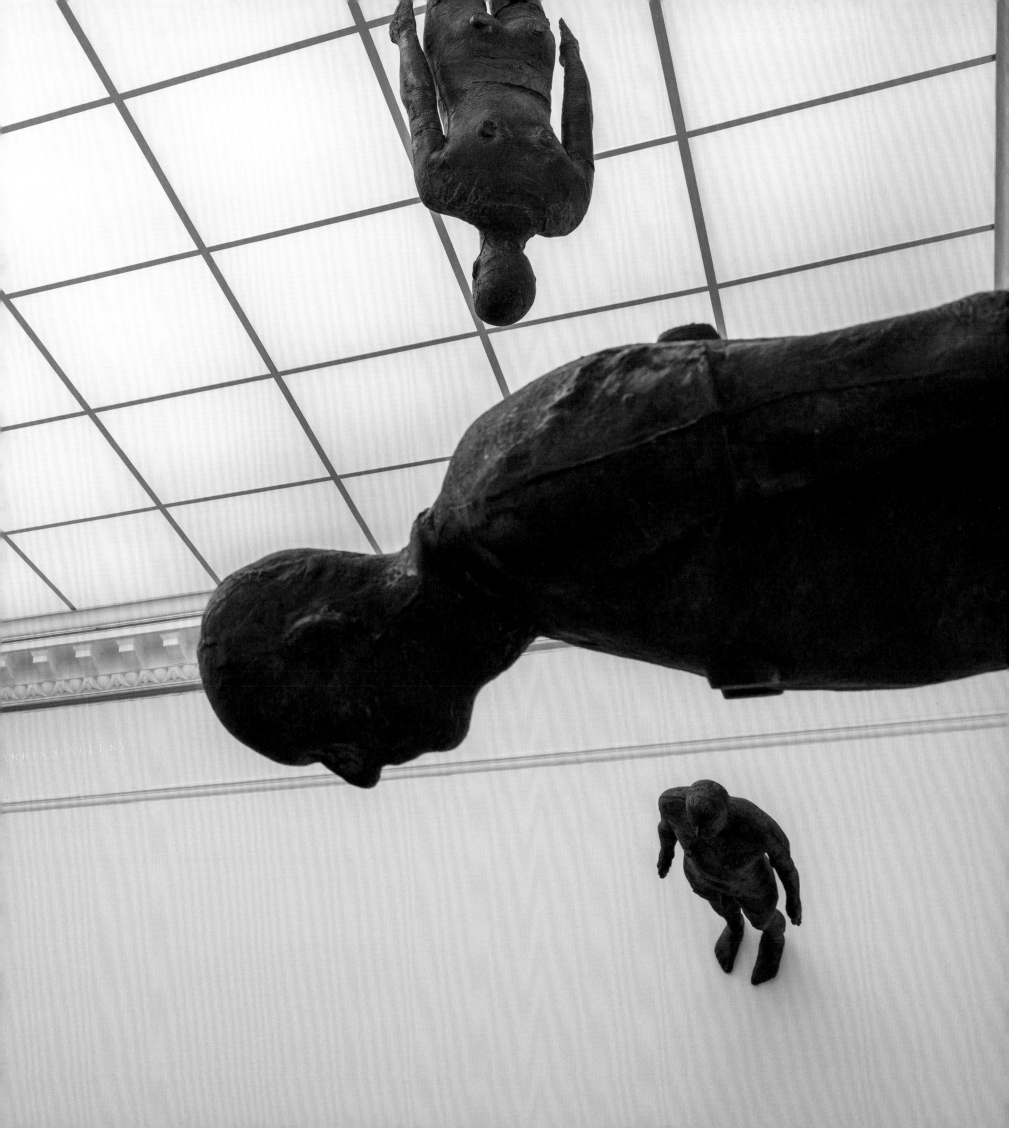

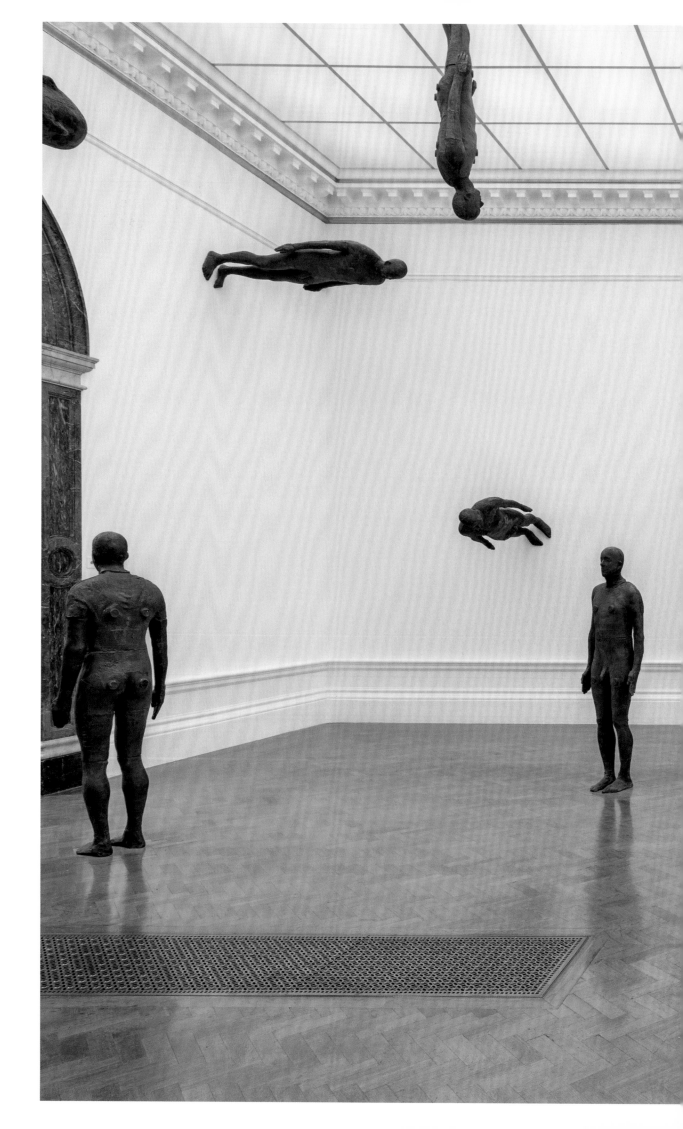

Lost Horizon I, 2008 (pages 185–91)
24 cast-iron bodyforms, each 189 × 53 × 29 cm
PinchukArtCentre, Kiev, Ukraine

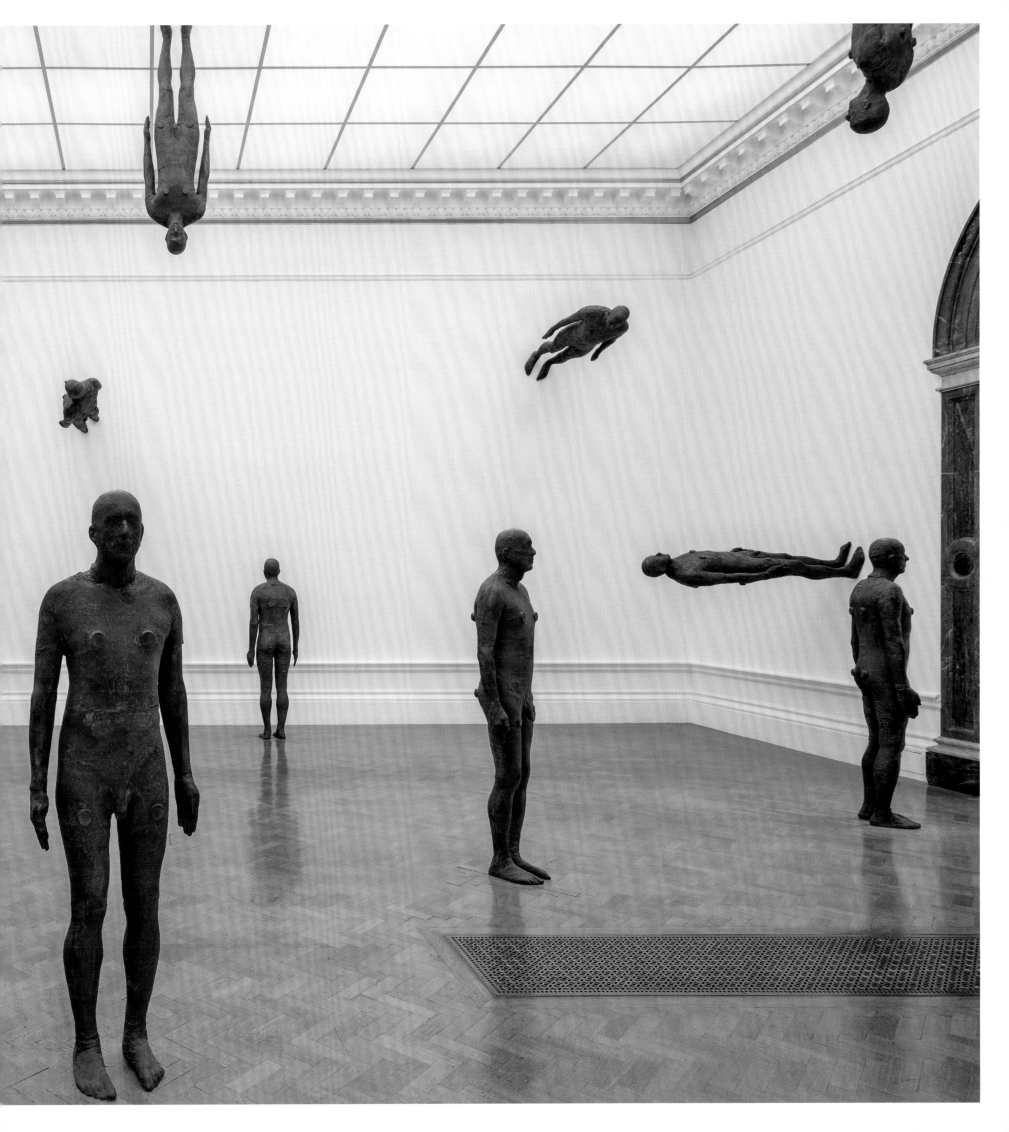

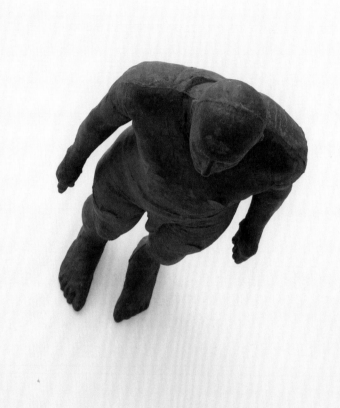

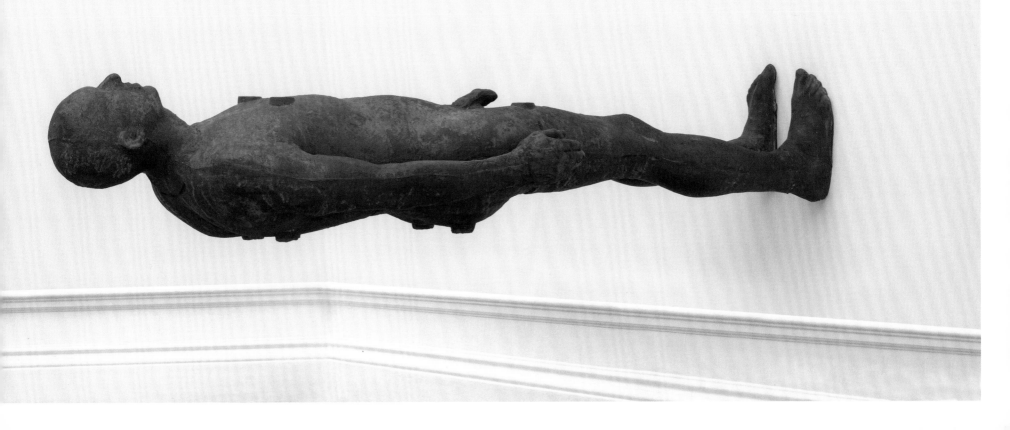

Fruit and Body

Two large, swollen, bulbous forms, soldered iron casings enclosing air, their surfaces mottled and rusted, hang in space just above floor level in the Wohl Central Hall, at the heart of the Academy's run of galleries. As their titles imply, *Fruit* and *Body* (both 1991/93) are natural forms, yet their origins are hard to determine: at opposite extremes of scale they could be taken for atomic, organic or planetary bodies. Gormley describes them as 'expansion works'. Each is modelled around the artist's body, in the form of a plaster mould recording a particular pose: in making them the artist attached wooden rods to the defining points of the plaster form, head, hands, elbows, knees and feet, radiating outwards a fixed length to suggest the energy field that surrounds the body – a notional repetition of the skin, the body's surface, as reflected in the wall drawing *Exercise Between Blood and Earth* earlier in the exhibition. The resulting form, bounded by a more expansive 'second skin' of plaster, is then cast in iron – the energy it encapsulated is caught, stilled, contained, held in space.

Body and *Fruit*, 1991/93 (pages 193–197)
Cast iron and air, 233 × 265 × 226 cm (*Body*),
110.7 × 129.5 × 122.5 cm (*Fruit*)

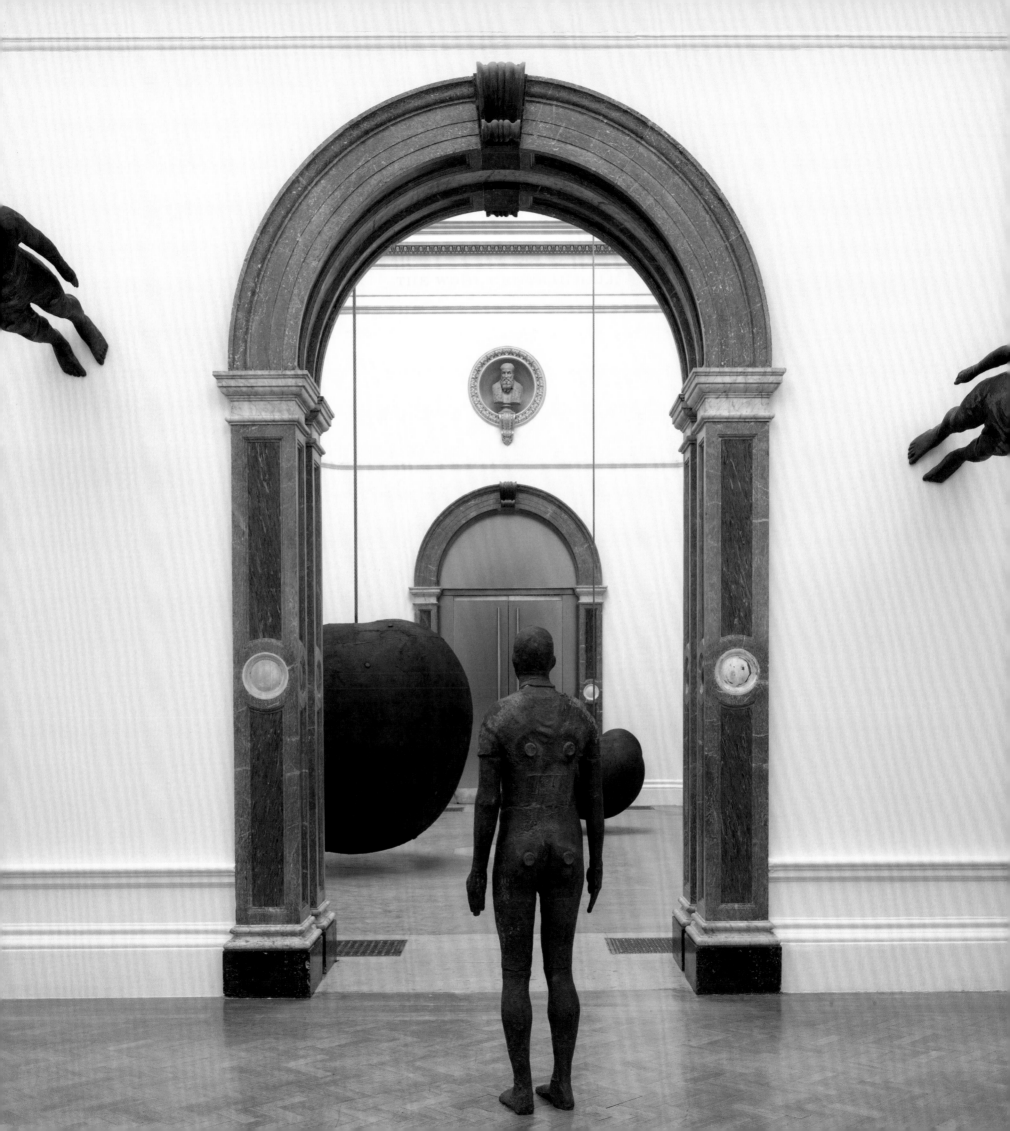

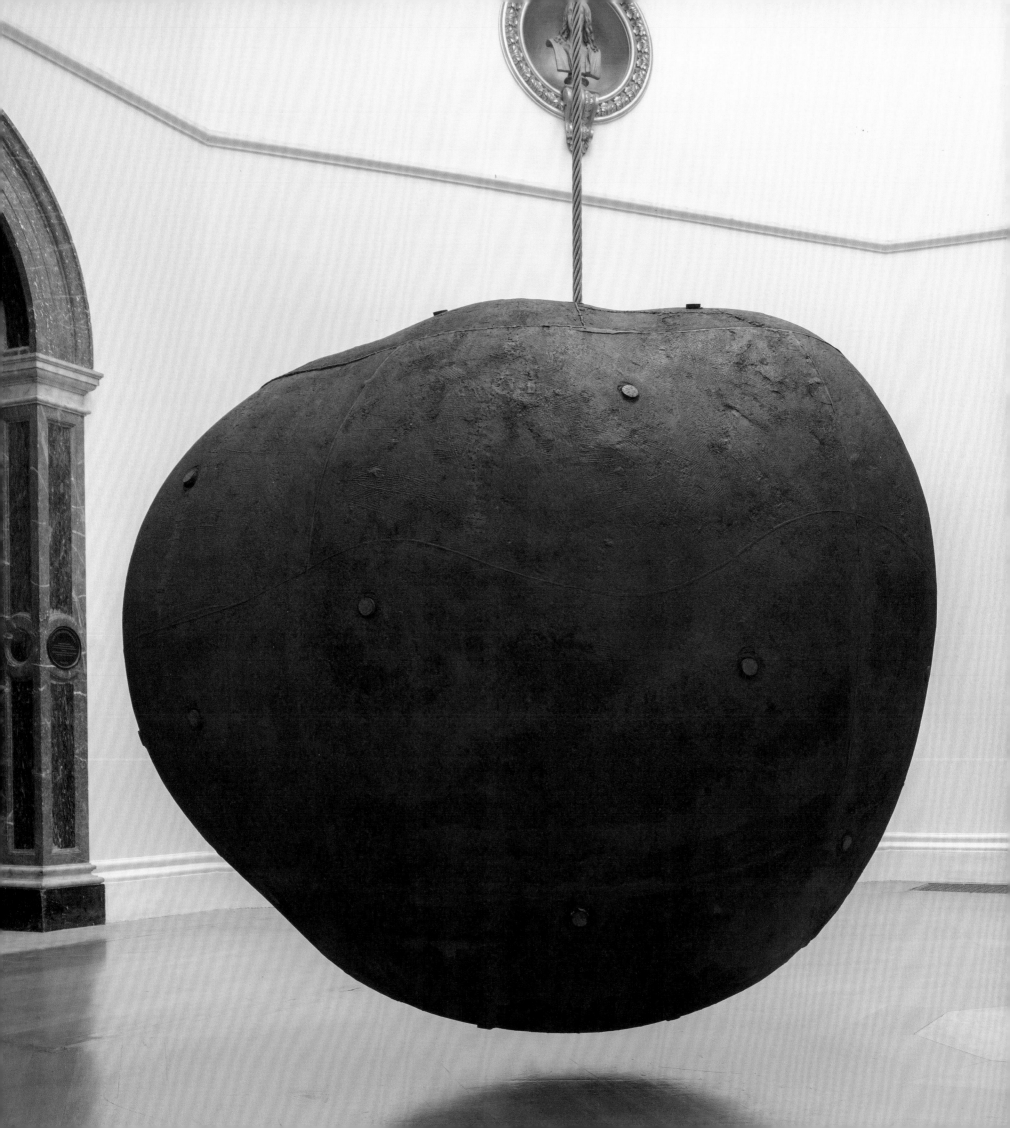

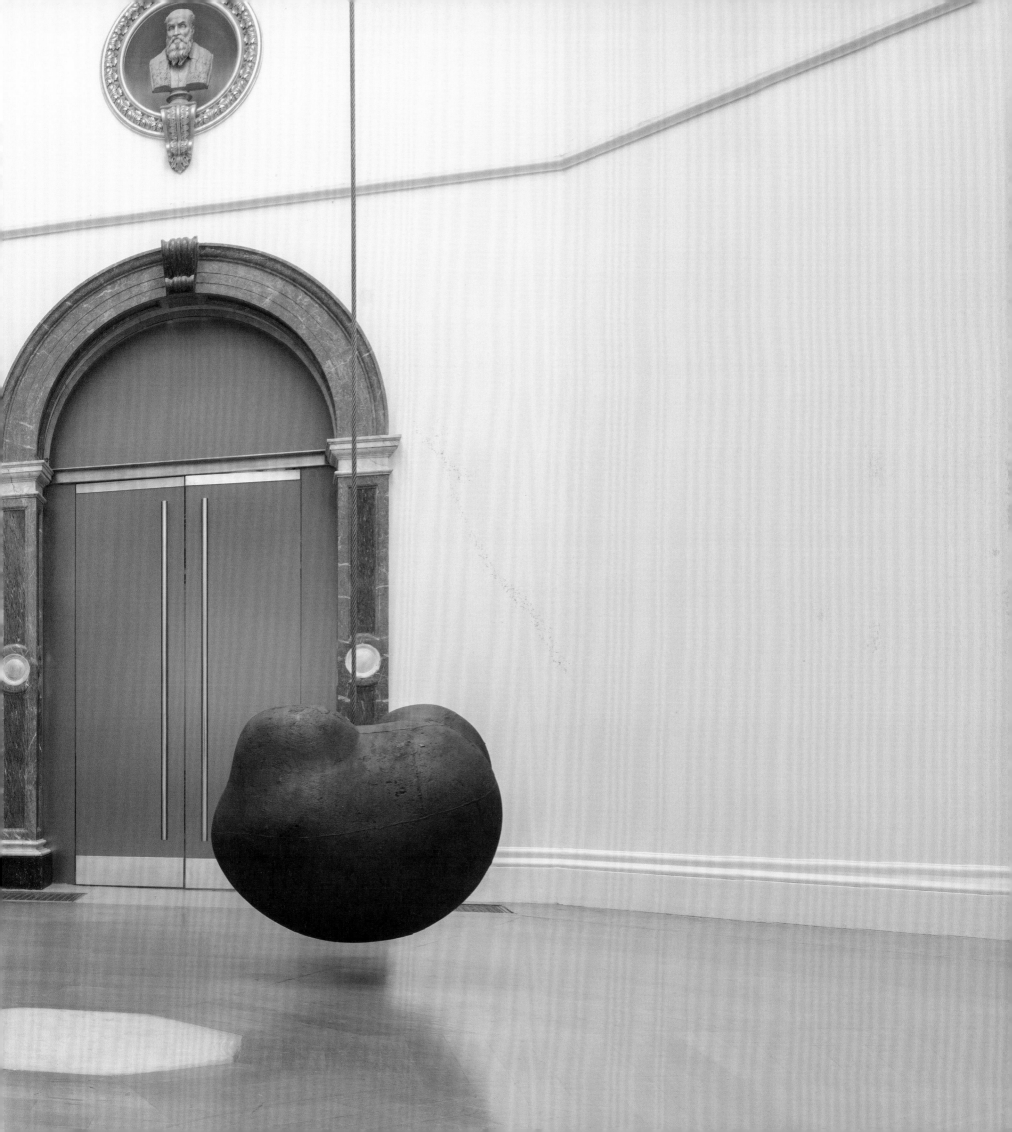

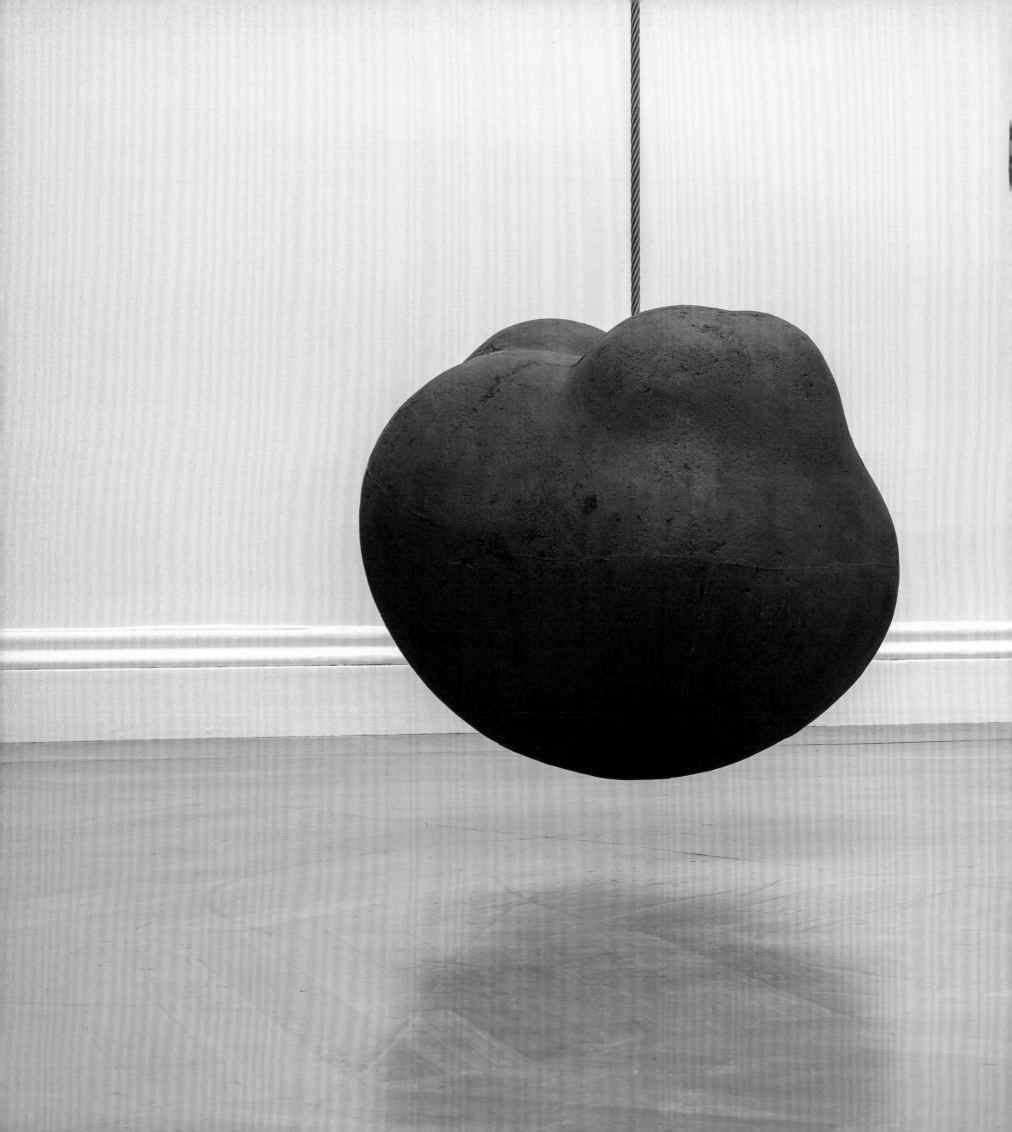

Concrete Works

Like *Fruit* and *Body*, the concrete works Gormley made in the early 1990s are casings for body forms. They rest close to the floor and are disposed as a group in line with the walls, making clear an equation between each simple cuboid mass (cube, slab, cross) and the volume of the gallery – they are all of them containers, building blocks. Within each simple geometric form, by way of a plaster body mould – a wax cast made of the mould and the 'lost-wax' casting process – a particular body form is registered as a dark internal void, invisible to the eye save for the points at which it breaks the surface of the block. At those points the slightest bodily traces can be seen, marks of a body's touch: the impression of skin at neck, feet, fingertips is 'indexical' evidence of an actual human presence at a moment in time.

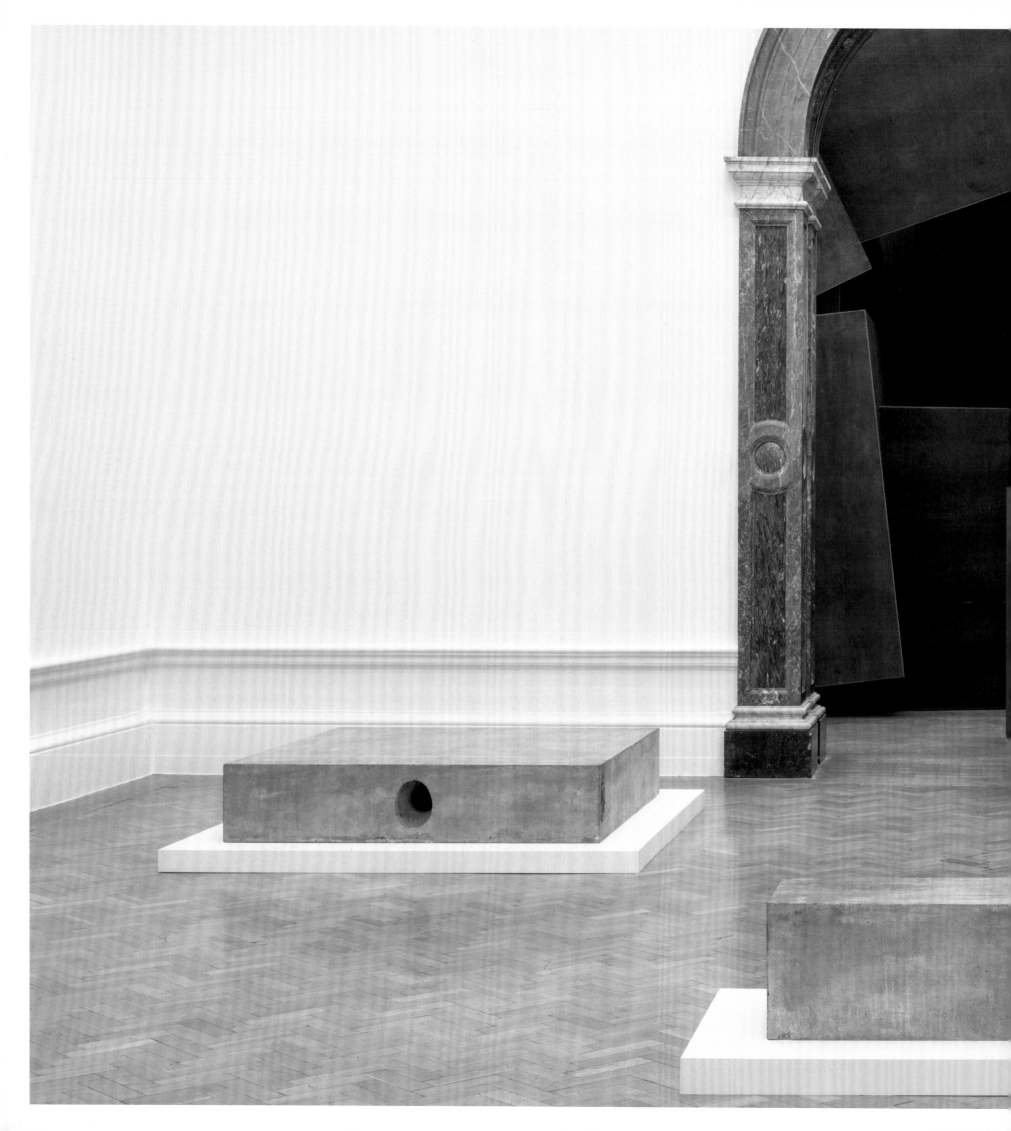

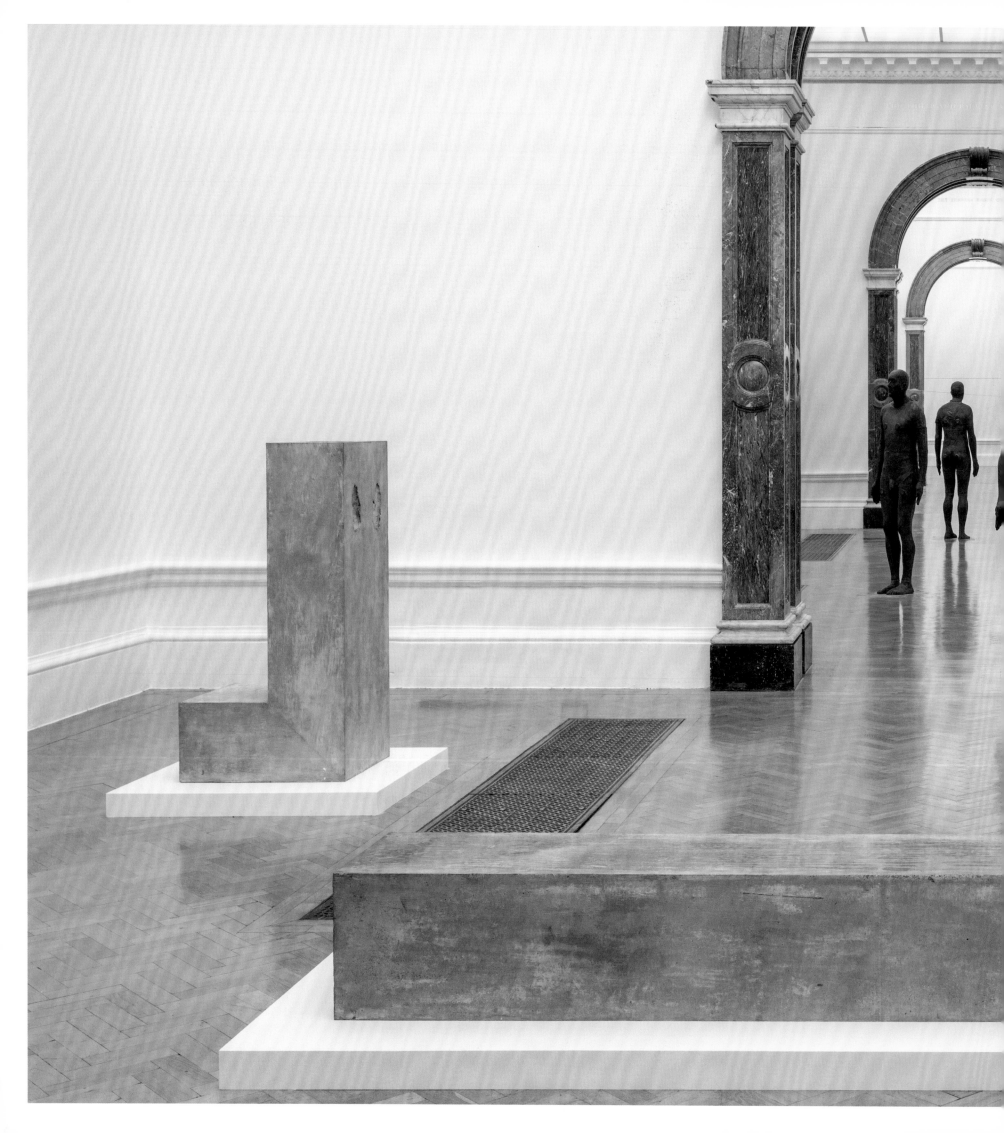

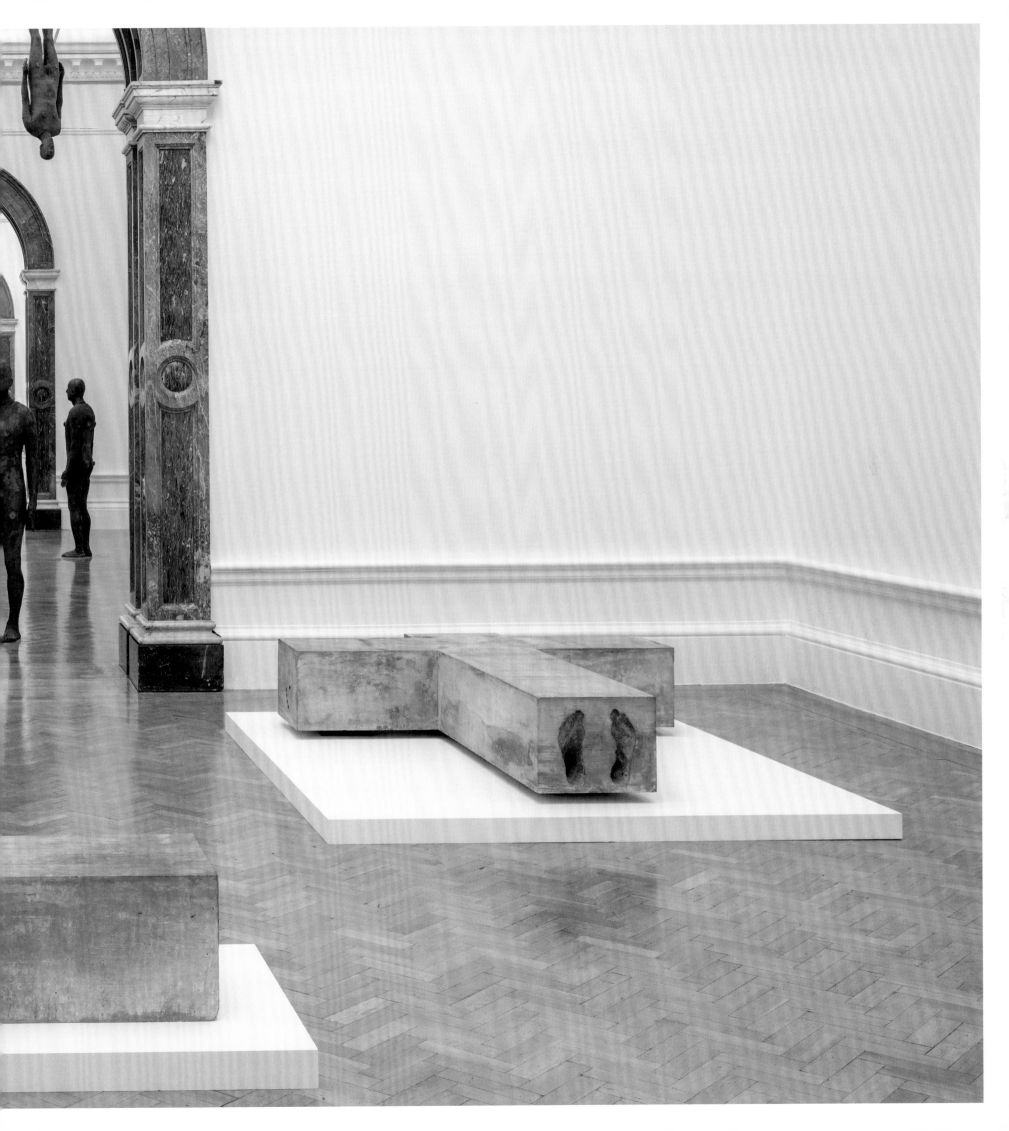

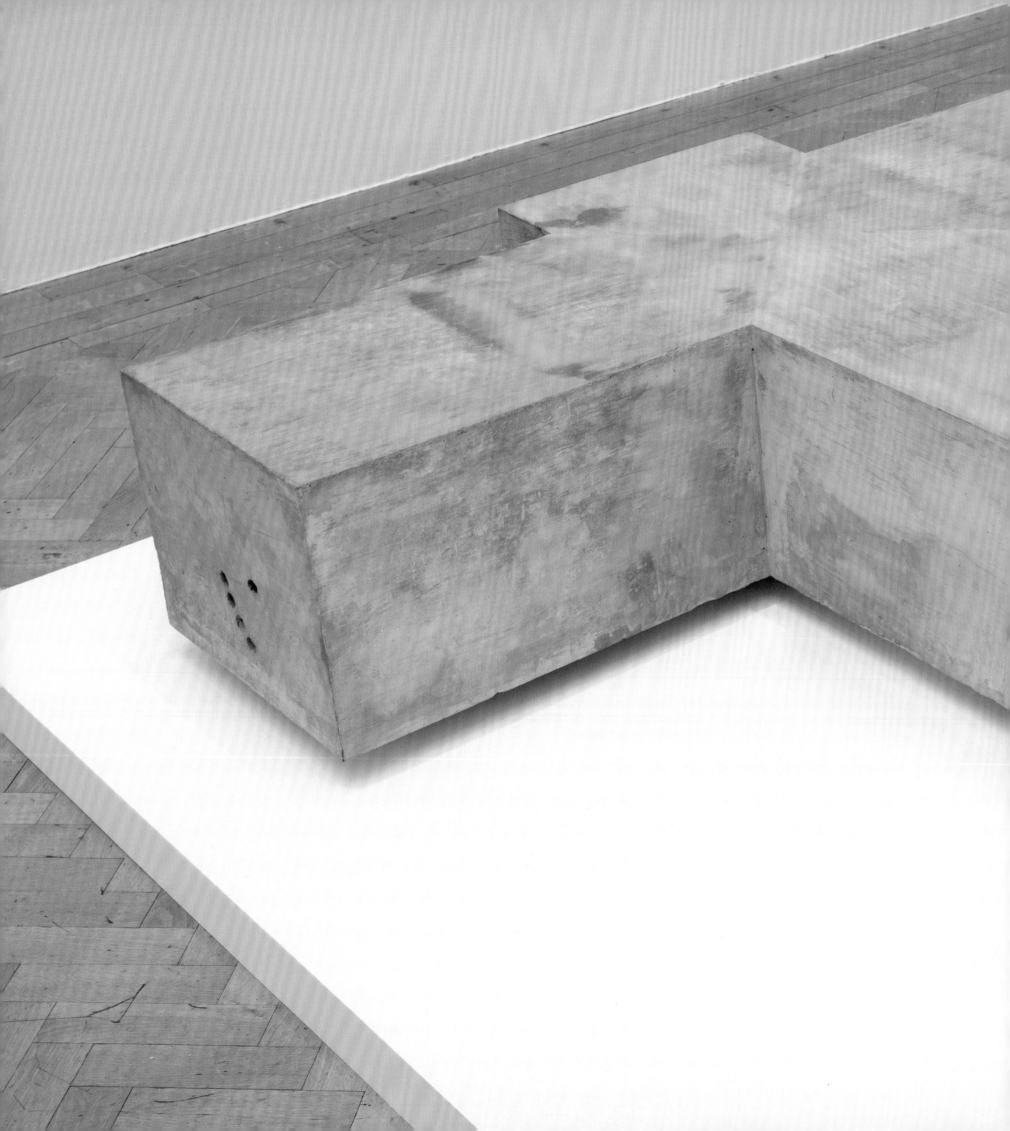

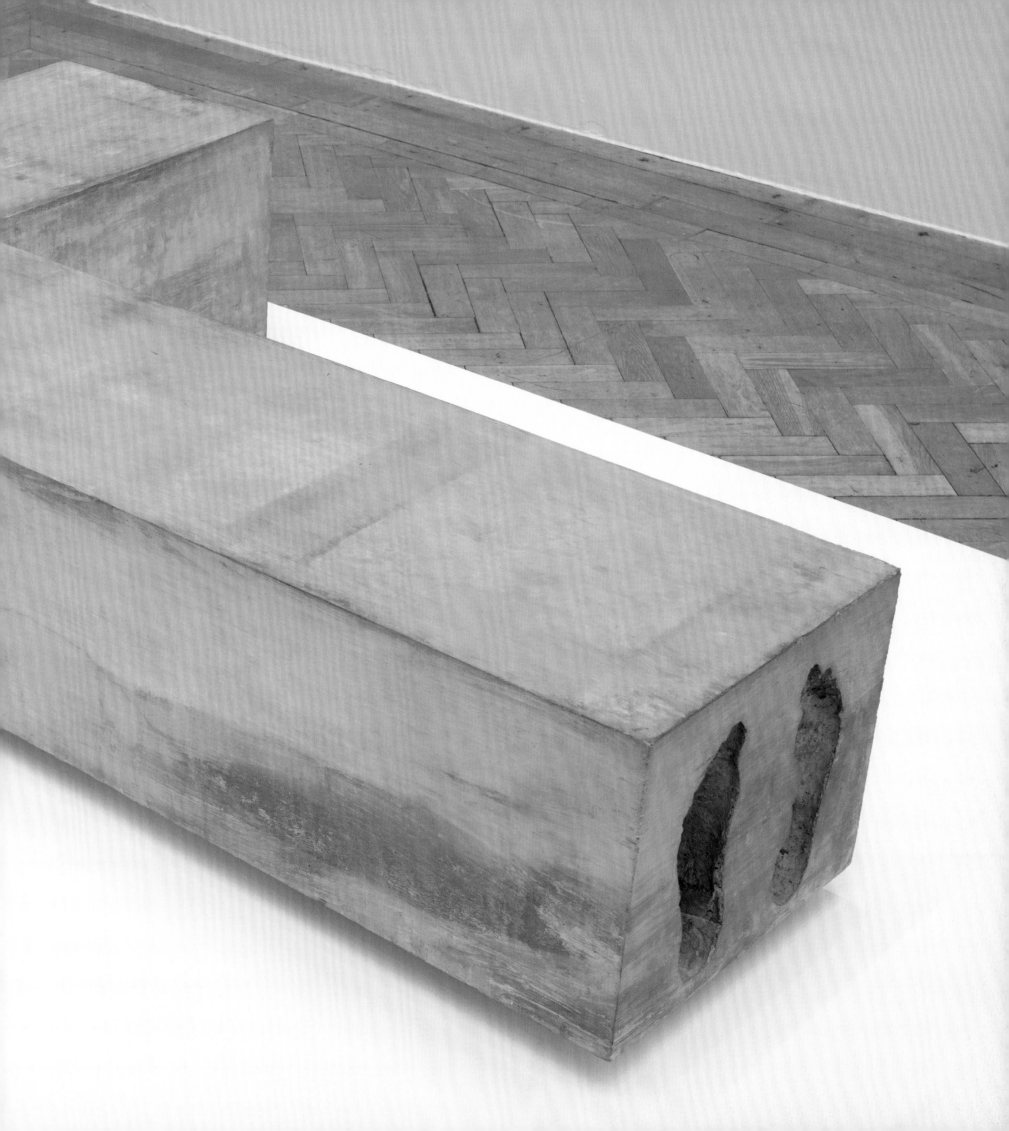

Base, 1993 (pages 200–01, left)
Concrete, 32 × 160 × 164.9 cm
Museum Voorlinden, Wassenaar

Press, 1993 (pages 202–203, left)
Concrete, 134 × 68 × 55 cm
D.Daskalopoulos Collection

Passage, 1993 (pages 202–03, centre)
Concrete, 36 × 44 × 229 cm
Collection of Jill and Peter Kraus

Flesh, 1990 (pages 204–05)
Concrete, 36 × 198 × 174 cm
Duerckheim Collection

Sense, 1991 (opposite, details on
pages 199 and 208–09)
Concrete, 74.5 × 62.5 × 60 cm

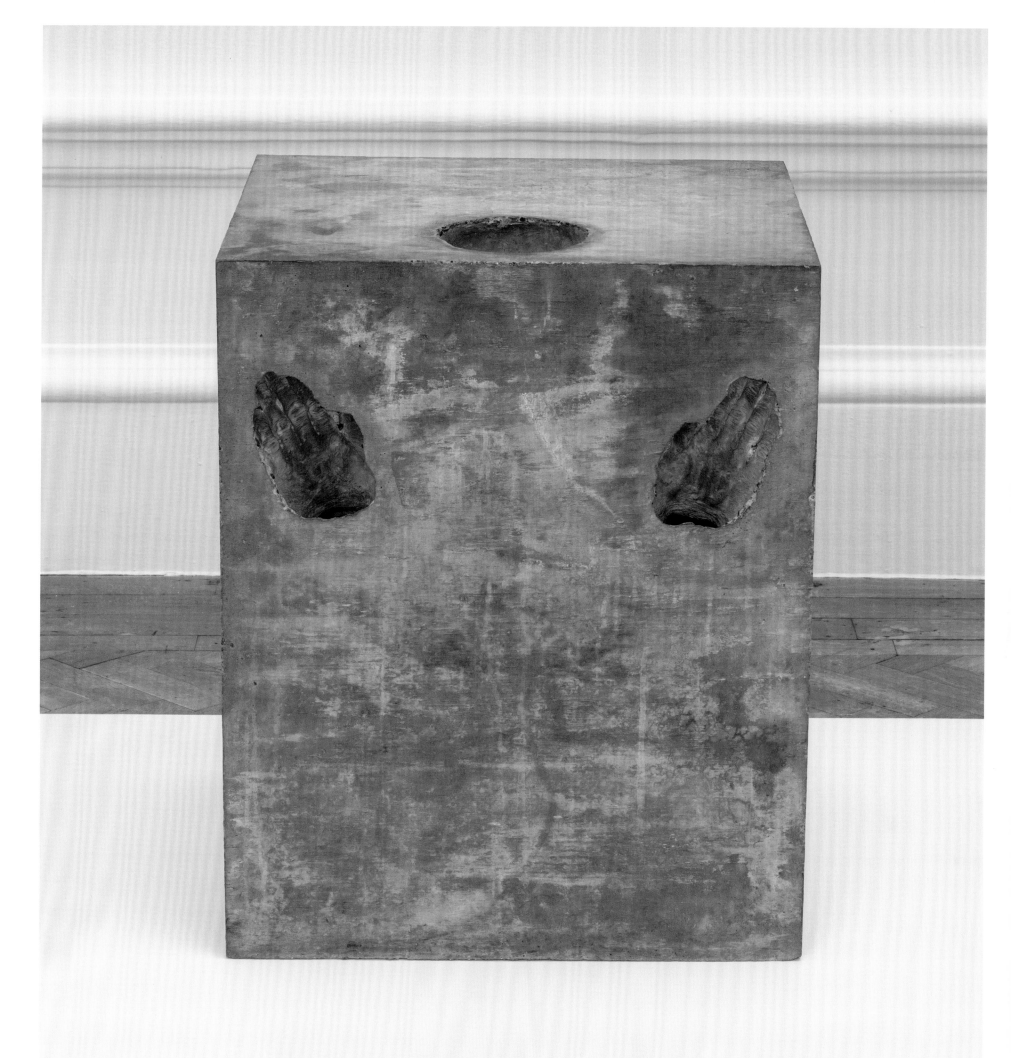

Matrix Drawings

While the intricate construction and enormous scale of Gormley's sculptural installation *Matrix* entailed extensive planning and intricate calculation, the drawings made alongside the sculpture involve no pre-drawing, no plan. The result of a steady, meditative application of ink on paper by brush, they evolve intuitively as variants of a basic principle, layer upon layer of ink wash adding to the density of the drawing's dark core. Intimate in scale, they share with the vast *Matrix* sculpture a conflation of the idea of architectural containment and the limitless extension of the mind, in a recreation of the mental space that Gormley describes when you close your eyes: the darkness that can lead from a sense of confinement to one of release.

Matrix II, 2014
Carbon and casein on paper,
14.3 × 19.4 cm

Matrix V, 2014 (detail on page 211)
Carbon and casein on paper,
13.7 × 19.5 cm

Matrix IX, 2014
Carbon and casein on paper,
14.2 × 19.3 cm

Matrix X, 2014
Carbon and casein on paper,
14 × 19.5 cm

Matrix XVIII, 2014
Carbon and casein on paper,
14 × 19 cm

Cave

At this point in the exhibition there is a radical departure from human scale – the one-to-one identification with the size of the body in *Lost Horizon* and the concrete works. The co-ordinates of the building – and the sense of stability afforded by the horizontal and vertical of wall and ceiling and floor – are again disrupted, this time more radically. *Cave* is a vast cluster of cuboid voids with irregular facets, set as if at random angles one to another. Sculpture on the scale of architecture, it fills the space, pressing against the gallery's perimeters. It is impossible to gather in one view; the form, difficult to read given the scale of the work and its position, is of a body, hunched, lying on one side, one knee raised. Its external form can be negotiated, and viewed, in part, from the constricted space between its outer surfaces and the gallery walls. This is the body as building: a foot protrudes through the gallery's

doorway; an aperture offers a way in, and the prospect of a slow, careful passage through internal chambers. Entering, you feel your own moving body more deeply, as you try to find your bearings and make your way through the larger body of *Cave*. Two facets of the body's surface are open (at the head, and the raised knee) to glimpses of the gallery's cornice and ceiling – and to allow light to fall from above, affording constant interplay of dim illumination and darkness in the cavernous, resonating space – almost subterranean in feel – inside the body. An exit is made, by way of the arm and the hand, to the gallery beyond.

Cave, 2019 (details on pages 215–27)
Approximately 27 tonnes of 8-mm weathering steel, 14.11 × 11.37 × 7.34 m

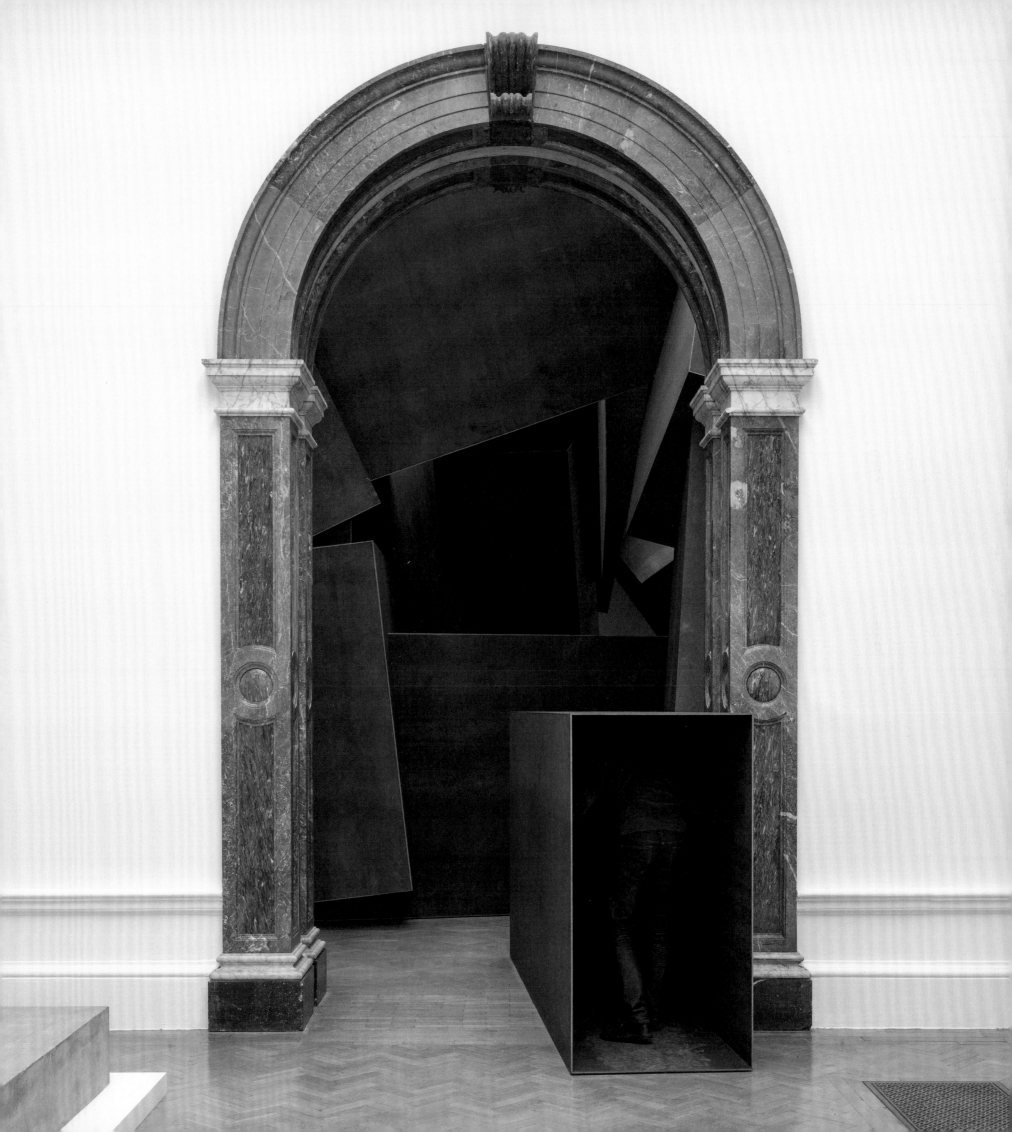

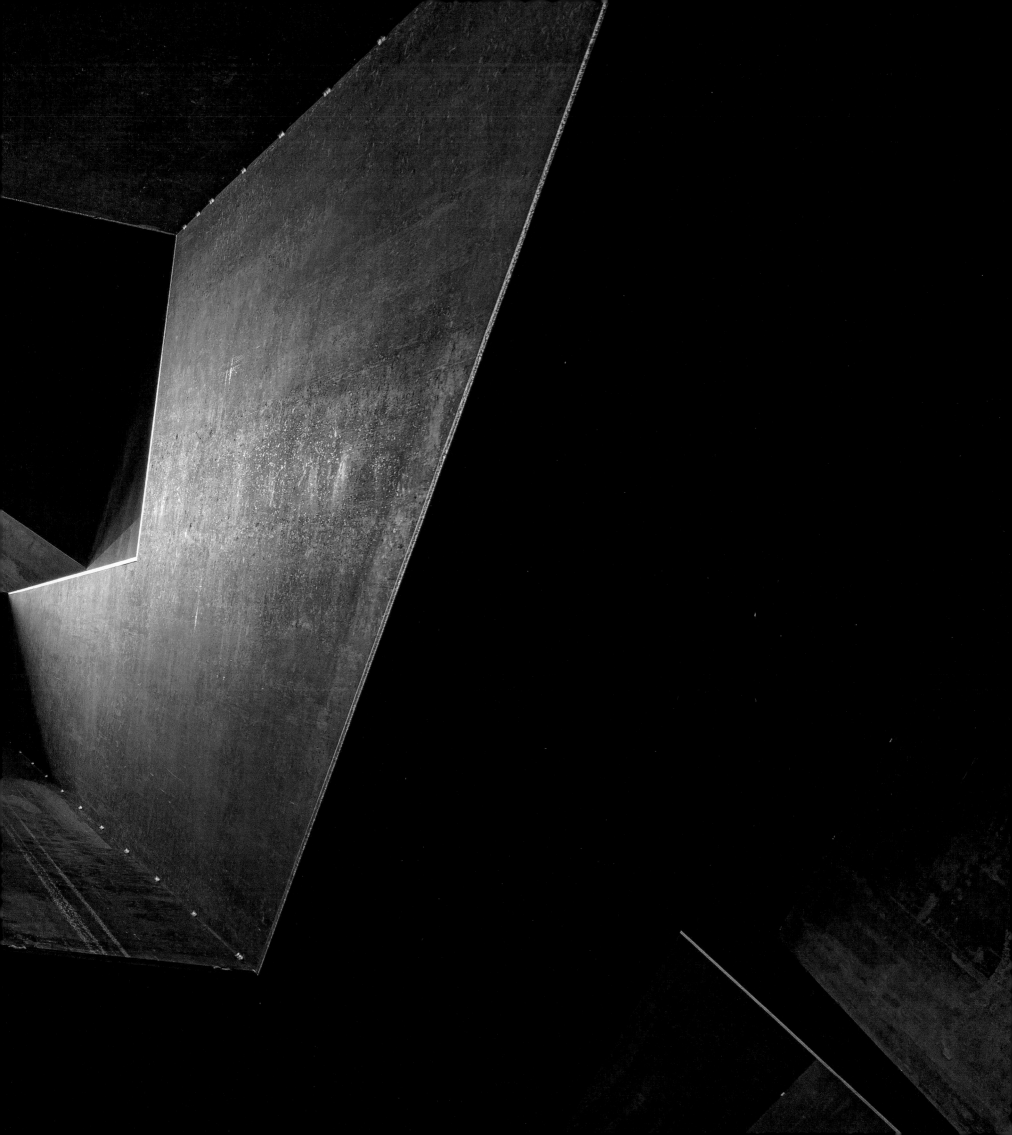

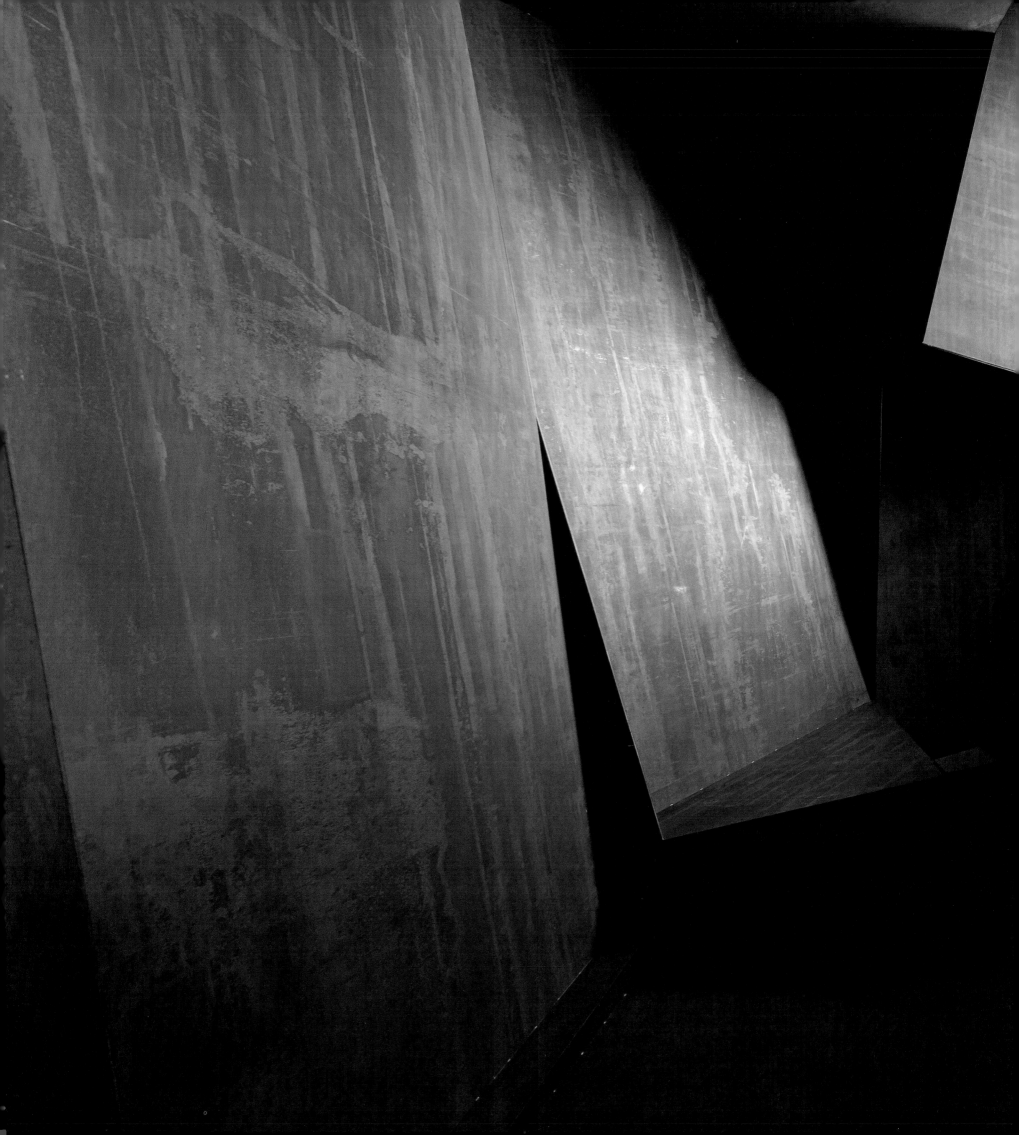

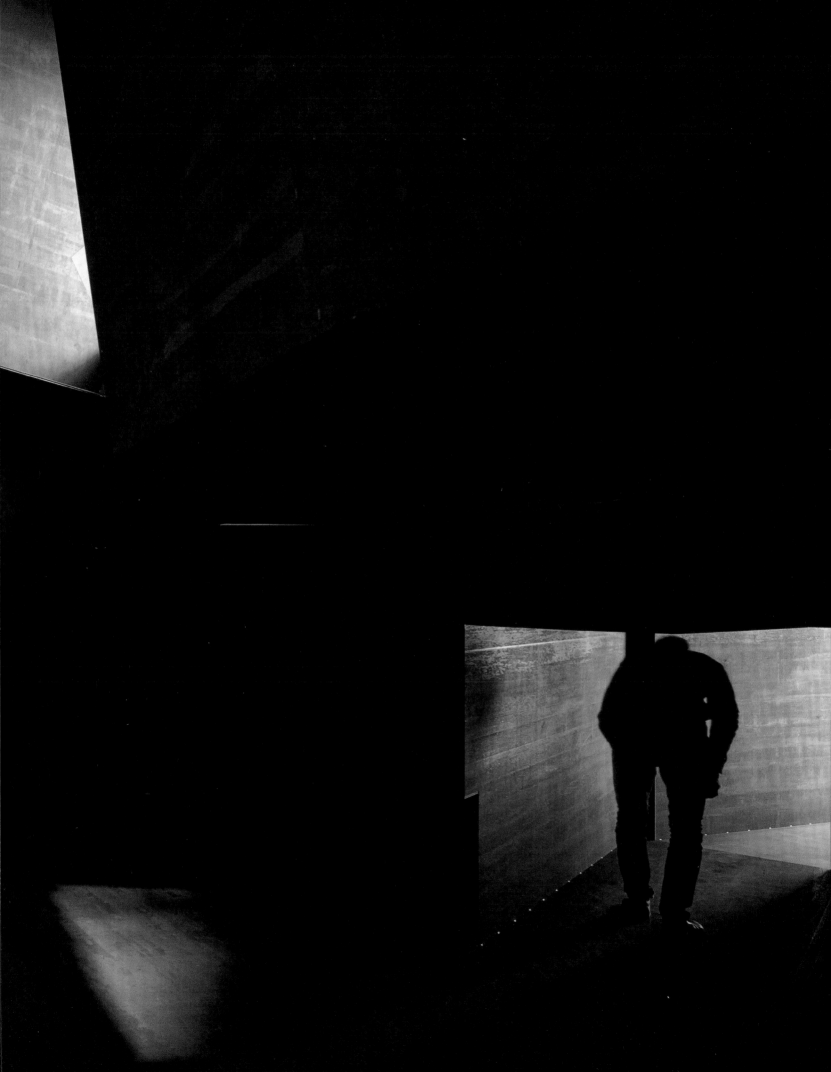

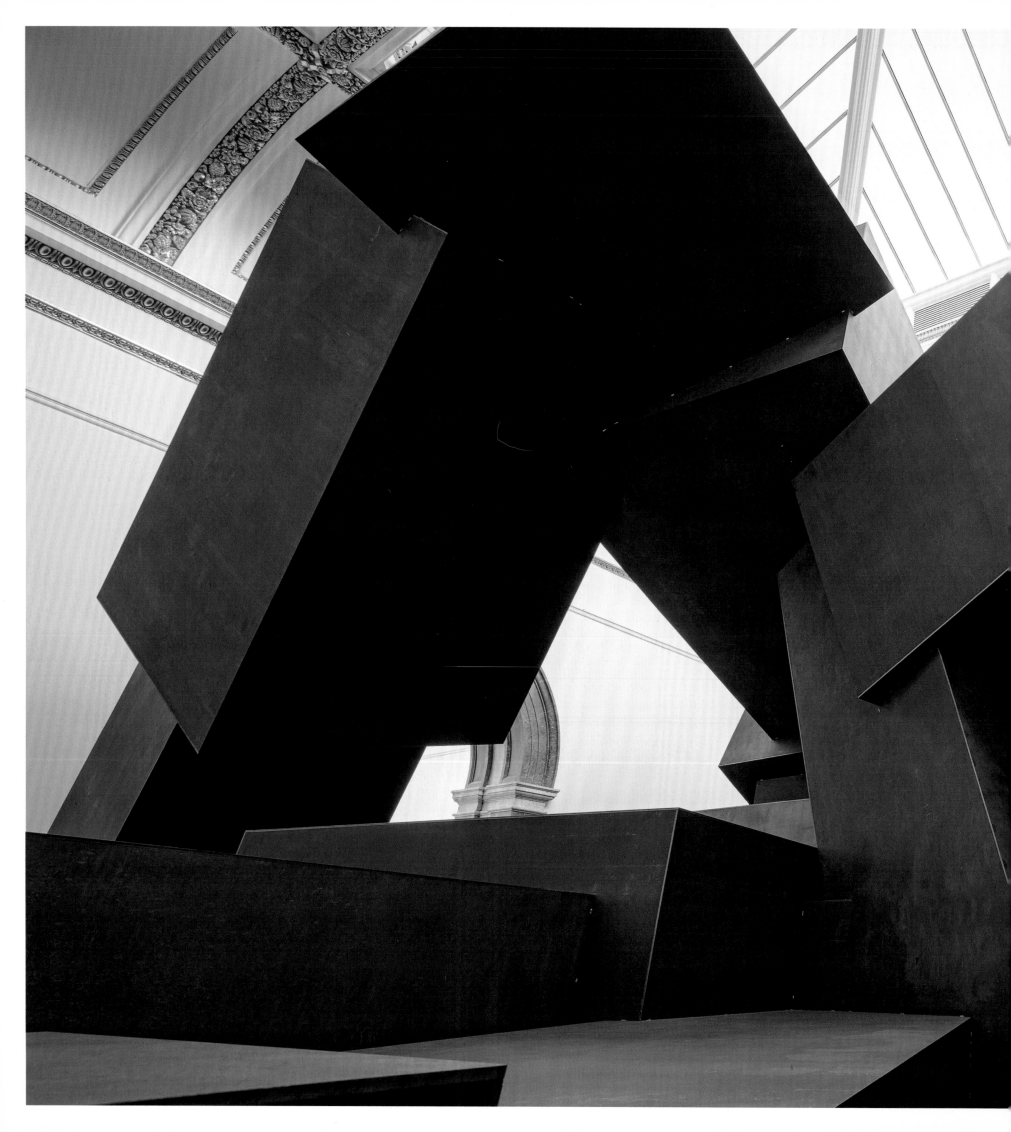

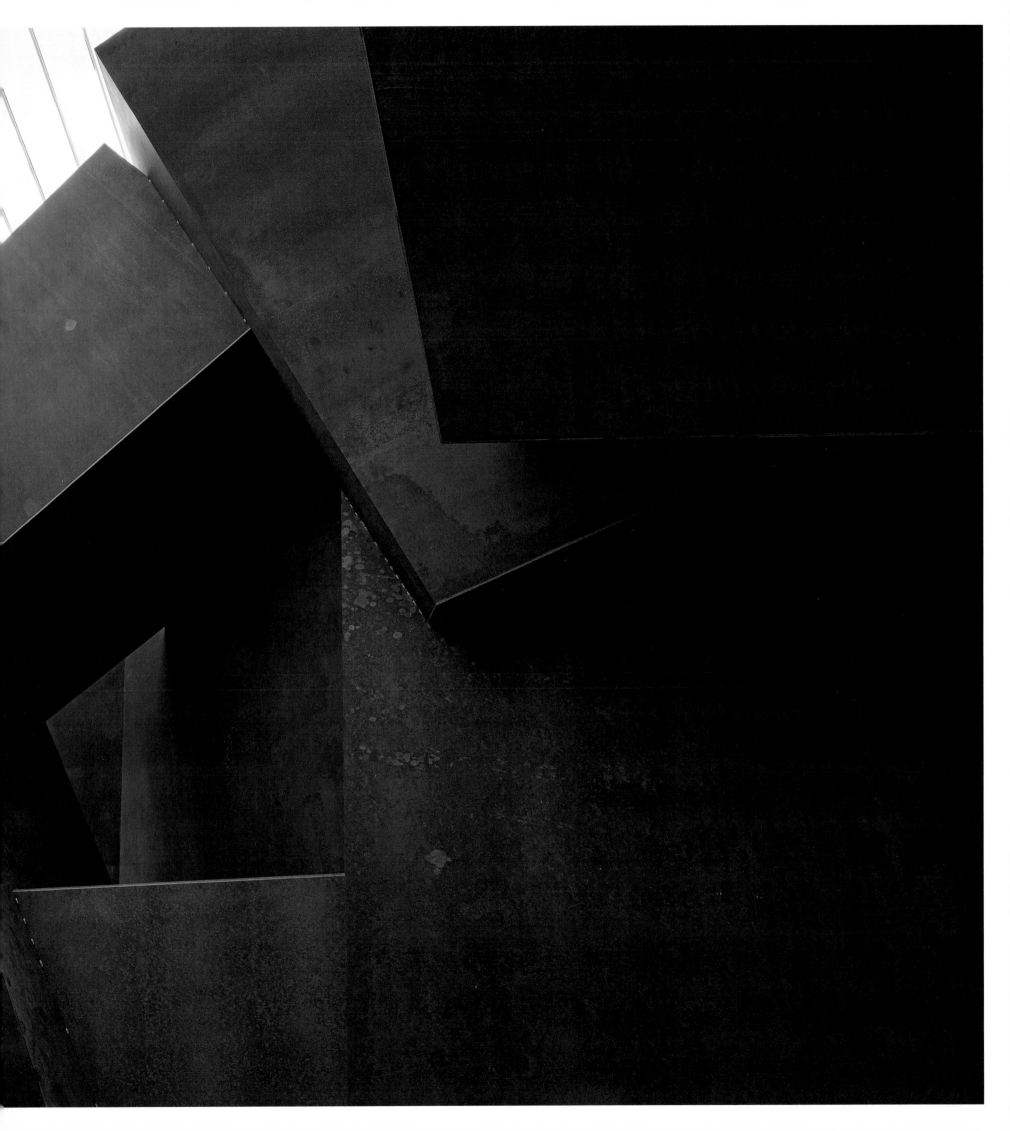

Red Earth Drawings

Made with a rich red earth found originally in the Lot region of France, mixed with rabbit-skin glue and water and overlaid with black pigment, these drawings imagine, prefigure and, later, recall Gormley's first encounter, in 1989, with the interior of a continent, the Great Australian Desert, which he saw on the ground and from the air. The red earth – a material used for image-making since prehistoric times – serves here both as subject and as medium; Gormley makes a strong link between the stuff taken from the ground and the place from which it comes. Often, the mark of a standing figure is set against an insistent horizon in a space of uncertain scale, asserting an identity between the two, marking an encounter and a passage of the body in space and time.

Untitled, 1988
Blood on paper,
20.5 × 22.5 cm

Tribe, 1988
Blood and oil on paper,
38 × 28 cm

Meaning, 1986
Blood on paper,
38 × 28 cm

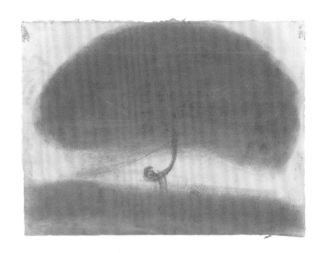

Placenta, 1987
Earth on paper, 28 × 38 cm

Cells, 1993
Earth and rabbit-skin glue
on paper, 28 × 38 cm

Growth, 1993
Earth and rabbit-skin glue
on paper, 19 × 28 cm

Heart, 1993
Earth and rabbit-skin glue
on paper, 19 × 28 cm

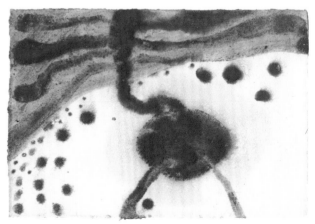

Brain, 1992
Earth and rabbit-skin glue
on paper, 28 × 38 cm

Branches, 1992
Earth and rabbit-skin glue
on paper, 28 × 38 cm

Untitled, 1989
Oil, pigment and blood
on paper, 38 × 28 cm

Horizon, 1987
Black pigment, linseed oil and
blood on paper, 38 × 28 cm

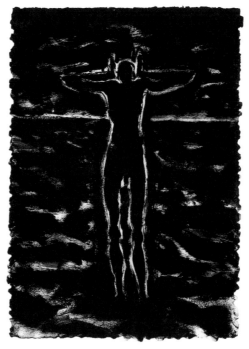

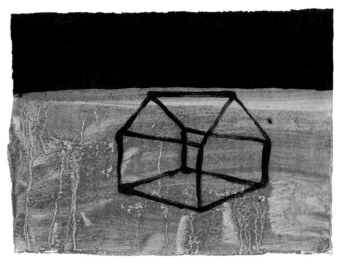

Mercia, 1987
Black pigment, linseed oil and
charcoal on paper, 28 × 38 cm

In and Beyond, 1985
Black pigment, linseed oil and
charcoal on paper, 38 × 28 cm

Home and the Underworld, 1989
Earth, rabbit-skin glue and black
pigment on paper, 28 × 38 cm

Structure II, 1989
Earth, rabbit-skin glue and black
pigment on paper, 28 × 38 cm

According to the Earth, 1989
Earth, rabbit-skin glue, oil and black
pigment on paper, 28 × 38 cm

Two Persons Reluctant to Be Born, 1989
Rabbit-skin glue, earth, oil and
black pigment on paper, 38 × 28 cm

Strata, 1989
Earth, rabbit-skin glue and black
pigment on paper, 28 × 38 cm

Continent, 1989
Earth, rabbit-skin glue, oil,
black pigment and charcoal
on paper, 38 × 28 cm
Private collection

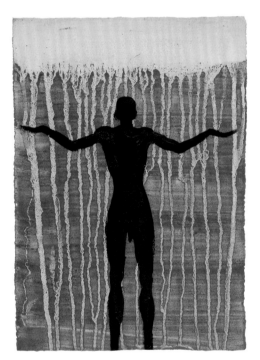

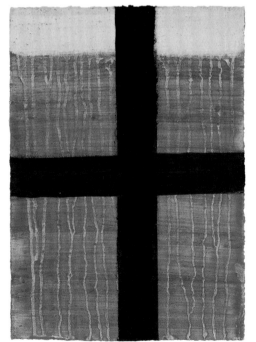

Creating the World, Dividing the World II, 1989
Earth, rabbit-skin glue and black pigment on paper, 28 × 38 cm

Black, 1989 (detail on page 229)
Rabbit-skin glue, earth and black pigment on paper, 28 × 38 cm

Flesh, 1989
Rabbit-skin glue, earth and black pigment on paper, 38 × 28 cm

Place, 1989
Earth, rabbit-skin glue and black pigment on paper, 28 × 38 cm

Threshold, 1987
Earth, rabbit-skin glue and black pigment on paper, 38.5 × 27.5 cm

Earth, Body, Light, 1989
Earth, rabbit-skin glue and black pigment on paper, 38 × 28 cm

Point II, 1989
Earth, rabbit-skin glue and
black pigment on paper,
38 × 28 cm

Home Box, 1989
Earth, rabbit-skin glue and
black pigment on paper,
38 × 28 cm

Home, 1990
Blood on paper, 28 × 38 cm

Reflection XXIII, 2017
Crude oil on paper, 38 × 28 cm

Reflection XXII, 2016
Crude oil on paper, 38.1 × 28 cm

Reflection XXI, 2016
Crude oil on paper, 38.1 × 27.4 cm

Reflection XX, 2016
Crude oil on paper, 38 × 27.8 cm

(Opposite) *Reflection XIX*, 2016
Crude oil on paper, 38.2 × 28 cm

Clay Works

Pile I and Pile II signal a return to Gormley's long engagement with clay as a material, which goes back to the 1980s and resulted most spectacularly in the multitudinous small figures that made up the various installations of Field. Here, they are single bodies, life-size, bunched – one sitting, one lying – recalling in their pose the Slabworks at the start of the exhibition. Here, though, the hard-edged precision of those smelted steel forms, products of industrial process, gives way to something more primal, provisional. Pile I and Pile II are, as their titles suggest, loose assemblages of body parts, head, neck, shoulder, chest and limbs, made of raw material, slabs of wet clay cut, wedged, loosely rolled and casually stacked, almost thrown together, their slumped, heavy forms moulded by the soft touch of their constituent parts one on another. The low-temperature firing of the clay effects the most minimal transformation of the base material; the works appear to retain a softness that extends also to their emotional register. In comparison to the abjection of the Slabworks, these body forms appear almost at rest, as if dreaming.

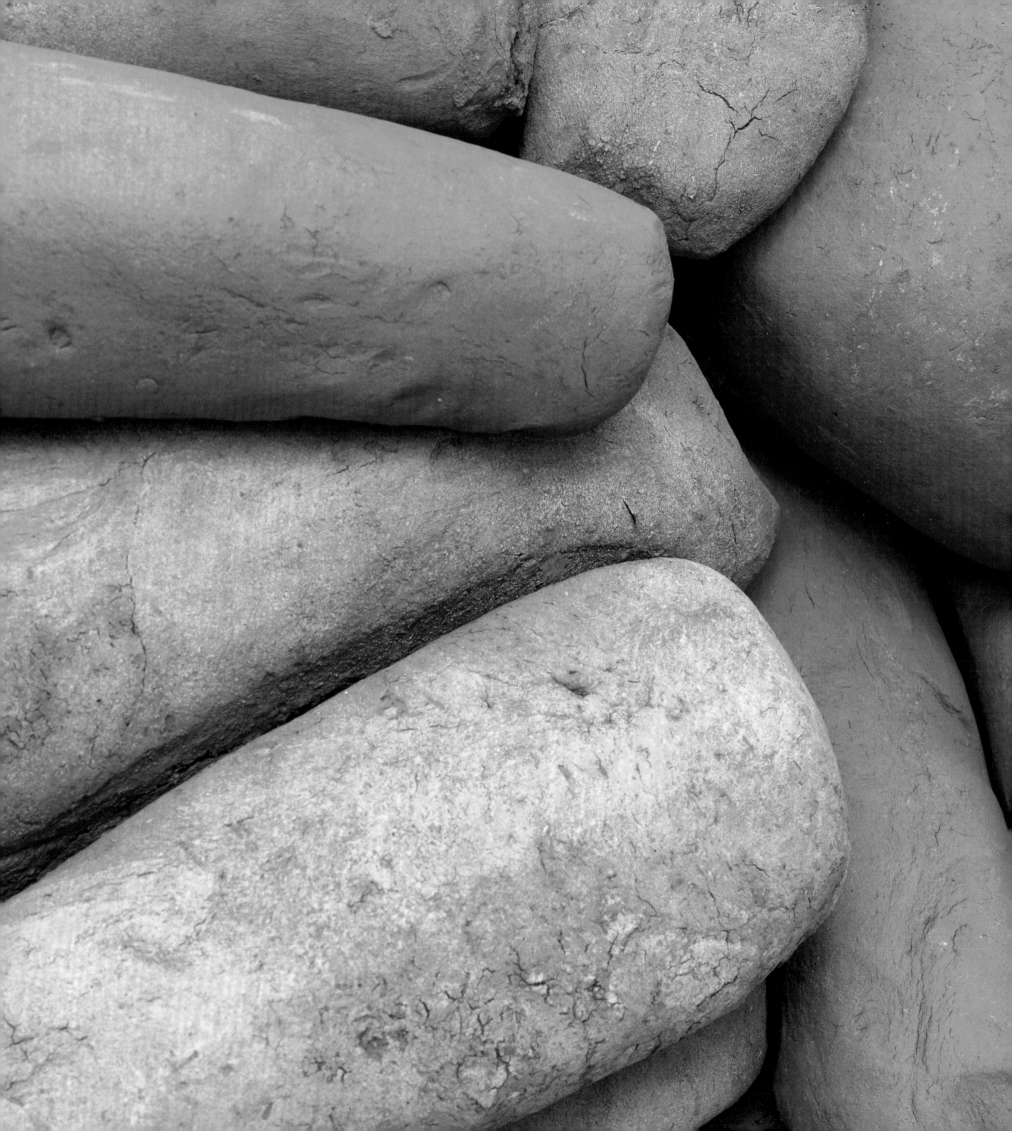

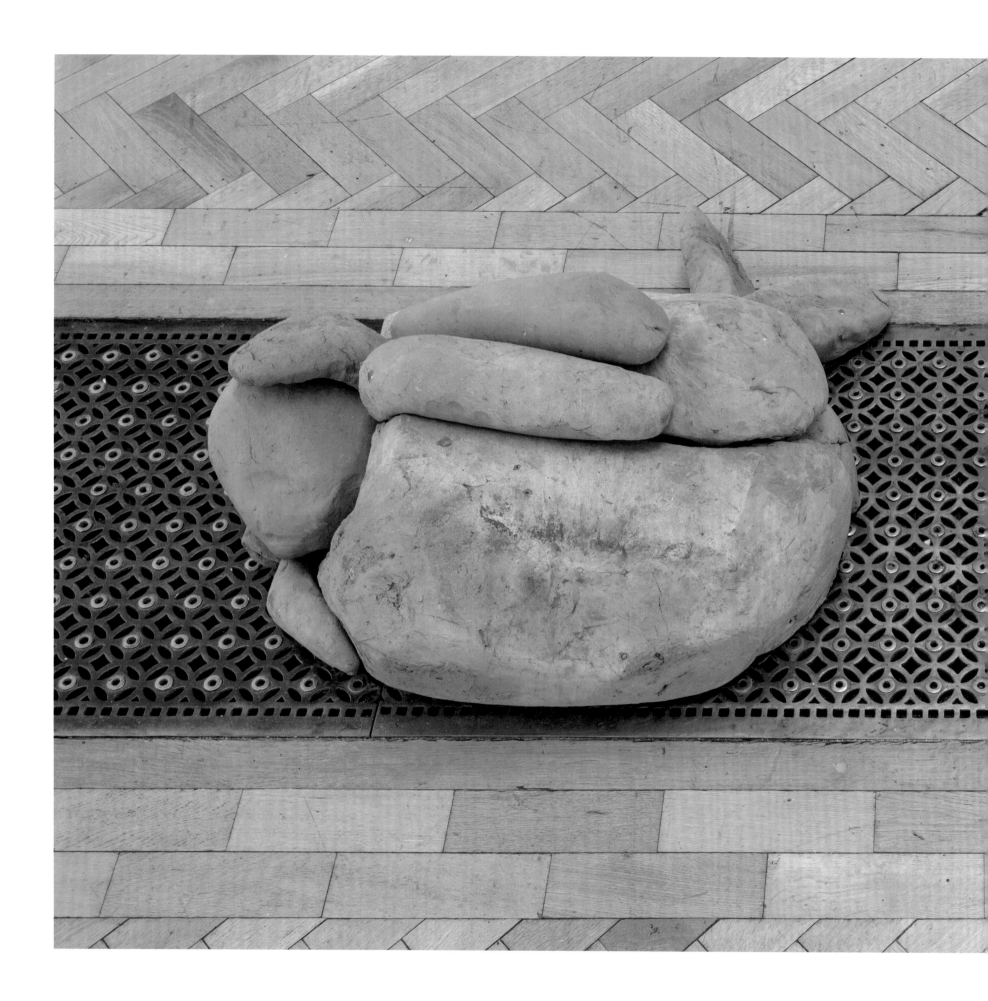

Pile II, 2018 (detail on page 247) *Pile I*, 2017
Clay, 34.7 × 71.9 × 71.9 cm Clay, 37.4 × 73.5 × 69.7 cm

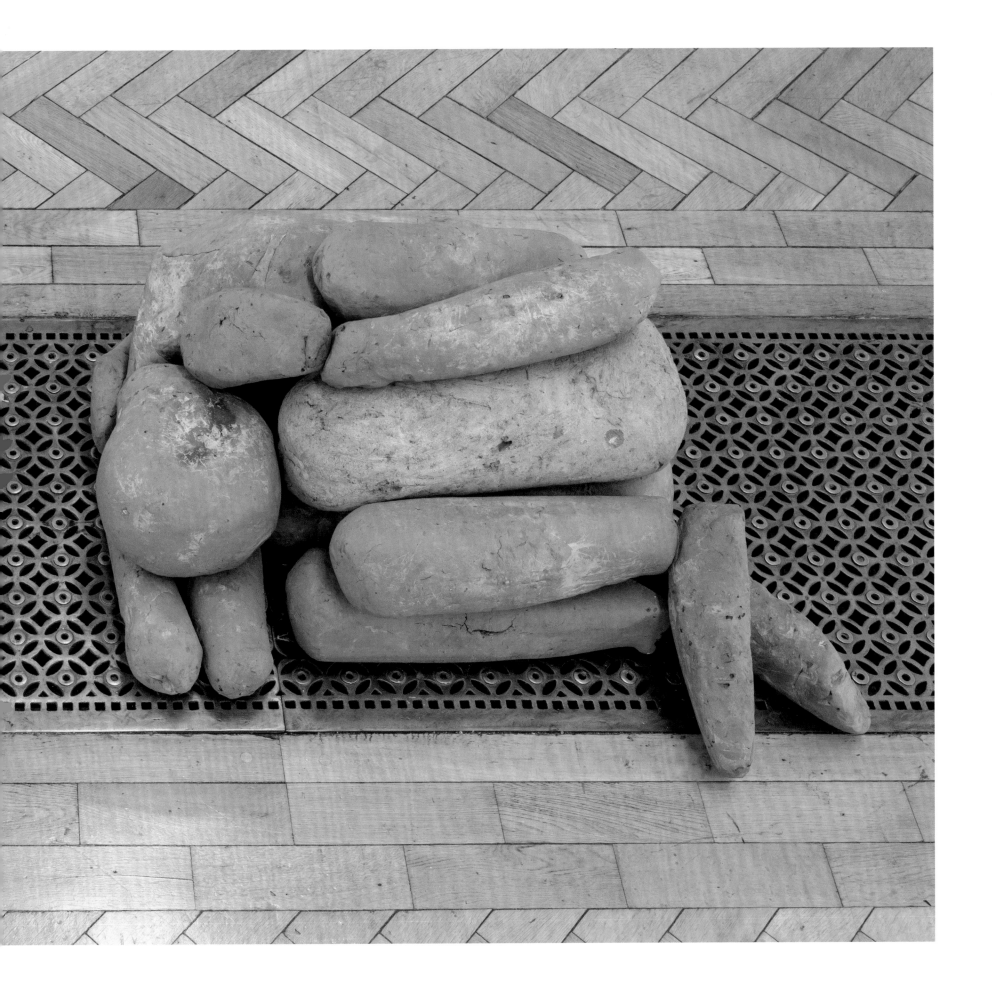

Host

Host completes the exhibition's trajectory, in its return to raw material, the stuff of the earth, its stark presentation of the unformed. Viewed from a threshold at one end of the last gallery – the Royal Academy's double-height Lecture Room – *Host* extends before you, immediate and visible in its entirety. It is a vast liquid expanse, an admix of equal parts earth and Atlantic seawater, flooding the gallery to a depth of 23 centimetres. A raw, uncanny occupation of space, the work unavoidably asserts the presence of the organic and the elemental in an exhibition of constructed environments and architectural reference. *Host* is 'the outside brought inside', as Gormley puts it, a *tabula rasa* and an evocation of the world yet to be acted upon. It enacts a still, silent assault on the senses as earth, air and water exchange their elements, exuding a rich organic smell; its red-brown surface reflects the shifting conditions of natural light as time passes. *Host* offers another horizon, though one framed by four walls; as such it could be read as a canvas laid down, a painting in two dimensions, or as a three-dimensional sculptural form – as an alien addition to the space, a deposit, or as a subtraction, an emptying out.

Host, 2019 (pages 251–57)
Buckinghamshire clay (51° 44' 52.5" N 0° 38' 42.6" W) and Atlantic seawater, dimensions variable

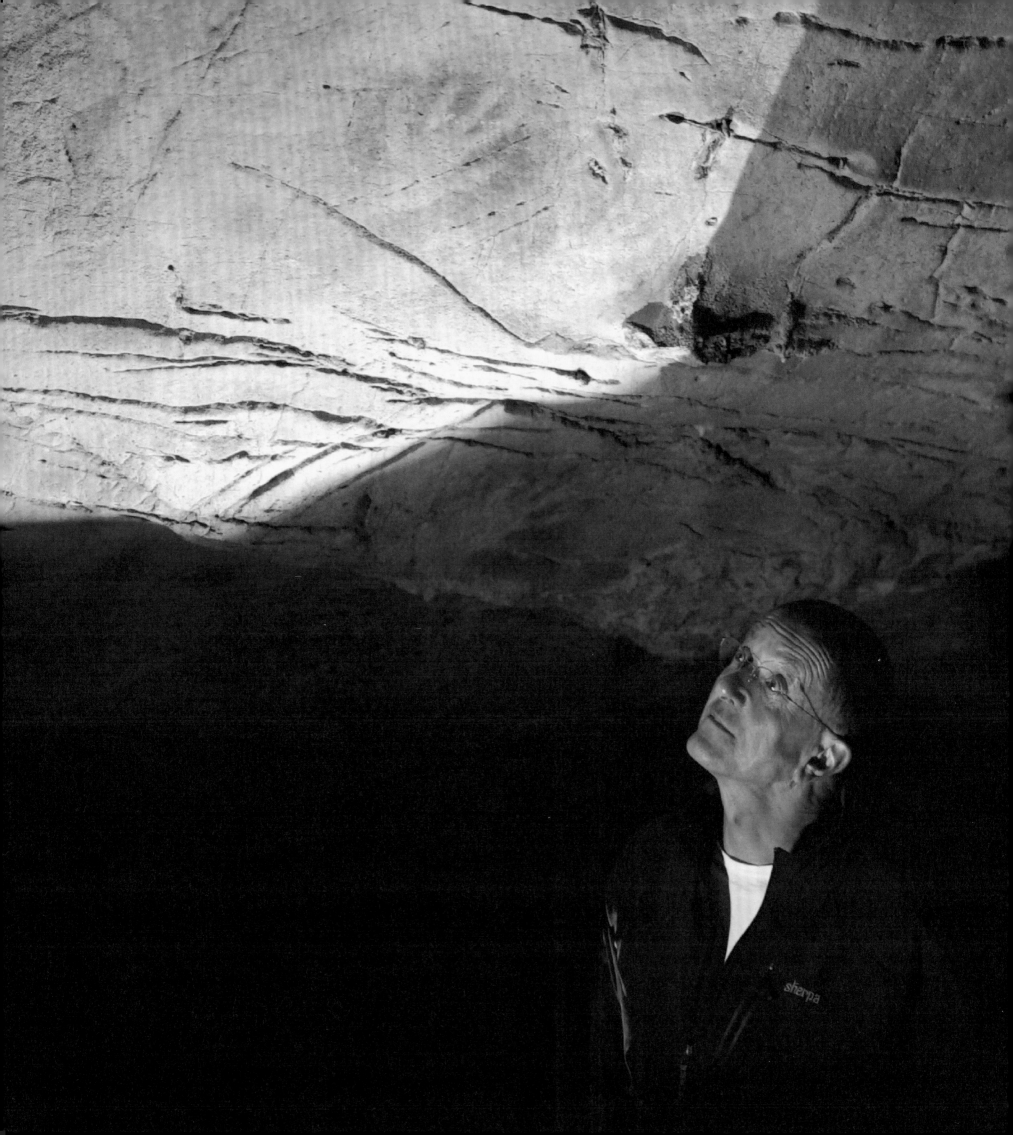

Chronology

Helen Luckett

1950
Born in London, the youngest of seven children. His parents are devout Catholics.

1951–60
Childhood in Hampstead Garden Suburb. Daily life is rigidly ordered; the experience of enforced afternoon rest endured from a young age, where 'eyes closed, I am released into a space that is cool and infinite', will later become fundamental to his work. Seeing the immense head of Ramses II on family visits to the British Museum leaves vivid memories, as do the excavations at Fishbourne Roman Villa near his grandparents' seaside home in West Wittering, Sussex – where he spends summer holidays, is given a rowing boat and learns to sail. In London, he takes possession of a garden shed as a personal laboratory and museum.

1961–1968
Education at the Benedictine public school, Ampleforth College, where the wide open spaces, 'weather and moors, heather and forests and deep winters of North Yorkshire are like a huge door opening in my imagination'. Father Dominic Milroy introduces him to French literature and critical thinking, inviting George Steiner to lead a memorable seminar on John Crowe Ransom; Walter Shewring teaches him classics and introduces him to the work of Eric Gill and Ananda Coomaraswamy. He spends afternoons immersed in silent concentration during sculptor John Bunting's drawing classes, where he discovers Modernist sculpture and poetry. Father Ambrose teaches him woodwork, advising: 'let the saw do the work; go with the feel and pace of the tool.'

1968–1971
Cambridge. He goes up to Trinity College to read archaeology and anthropology in October. Weeks later, he takes part in a big anti-Vietnam demonstration in London and joins a student protest in Cambridge against visiting speaker Enoch Powell, who advocated the repatriation of immigrants. Intrigued by his father's tales of India and inspired by Jiddu Krishnamurti's writings, Coomaraswamy's *Dance of Shiva* and the *Tibetan Book of the Dead*, he goes to India for the first time in the summer of 1969, travelling through Iran, Afghanistan, Pakistan and Kathmandu. Back at Cambridge, he starts the second part of his tripos in art history. The following summer he visits the great sites in Turkey, Syria, Lebanon and Egypt, spending an unforgettable hour lying in the Tomb of Cheops in the Great Pyramid of Giza.

Antony Gormley in the cave of El Castillo, Cantabria, Spain, presenting the BBC Two documentary 'How Art Began', directed by Morag Tinto, first aired January 2019

1971–1974
India. After graduating, he travels east again, via the Levant. In Iraq he is arrested as a spy, briefly imprisoned and expelled from the country. In Afghanistan, he sits on the head of the then intact great Bamiyan Buddha, 2,500 metres above sea level. In Sri Lanka, he finds the ancient rock fortress of Sigiriya and the giant reclining Buddha carved from the rockface at Polonnaruwa. He spends time in the mountainous region of Northern India, in Dalhousie and Bihar, where he studies Vipassana meditation with S. N. Goenka. Gormley will come to regard this as the single most important experience of his life: 'he taught us how to focus *vedana* which is Pali for "feelings" or "sensations", experiencing the body as a zone or place.' Enrolling in the Kargud monastery in Sonada, Western Bengal, he takes *dharma* classes with Kalu Rinpoche. A decisive moment occurs when he is taught Chinese brush drawing in Kalimpong by Shen, a refugee from China's Cultural Revolution. Having seriously considered becoming a Buddhist monk, the daily activity of drawing is revelatory and 'seems to combine all the elements of freedom and control that I have been juggling with'. He returns to the UK in April 1974, determined to be an artist.

1974–1975
London. On his return from India, he establishes a squat in Clerkenwell and, with a friend, transforms an old warehouse into a studio for about 20 artists in King's Cross Road, where he will work for six years. He sees Martin Naylor's scarecrow-like *Discarded Sweater* and Michael Craig-Martin's act of transubstantiation, *An Oak Tree*, at the Rowan Gallery and is 'utterly amazed'. In autumn 1974 he enrols at the Central School of Art, where he makes experimental works in clay and found materials and learns to cast in the school's foundry. His first 'serious works' (since destroyed) are created by draping plaster-soaked sheets over recumbent bodies, recalling shrouded street sleepers in India. In summer 1987, at the Hayward Gallery's 'Condition of Sculpture' exhibition, works by Richard Serra, Paul Neagu and Christopher Wilmarth make a powerful impact.

1975–1977
In the autumn, he transfers to Goldsmiths College, experiencing deep immersion in 'two very different ideas of what art was and how it could work on and in the world'. His tutors include figurative sculptor Michael Kenny and the 'poetical monument-maker' Ivor Roberts-Jones as well as Richard Wentworth, Michael Craig-Martin and Carl Plackman – 'very conceptually-orientated, interested in Chomsky, structuralism and notions of artistic language'. Martin Naylor, a visiting tutor, becomes a mentor, providing 'a sense of freedom about what art could be: that it could be poetic and dangerous'. During summer vacations, Gormley works at a

farm in the Brecon Beacons, where he engages directly with the land and makes large concrete outdoor sculpture. In spring 1977, visionary sculptor and architect Walter Pichler's exhibition at the Whitechapel Gallery precipitates Gormley's lasting engagement with architecture. After graduation, Gormley tours Ireland with his brother Michael, visiting megalithic sites.

1977–1979
Studies at the Slade School of Fine Art and teaches part-time at Southend School of Art. Starts carving in stone and wood, 'taking things apart, dealing with matter, with things I come across.' In spring 1978, 'Carl Andre: Sculpture 1959–78' at the Whitechapel Gallery impresses him by the objective qualities and constraints of the materials, including timber, steel, copper and bricks. Crucially, Gormley begins to explore the potential of lead as a sculptural material, beating sheets of it around rocks and other objects, using boxwood hammers and dressers. His Slade Postgraduate Sculpture show includes *Bread Line* (1979) – 'a loaf of bread laid out one bite at a time … a measuring of life, the distance we go' – and his first lead sculptures: *Full Bowl* (1977–78, a nest of 40 bowls, beaten one inside the other) and *Land Sea and Air I* (1977–79, based on a granite stone found in Connemara, which he later considers to be the foundation of his work).

1979
He meets artist Vicken Parsons, a painting student at the Slade who will soon become his lifelong partner and collaborator. Awarded Boise Travel Scholarships, they both elect to go to the States. Gormley travels ahead; he works at Sotheby's in New York; spends time with Mark Lancaster; experiences Walter De Maria's *Earth Room*; visits Isamu Noguchi and Richard Serra and sees Serra's lead *Splash Piece: Casting* at Jasper Johns's studio. Parsons joins him on a road trip across the States. In New Mexico they see Walter De Maria's *Lightning Field*, spending days 'released into this high desert that had been somehow transformed by the presence of these space-age, surgically cool needles; space, light, time, temperature all meant something there'. In Death Valley, Arizona, close to the site of De Maria's *Mile-Long Drawing*, Gormley creates *Rearranged Desert* and other sculptural actions.

1980
London. Now working independently, he takes part in his first international group exhibition, 'Nuova Immagine' (New Image), the 16th Milan Triennial. He and Parsons marry in June and spend their honeymoon in France, visiting the passage grave of Gavrinis; the 6,000-year-old tombs and standing stones at Carnac; the long alignment of fallen dolmens at Locmariaquer; and Palaeolithic cave art in the Dordogne and the Lot Valley. During this year he begins working on *Bed* (1980–81), drying and preserving some 8,500 slices of Mother's Pride bread to create a layered slab in which the traces of two embedded figures are voids equalling his own body volume, which he has eaten.

1981
In March, Nicholas Serota gives him his first significant solo exhibition at the Whitechapel Gallery; in July, 'Antony Gormley: Two Stones', at the Serpentine Gallery, features his first commission, two sculptures made for Singleton Village, Kent. In the summer, he takes students from Maidstone College of Art to the Yorkshire Dales, organising a 'drawing on the land' project which could only be seen from the air, in a hired plane. He is struck by the power and presence of Jacob Epstein's work *Elemental* (1932) in the huge survey exhibition 'British Sculpture in the Twentieth Century' at the Whitechapel, which includes Gormley's *End Product* (1979), a seed shape carved from the stump of an elm. He initiates a series of large-scale brush drawings in oil and begins creating hollow lead forms from moulds of his own body; the first of these – the start of a long succession of lead 'body cases' – is the tripartite *Three Ways*.

1982
Shortly before his first child, Ivo, is born in April, Gormley photographs the second of his three-part body-case works, *Land Sea and Air II*, by the sea at West Wittering, seeing it as 'a body that is empty, that invites imaginative inhabitation but invites connectivity with the world of the elements.' In the summer, *Three Ways* (1981) is shown in 'Aperto '82' at the Venice Biennale. These early lead works 'relate to the body in the same way that a violin case relates to a violin: they follow the contours and evoke the presence of the object but do not describe it'. The family moves to a house in Peckham, where he builds a garden studio for making works using plaster and lead.

1983
In the summer, he takes students from Brighton School of Art to Tout Quarry, Portland, and carves *Still Falling* on the cliff face. His lead body-case works are included in exhibitions of new sculpture at home and abroad alongside his contemporaries Richard Deacon, Alison Wilding, Tony Cragg, Bill Woodrow, Anish Kapoor and others in 'The Sculpture Show' at the Hayward Gallery; 'New Art' at the Tate and the British Council's 'Transformations: New Sculpture From Britain', which opens at the São Paulo Biennial. In an important early interview in *Aspects* magazine, he establishes his ground: 'I am now trying to deal with what it feels like to be human … I want to talk about the relationship between the space outside and the space inside the body.'

1984–1985
During 1984 he has solo exhibitions at Salvatore Ala in New York (his first with a commercial gallery) and at the Riverside Studios in London, and participates in group shows at MoMA, New York, and in Japan, which he visits for the first time; later, he finds 'this extraordinary place, which seems to breathe at a different rate, has totally marked my imagination and my soul'. He attends the opening of 'Transformations' in Mexico City and travels around the country; his exposure to the power and paranoia of Aztec art and the tribal cultures of the Chiapas villages is the beginning of a long, ongoing dialogue with Mexico. At home, he makes a series of works

involving extended body forms with extraordinary proportions like those experienced in dreams or hallucinations. 1985 sees his first drawing show at Salvatore Ala; drawing is a daily activity and 'the laboratory of my work': 'It's a touchstone. It's a balancing and meditation instrument … literally the foundation of my sculpture.' This period of intense work and visibility does not go unnoticed; he is soon approached by other younger gallerists including Xavier Hufkens, Thaddaeus Ropac and – later – Jay Jopling with whom he forms strong and lasting partnerships. In June his second son, Guy, is born.

1986–1987
Surmounting a former slag heap overlooking Stoke-on-Trent, *A View: A Place* – his first lead body case installed in the public realm – forms part of the city's 1986 Garden Festival. Later this year, he launches another public project, a proposal for a 33-metre-high *Brick Man*, planned for the derelict 'Holbeck Triangle' site outside Leeds railway station. In 1987, at the height of the 'Troubles', he is commissioned to make a public work for Derry, Northern Ireland: three double cruciform figures, his first cast-iron sculptures, placed at particular locations on the city walls. During its installation the work is publicly attacked and one sculpture is set alight; this, in his view, is 'the work as poultice drawing violence and evil onto itself,' diverting harm from elsewhere. In January, Channel 4 broadcasts 'State of the Art: Ideas and Images in the 1980s'; one part focuses on Gormley and Parsons in his Peckham studio, filming the body-moulding process in progress. In February, he shows five works at the Serpentine Gallery, featuring hollow forms that are 'vessels' for the imagination. In Japan, he shows drawings in Seibu Gallery in Tokyo; in Germany, he takes part in 'Documenta 8' in Kassel. In July, his daughter Paloma is born. In October, the Great Storm demolishes his sublet studio in Acre Lane, Brixton, destroying two years' work, and blows out the windows in his new studio at Bellenden Road in Peckham, then under construction.

1988–1989
The new purpose-built studio designed by Eric Parry at Bellenden Road is completed. His first exhibition in Los Angeles opens at the Burnett Miller Gallery; he spends time with sculptor Charles Ray. In Germany, *Out of the Dark* – a hollow ductile iron figure that he describes as 'enclosed darkness made visible' – is commissioned as a public work for Kassel. The proposed *Brick Man* – an important precursor to the *Angel of the North* – is refused planning permission by Leeds City Council, who had commissioned the project. In 1989, time spent in Denmark preparing his solo show at Louisiana Museum of Modern Art compels him to seek out his Danish ancestry: he visits the massive carved runestones raised by King Gorm the Old at Jelling in the heart of Jutland. Back in London, wanting to find 'a new way of making which goes back to what art was before it was called art', he works on the first *Field*, consisting of 156 hand-high clay figures made by Gormley and his assistants and shown at Salvatore Ala in New York. Later that year a second *Field* with 1,100 figures is made in Sydney with the help of art students and installed at the Art Gallery of New South Wales. In Paris, he is impressed by Jean-Hubert Martin's seminal exhibition

'Magiciens de la Terre', which represents 'a release both from the rigid conceptual frameworks of post-Minimalism and a recognition of material thinking outside Western art historicism'.

1990–1991
The family moves to a larger house near Camden Town. Gormley begins a series of works using the 'lost wax' process, casting body-shaped voids inside concrete blocks. Traces of the body are visible, inviting the viewer's imaginative inhabitation of the hollow interior. In September he shows in Stockholm at Galerie Nordenhake where he is introduced to the Scandinavian art scene and to Polish sculptor Mirosław Bałka, whose installation at the 1990 Venice Biennale strongly affects Gormley: 'the simple traces of an artist's life made out of old bits of wood … the sense of a life already lived and lost and half-remembered.' In December, with the support of the British Council, he works with Gabriel Orozco and Mexican brickmakers and their families to produce a field of 35,000 small, simply-formed terracotta figures. In March 1991, this *American Field* fills the Salvatore Ala Gallery in New York before touring the US, Mexico and Canada. In May, it goes to Charleston, South Carolina, as part of Gormley's contribution to 'Places with a Past', an international exhibition of site-specific sculpture. He selects the Old City Jail as his site and makes *Fruit* (using crushed shells from the oyster middens) and *Host* (flooding a large communal cell with pluff mud and sea water from the harbour).

1992–1993
In January 1992, as a guest of the Goethe Institute in the Amazon Basin, he generates another large version of *Field*, working with adults and children from the favelas of Porto Velho. This is for the exhibition 'Arte Amazonas', held in Rio de Janeiro at the time of the Earth Summit, which he attends. Hearing environmental activists David Suzuki, Stewart Brand, Vandana Shiva speak is inspirational, as is the Tribal Parliament where Indigenous peoples talk about shared problems of land infringement and the loss of native flora and fauna on which they depend, bringing him into direct contact with the relationship between art, land and language. In spring 1993, he works with local families and students at Östra Grevie in Sweden to make *European Field*, which tours Central and Eastern Europe (on both sides of the former Iron Curtain) for the next three years. In September he makes *Field for the British Isles*, working with a local community in St Helens, Merseyside. *Iron:Man* (1993), his meditation on the Industrial Revolution, is permanently installed in Victoria Square, central Birmingham.

1994–1995
Early in 1994, *Havmann* (Man of the Sea) is created for the coastal town of Mo i Rana in northern Norway, close to the Arctic Circle. This 10.1-metre-high body form is his first large-scale stone sculpture, carved from arctic granite near Narvik by Lithuanian stonemasons, and installed in a fjord. In the autumn, he wins the Turner Prize for *Field for the British Isles*. In 1995, at the Remise, a disused tram shed in Vienna, sixty iron body forms, some suspended by their feet and others heaped together on the floor, form

Critical Mass. An 'anti-monument evoking all the victims of the twentieth century,' this is the darkest work he has ever made.

1996–1997
His first major retrospective, 'Still Moving: Works 1975–1996', opens at the Museum of Modern Art in Kamakura, Japan, in the autumn and tours five cities. In November, in Malmö, Sweden, he takes part in 'Betong' (Concrete) with Mirosław Bałka and Anish Kapoor; he makes *Allotment II*, 300 hollow concrete block-like body cases resembling abstracted modernist buildings, based on the dimensions of local people. In 1997 he is appointed OBE for services to public art. At Cuxhaven, Germany, once one of the major ports for emigration to America, he creates *Another Place*, 100 solid iron casts of his own body installed on the beach, looking out to sea. He embarks on the *Insiders*, a series of iron works investigating the body's inner core.

1998–1999
On 15 February 1998, the *Angel of the North* is hoisted into position on the site of the St Anne Colliery in Gateshead, overlooking the main routes into Newcastle. He uses the language of shipbuilding, a regional industry in major decline, to make 'an object that would be a focus of hope at a painful time of transition for the people of the north-east'. It soon becomes an icon. In March 1999 he takes part in a discussion about art and science, meeting Basil Hiley whose ideas about pre-space as a mathematical structure underlying space-time and matter will inform his *Quantum Cloud* works. He makes his first life-size *Quantum Cloud*, which evolves from the form of an *Insider*, with the condensed body encased in a cloud-like open structure of tetrahedral units. This recalls Vipassana meditation, and its experience of 'the dimensionless space of the internal being'.

2000–2001
The thirty-metre-high *Quantum Cloud*, commissioned as part of the British government's Millennium Project, is unveiled at Greenwich Peninsula on 1 January 2000; its galvanised steel matrix has been created using chaos theory and 'fractal growth' computer software. He makes the first *Blockworks*, creating dynamic sculptures from body moulds using small pixel-like blocks. The transition from casting to digital design begins. In Berlin, his commission for the new Bundestag, *Steht und Fällt* (Stands and Falls), is permanently installed in the courtyard of the Jakob-Kaiser-Haus.

2002–2003
Architect David Chipperfield is commissioned to design Gormley's new studio in King's Cross. Echoing the area's industrial vernacular, the seven-bay building provides space and dedicated areas for drawing, metalwork and engineering projects. In April 2002, searching for a site for his commission *Inside Australia*, Gormley flies over Western Australia, discovering that the country from the air 'is like an Aboriginal painting … it reminds me of the age of the planet and how insignificant we are.' He completes the complex and demanding installation in 2003: a series of 51 *Insiders* (derived from local people), positioned far apart in remote

Lake Ballard, a vast, crystalline salt lake near Menzies, 730 km north-east of Perth. Concerned that the work's anthropological context is clear, he asks Hugh Brody, the British anthropologist, to write about and film the project. In January 2003, working with people of all ages from Xiangshan village in southern China, he makes *Asian Field*, comprising some 210,000 hand-sized clay figures; over the next twelve months it is shown in non-art venues in Guangzhou, Beijing, Shanghai and Chongqing. At BALTIC Centre for Contemporary Art in Gateshead, north-east England, he makes *Domain Field* with volunteers, turning solid flesh into quivering, immaterial bodies welded from stainless steel antennae and making a 'collective energy field'. He is elected a Royal Academician.

2004–2005
In April 2004, *Clearing I*, a three-dimensional drawing formed from 5 kilometres of continuous raw metal rod, is developed for White Cube; it arcs around the room, filling the entire space. A long-term partnership forms with Galleria Continua when a permanent work, *Making Space Taking Place*, is commissioned for the Tuscan town of Poggibonsi. In March 2005, he joins the Cape Farewell team for their third fieldwork expedition to the Arctic, highlighting the urgency of climate change. One of twenty artists, scientists and journalists, he shares a bunkroom with Ian McEwan on the converted lightship *Nooderlicht*, locked in ice north of the 79th parallel. *Clearing* travels to New York, where it is shown in Gormley's first exhibition with the Sean Kelly Gallery. Gormley's interest in dance 'as being the most direct medium for the translation of emotion through working with life itself' emerges in the form of a dance collaboration, *Zero Degrees*, a project led by Akram Khan, Sidi Larbi Cherkaoui and Nitin Sawhney, for Sadler's Wells. *Another Place* is installed on Crosby Beach, Merseyside, and becomes one of the most well-loved and widely recognised public art works in the UK.

2006–2007
Breathing Room, an object hovering 'between architecture and an image of architecture', is developed for Galerie Thaddaeus Ropac in Paris in early 2007. Like *Clearing*, it is a drawing in space which the viewer can enter, but consists of straight lines and angles created from square-section aluminium tubing covered in photoluminescent paint: 'it is my conversation with Piero della Francesca or with the idea of the *cité idéale*.' During this year, his work with architects, scientists and others intensifies to realise *Blind Light*, a cloud-filled box in which people appear to vanish, where 'light itself is the opposite of illuminating – it is part of an experience of disorientation'. This is the centrepiece of his Hayward Gallery exhibition, in which *Event Horizon* – 31 body forms installed across the rooftops and walkways of central London – plays a major part. He receives the Bernhard Heiliger Award for Sculpture.

2008–2009
As ideas proliferate and the studio expands, Gormley forms a new relationship with engineers in the development of the *Firmament* works, consisting of room-sized constellations of steel elements and steel balls

welded together. Around now, he meets mathematical physicist Roger Penrose and is inspired by his 'ideas about emergence and chaos theory; the relationship between repeating algorithmic patterns and the evolution of form and structure.' In recognition of the impact that particle physics has had on his art, Gormley donates *Feeling Material XXXIV* (2008) to CERN, the European Organisation for Nuclear Research. Gormley and David Chipperfield collaborate on a concrete pavilion interacting with the surrounding landscape for the Kivik Art Centre, Sweden. In spring 2009, he initiates 'Clay and the Collective Body', a project in Helsinki focused on a gigantic block of clay available for groups of people to make whatever they like. *One & Other*, enacted in the summer in London's Trafalgar Square, invites members of the public to take up hour-long residencies on the empty Fourth Plinth, giving them a platform for anything they choose to do. In June, he presents 'The Essay' on BBC Radio 3; the five episodes feature his heroes Epstein, Brancusi, Giacometti, Beuys and Serra.

2010–2011
A further period of intense work, exhibition-making and public commissions ensues. In the summer, *Horizon Field* – 100 life-size works forming an exact horizontal located at 2,039 metres above sea level – is installed in Vorarlberg in the Austrian Alps for a period of two years. A major drawings retrospective opens at MACRO in Rome in October 2010. During this year, he opens a second studio in Hexham, Northumberland, close to one of the foundries with which he regularly works, and acquires a country house in Norfolk, where studio and living space is provided for artists. Permanent installations include *Exposure*, a vast open-framed crouching figure, constructed by Scottish pylon manufacturers at the end of the IJsselmeer Polder in Holland, and the crouching blockwork, *Habitat (Anchorage)*, in Alaska. For his solo exhibition at the State Hermitage Museum in St Petersburg in 2011, he removes classical statues from their plinths, allowing direct interaction with the viewer, pitting them against an installation of his own raw, industrial iron *Blockwork* sculptures in the adjacent space.

2012–2013
In April 2012, *Horizon Field Hamburg* opens in the immense space of the city's Deichtorhallen: a 50- by 20-metre 'flying carpet' accommodating 100 people slowly oscillates about seven metres from the ground, demonstrating the democratic principle that the movement of one person affects all and vice versa. He conceives *Model*, a monumental new work in Corten steel, as both sculpture and building for White Cube's new space in Bermondsey. During this year he gives a TED talk on 'sculpted space, within and without'; he collaborates with Hofesh Shechter on the dance work *Survivor*; and is awarded the Obayashi Prize for outstanding achievement in activities related to cities. In 2013 he receives the Praemium Imperiale, awarded by the Japan Art Foundation on behalf of the Imperial family.

2014–2015
Awarded a knighthood in the 2014 New Year Honours. At the Zentrum Paul Klee in Bern, he installs *Expansion Field*, an immense 'field' of sixty 'Tankers' – expanded cellular body cases – using 21 different poses to 'attempt a bridge between the darkness of the body and deep space'. The King's Cross studio acquires a body scanner, developed with Roberto Cipolla, Professor of Information Engineering at Cambridge University – a pivotal moment in the development of the work. In 2015, at the Forte di Belvedere overlooking Florence, an installation of 103 life-size iron body forms infiltrates the spaces and terraces, setting up a dialogue between anatomy and architecture. *Chord*, a helical, open column rising four storeys from floor to skylight, is permanently installed in the Massachusetts Institute of Technology. In the autumn, 'Antony Gormley: Being Human', is shown on BBC One, as part of the 'Imagine' series.

2016–2017
Following the decline of the local steel industry, the iron foundry in north-east England that had cast Gormley's work is on the brink of closure, so he takes it over for technically innovative projects of his own. In a solo exhibition at White Cube Bermondsey in October 2016, he shows major new works including *Run*, his largest single casting to date, and *Sleeping Field*, a multitude of small iron blockwork figures forming a vast cityscape. He carries out development work for *Form*, a 4-metre-high, 11-tonne sculpture for the Niels Bohr Centre for Electromagnetic Research in Copenhagen. Completed in 2017, this graphite work balances an unstable blockwork form on top of a cubic mass in which 'there are references to the transformation of material into form (like the *schiavi* of Michelangelo) but also the relationship of all life forms to carbon'. During this year, he regularly visits prisons to meet with men and women offenders, secure patients and detainees, and curates 'Inside' for the Koestler Trust's annual exhibition of work by UK prisoners at the Southbank Centre.

2018–2019
Subject, a site-specific installation named for the first in a new series of single-figure works that map the human body using three co-ordinates, opens at Kettle's Yard, Cambridge, in May. Filming for the BBC Two documentary 'How Art Began', Gormley visits caves in Europe, Indonesia and Australia, where he spends days with the Gwion Gwion rock paintings in Kimberley. Looking at cave art that he first saw on his honeymoon in France in 1980, he says: 'You realise that art was essential, universal, a part of human life from the start. And that's a message that needs to be shouted from the rooftops.' The 75-minute programme is broadcast in January 2019, the start of a year of major exhibitions – in Philadelphia; in Florence, at the Uffizi Gallery; on the sacred Greek island of Delos (the first ever 'conversation' between ancient and contemporary art in this UNESCO World Heritage site); and at the Royal Academy of Arts in London.

All quotations are from Antony Gormley

Endnotes

Human Relations (pages 42–55)
Michael Newman

1 The philosopher Hannah Arendt argues for the importance of 'natality' against the primacy of 'being-towards-death', with the claim that the human being is singular in the very capacity for new beginning. See Hannah Arendt, *The Human Condition*, Chicago, 1998, pp. 26–29, 190–91, and 247 where she writes: 'The miracle that saves the world from its normal, "natural" ruin is ultimately the fact of natality, in which the faculty of action is ontologically rooted. It is, in other words, the birth of new men and the new beginning, the action they are capable of by virtue of being born.'

2 See http://www.antonygormley.com/projects/item-view/id/254. Last accessed 3 July 2019.

3 'Antony Gormley's Seminal Sculpture: Brancusi's *Endless Column*', BBC Radio 3, 16 June 2009, https://www.bbc.co.uk/sounds/play/b00l0yjc. Last accessed 3 July 2019. See also Antony Gormley, *On Sculpture*, Mark Holborn (ed.), London and New York, 2015, pp. 93–103.

4 See Martin Caiger-Smith, *Antony Gormley*, New York, 2017, pp. 210–20, on *Critical Mass* as warning with respect to the Enlightenment. For the place of *Critical Mass* in relation to the dystopian and utopian aspects of Gormley's work, see Richard Noble, 'Stillness, Movement, Space', in *Antony Gormley: Still Moving*, Shanghai, 2018, pp. 15–28. A passage from Elias Canetti's *Crowds and Power* was printed as 'The Language of the Body' in the catalogue *Critical Mass*, exh. cat., Royal Academy of Arts, London, 1998.

5 Claude Lanzmann, *Shoah: An Oral History of the Holocaust: The Complete Text of the Film*, New York, 1985, p. 13.

6 The proposal to call a new geological age the Anthropocene was made by the Nobel Prize-winning chemist Paul J. Crutzen with the marine scientist Eugene F. Stoermer in a statement published in 2000, 'The Anthropocene', *IGBP (International Geosphere-Biosphere Programme) Newsletter*, 41, 2000, p. 17.

7 Victoria C. Gardner Coates, Kenneth D. S. Lapatin and Jon L. Seydl, *The Last Days of Pompeii: Decadence, Apocalypse, Resurrection*, exh. cat., J. Paul Getty Museum, Los Angeles, and Cleveland Museum of Art, 2012, pp. 234–35.

8 For the collapse in the face of the Anthropocene of the distinction between history and nature that formed the basis for the emergence of history as a discipline, see Dipesh Chakrabarty, 'The Climate of History: Four Theses', *Critical Inquiry*, 35, Winter 2009, pp. 197–222.

9 *How Art Began*, presented by Antony Gormley, directed by Morag Tinto, BBC Two, 26 January 2019.

10 See Tobias Capwell and Hannah Higham, *Henry Moore: The Helmet Heads*, London, 2019.

11 'Notes on Gesture', in Giorgio Agamben, *Infancy and History*, London, 1993, pp. 135–40.

12 See Sander L. Gilman, *Stand Up Straight! A History of Posture*, London, 2018.

13 For a brilliant philosophical discussion of posture, where uprightness can signify autonomy and inclination dependence, see Adriana Cavarero, *Inclinations: A Critique of Rectitude*, Stanford, 2016.

14 In her *Passages in Modern Sculpture*, New York, 1977, p. 15, Rosalind E. Krauss states that, in its final version, *The Gates of Hell*, which Rodin worked on from 1880 until his death in 1917, 'resists all attempts to be read as a coherent narrative'. She argues that Rodin takes sculpture in the direction of surface without interiority or an interior organising skeleton.

15 Emmanuel Levinas, *Existence and Existents*, The Hague, 1978, p. 72.

16 See Celeste Farge, Ian Jenkins and Bénédicte Garnier, *Rodin and the Art of Ancient Greece*, exh. cat., British Museum, London, 2018.

17 'Antony Gormley's Seminal Sculpture: Giacometti's *La Place*', BBC Radio 3, 17 June 2009 (last accessed 3 July 2019). See also Antony Gormley, *On Sculpture*, Mark Holborn (ed.), London and New York, 2015, pp. 107–13.

18 For a discussion of the measurement problem in quantum physics that brings out its implications for art and ethics and is based on a non-human-centred relational ontology, see Karen Barad, *Meeting the Universe Halfway: Quantum Physics and the Entanglement of Matter and Meaning*, Durham, 2007, pp. 106–15, 275–87, 331–52.

19 Email to the author, 26 June 2019.

20 For an account of this period in Gormley's life, see Martin Caiger-Smith, *Antony Gormley*, New York, 2017, pp. 36–42.

21 The relation of the need for a standpoint, and for new forms of 'long' history, in relation to the Anthropocene, is discussed in Dipesh Chakrabarty, *The Crises of Civilisation: Exploring Global and Planetary Histories*, New Delhi, 2018, pp. 178–90. The question of standpoint is discussed in Dipesh Chakrabarty, *The Human Condition in the Anthropocene, The Tanner Lectures on Human Values*, delivered at Yale University, 18–19 February, 2015, pp. 142–52, https://tannerlectures.utah.edu/Chakrabarty%20 manuscript.pdf. Last accessed 17 July 2019.

22 Walter Benjamin, *Selected Writings, Volume 4*, 1938–40, trans. Edward Jephcott and others, Harvard, 2006, pp. 392–93.

23 Sophocles, *Antigone*, chorus at beginning of second act, in Friedrich Hölderlin, *Hölderlin's Sophocles*, trans. David Constantine, London, 2001, p. 81.

24 See Sigmund Freud, 'The Uncanny', in *The Standard Edition of the Complete Psychological Works of Sigmund Freud*, Volume XVII, trans. James Strachey, London, 1955, pp. 219–252.

25 Gormley writes in a note to the author, 13 July 2019: 'This height was given by Sonnendach, a rise next to Widderstein at the north-western sector of the proposed field that was adequately above the tree line to afford an open view, essential to the function of the *Horizon Field*.'

26 Carlo Rovelli, *Reality Is Not What It Seems: The Journey to Quantum Gravity*, London, 2016, p. 115.

27 A clear exposition of Whitehead's views, which also makes the comparison with Carlo Rovelli's approach to quantum physics, is provided in 'Alfred North Whitehead', *Stanford Encyclopaedia of Philosophy* (available at https://plato.stanford.edu/entries/ whitehead/). Last accessed 16 July 2019. For the full elaboration of Whitehead's system delivered in the Gifford Lectures, 1927–28, see Alfred North Whitehead, *Process and Reality: An Essay in Cosmology*, New York, 1978.

28 Hannah Arendt, *Between Past and Future: Eight Exercises in Political Thought*, New York, 1968, pp. 265–80 (available at https://www.thenewatlantis.com/publications/ the-conquest-of-space-and-the-stature-of-man). Last accessed 11 July 2019.

29 For the discussion of such a 'planetary' otherness, see Gayatri Chakravorty Spivak, 'Imperative to Re-imagine the Planet', in *An Aesthetic Education in the Era of Globalisation*, Cambridge, Mass., 2012, pp. 335–50; and 'Planetarity', in Barbara Cassin (ed.), Steven Rendall and Emily S. Apter (translation eds), *Dictionary of Untranslatables: A Philosophical Lexicon*, Princeton, 2014, p. 1223.

30 For the idea of sculpture as expanded field, see Rosalind E. Krauss, 'Sculpture in the Expanded Field', *October*, 8, Spring 1979, pp. 30–44.

Unravelling the Invisible Universe:
Colourless, Soundless, Odourless and Painless but Real (pages 56–65)
Priyamvada Natarajan

1 The phrase 'colourless, soundless, odourless and painless' in this essay's title is quoted from Wisława Szymborska's *View with a Grain of Sand*, New York, 1995.

2 The Michaelson–Morley experiment demonstrated that light did not require a medium to propagate, and that its true nature was neither exclusively wave-like nor exclusively particle-like. Their experiment presaged the development of quantum mechanics, which postulated that all particles were simultaneously waves and vice versa.

Selected Monographs and Catalogues

Sight, texts by Dimitrios Athanasoulis, Iwona Blazwick, Fanis Kafantaris, Elina Kontouri, Emily Riddle, and a conversation between Antony Gormley, I. Blazwick and E. Kontouri, Neon Foundation, Athens, 2019

Essere, texts by Eike D. Schmidt, Luca Massimo Barbero, Shen Qilan, Renata Pintus, Max Seidel and Serena Calamai, and Antonio Godoli, Gallerie degli Uffizi and Giunti, Florence, 2019

Subject, text by Caroline Collier. Antony Gormley in conversation with Jamie Fobert and Jennifer Powell, Kettle's Yard, Cambridge, 2018

Critical Mass and Expansion Field, text by Shen Qilan and a conversation between Antony Gormley and Hans Ulrich Obrist, Changsha Museum of Art, Changsha, 2018

Still Moving, texts by Pi Li and Richard Noble, Long Museum, Shanghai, 2018

Antony Gormley, text by Martin Caiger-Smith, Rizzoli International Publications, New York, 2017

Land, text by Jeanette Winterson, The Landmark Trust, Shottesbrooke, 2016

Field for the British Isles, texts by Hugh Brody and Antony Gormley, Hayward Publishing, London, 2016

Antony Gormley on Sculpture, texts by Antony Gormley, Thames & Hudson, London, 2015

Human, texts by Dario Nardella, Sergio Risaliti, Andrew Benjamin, Mario Codognato, Antony Gormley, Arabella Natalini and Marco Casamonti, Forte di Belvedere, Florence, 2015

Expansion Field, texts by Rebecca Comay, Peter Fischer and Andrew Renton, Zentrum Paul Klee, Bern, 2014

Still Being / Corpos Presentes, 2nd ed., texts by Marcello Dantas, Agnaldo Farias, W. J. T. Mitchell and Luiz Camillo Osorio. Antony Gormley interviewed by Marcello Dantas, Centro Cultural Banco do Brasil, São Paulo, 2013

Model, texts by Antony Gormley and Michael Newman, White Cube, London, 2013

Horizon Field Hamburg, texts by Stephen Levinson, Dirk Luckow and Iain Boyd Whyte, Deichtorhallen Hamburg / Snoeck, Cologne, 2012

Horizon Field, texts by Eckhard Schneider, Martin Seel and Beat Wyss, Kunsthaus Bregenz, 2011

Still Standing, texts by Margaret Iversen, Dimitri Ozerkov and Anna Trofimova, Fontanka, London, 2011

Antony Gormley, texts by Martin Caiger-Smith, Tate Publishing, London, 2011

One and Other, texts by Hugh Brody, Lee Hall, Darian Leader, Alphonso Lingis and Hans Ulrich Obrist, Jonathan Cape, London, 2010

Exposure, texts by Karel Ankerman and Christophe Van Gerrewey, he Municipality of Lelystad, 2010

Drawing Space, text by Anna Moszynska. Antony Gormley interviewed by Luca Massimo Barbero, Macro, Museo d'Arte Contemporanea Roma / Electa, Rome, 2010

Antony Gormley, texts by Antonio Damasio, Yilmaz Dziewior, Eckhard Schneider and Marcus Steinweg, Kunsthaus Bregenz, 2009

Antony Gormley, texts by Jorge Contreras and Mark Cousins. Antony Gormley interviewed by Hans Ulrich Obrist, Museo de Arte Contemporaneo, Monterrey, Mexico, 2008

Antony Gormley, texts by Antony Gormley and Richard Noble, SteidlMack, Göttingen and London, 2007

Antony Gormley: Blind Light, texts by W. J. T. Mitchell, Susan Stewart and Anthony Vidler. Conversation between Antony Gormley, Jacky Klein and Ralph Rugoff, Hayward Gallery Publishing, London, 2007

Intersezioni 2: Time Horizon, texts by Bruno Corà, Alberto Fiz, Maria Grazia Aisa and Colin Renfrew, Parco Archeologico di Scolacium, Roccelletta di Borgia, Catanzaro: 2006

Inside Australia, texts by Anthony Bond, Hugh Brody, Shelagh Magadza and Finn Pederson, Thames & Hudson, London, 2005

Mass and Empathy, texts by Paolo Herkenhoff and Maria Filomena Molder. Antony Gormley interviewed by Jorge Molder, Fundaçao Calouste Gulbenkian, Lisbon, 2004

Broken Column, edited by Jan Inge Reilstad; texts by Stephan Bann, Trond Borgen, Kjartan Fløgstad and Siri Meyer, Wigestrand Forlag in cooperation with Rogaland Museum of Fine Arts, Stavanger, 2004

Asian Field, texts by Hu Fang and Richard Noble. Antony Gormley interviewed by Sui Jianguo, The British Council, London, 2003

Domain Field, text by Darian Leader, Baltic Centre for Contemporary Art, Gateshead, 2003

Antony Gormley, texts by Lisa Jardine and Michael Tarantino. Antony Gormley interviewed by Enrique Juncosa, Centro Galego de Arte Contemporanea, Santiago de Compostela, 2002

Antony Gormley Drawing, text by Anna Moszynska, The British Museum, London, 2002

Some of the Facts, texts by Iwona Blazwick, Stephen Levinson and Will Self, Tate St Ives, St Ives, 2001

States and Conditions, texts by Caoimhín Mac Giolla Léith, Brendan McMenamin and Declan McGonagle, Orchard Gallery, Derry, 2001

Antony Gormley, revised edition with an additional essay by W. J. T. Mitchell; Antony Gormley in conversation with E. H. Gombrich. Texts by Antony Gormley, John Hutchinson and Lela B. Njatin. Antony Gormley interviewed by Declan McGonagle, Phaidon Press, London, 2000

Total Strangers, texts by Antje von Graevenitz and Ingrid Mehmel. Antony Gormley interviewed by Udo Kittelman, Edition Cantz, Ostfildern, 1999

Gormley / Theweleit, three-way discussion between Antony Gormley, Monika Kubale-Theweleit and Klaus Theweleit. Introduction by Hans-Werner Schmidt, Kunsthalle zu Kiel and Cuxhaven Kunstverein, Kiel, 1999

Making an Angel, texts by Gail-Nina Anderson, Stephanie Brown, Beatrix Campbell, Neil Carstairs, Antony Gormley and Iain Sinclair, Booth-Clibborn Editions, London, 1998

Critical Mass, Antony Gormley interviewed by George Benjamin, Royal Academy of Arts, London, 1998

Still Moving: Works 1975–1996, texts by Stephen Bann, Daniel Birnbaum, Antony Gormley, Tadayasu Sakai and Kazuo Yamawaki, Japan Association of Art Museums, Tokyo, 1996

Critical Mass, text by Andrew Renton. Antony Gormley interviewed by Edek Bartz. Excerpts from Crowds and Power by Elias Canetti, Stadtraum Remise, Vienna, 1995

Field for the British Isles, texts by Lewis Biggs, Caoimhín Mac Giolla Léith and Marjetica Potrc, Oriel Mostyn, Llandudno, 1994

Field, texts by Antony Gormley, Thomas McEvilley, Gabriel Orozco and Pierre Théberge, The Montreal Museum of Fine Arts / Oktagon, Montreal and Stuttgart, 1993

Antony Gormley, texts by Stephen Bann and Lewis Biggs. Antony Gormley interviewed by Declan McGonagle, Tate Gallery Publications, London, 1993

Learning to See: Body and Soul, text by Masahiro Ushiroshoji, Contemporary Sculpture Centre, Tokyo, 1992

Field and Other Figures, texts by Richard Calvocoressi, Antony Gormley and Thomas McEvilley, Modern Art Museum of Fort Worth, 1991

Five Works, Serpentine Gallery / Arts Council of Great Britain, London, 1987

Antony Gormley, text by Lynne Cooke, Salvatore Ala Gallery, Milan/New York, 1984

Photographic Acknowledgements

All works of art are reproduced by kind permission of the owners. Every attempt has been made to trace copyright holders. We apologise for any inadvertent infringement and invite appropriate rights holders to contact us. Specific acknowledgements are as follows:

Photographic Acknowledgements

Frances Andrijich: fig. 20

Arles, Musée Reattu: fig. 42

Arnaville, courtesy PhotoVintageFrance: fig. 40

Ela Bialkowska, OKNO Studio; Courtesy Galleria Continua: fig. 26

Richard Bryant/ arcaidimages.com: fig. 22

Joseph Coscia, Jnr.; Courtesy Salvatore Ala Gallery, New York: fig. 17

Charles Duprat; Courtesy Galerie Thaddaeus Ropac: fig. 31

© Edifice / Bridgeman Images: fig. 13

EHT Collaboration; Creative Commons Attribution 4.0 International License: fig. 49

Benjamin Katz © DACS 2019: fig. 23

Helmut Kunde: figs 16, 29

Jorge Lewinski © The Lewinski Archive at Chatsworth / Bridgeman Images: fig. 10

London, © Alamy Stock Photo/Albert Knapp: fig. 44

London, Blast! Films: p. 258

MACS0416 courtesy of ESA/Hubble, NASA, HST Frontier Fields and J. Lotz, M. Mountain, A. Koekemoer and the HFF Team; Creative Commons Attribution 4.0 Unported license: fig. 50

MACS J0416.1-2403 courtesy of ESA/Hubble, NASA, HST Frontier Fields and Mathilde Jauzac (Durham) and Jean-Paul Kneib (EPFL, Switzerland); Creative Commons Attribution 4.0 Unported license: fig. 51

Yuri Molodkovets: figs 24, 25

Nigel Moore. Reproduced by permission of The Henry Moore Foundation: fig. 41

NASA, ESA, and Johan Richard (Caltech, USA) and Davide de Martin & James Long (ESA/ Hubble): fig. 52

Paris, © Centre Pompidou, MNAM-CCI, Dist. RMN-Grand Palais / Adam Rzepka: fig. 38

Priyamvada Natarajan et al, doi: 10.1093/mnras/stw3385: fig. 53

Prudence Cuming Associates: pp. 157–159, 173

Antonia Reeve: figs 3, 4, 5, 6

Henning Rogge: fig. 30

© Oak Taylor-Smith: figs 35, 36 (Courtesy Galleria Continua); pp. 2–3, 9, 73–75, 77–83, 85–99, 101–07, 109, 111, 113, 115–121, 127–129, 131–33, 185–91, 193–97, 199–205, 207–09, 215–27, 248–49, 251–55, 257

Jan Uvelius; Courtesy of Malmö Konsthall, Sweden: fig. 1

Venice, Peggy Guggenheim Collection, 76.2553 PG 135: fig. 45

Andreas Von Einsiedel: fig. 7

Boyd Webb © Boyd Webb. All Rights Reserved, DACS 2019: fig. 2

Benjamin Westoby: fig. 21 (Courtesy White Cube, London)

Stephen White & Co.: figs 27, 28, 32, 37, 46, 47; p. 247; cover

© Ray Woodbury, AGNSW: fig. 19

Zurich, Joachim Stadel, University of Zurich: fig. 54

Additional Copyright

Constantin Brancusi © Succession Brancusi – All rights reserved. ADAGP, Paris and DACS, London 2019: fig. 38

Alberto Giacometti © The Estate of Alberto Giacometti (Fondation Giacometti, Paris and ADAGP, Paris), licensed in the UK by ACS and DACS, London 2019: fig. 45

Antony Gormley © the Artist: figs 1–37, 39, 43, 46–48; pp. 2–3, 9, 11, 73–75, 77–83, 85–99, 101–07, 109, 111, 113, 115–21, 123, 125, 127–29, 131–33, 135–37, 139–43, 145, 147–55, 157–59, 161–67, 169–71, 173, 175, 177–83, 185–91, 193–97, 199–205, 207–09, 211–13, 215–27, 229–37, 239–45, 247–49, 251–55, 257

Anish Kapoor. All Rights Reserved, DACS 2019: fig. 9

Henry Moore © Reproduced by permission of The Henry Moore Foundation: fig. 41

Germaine Richier © ADAGP, Paris and DACS, London 2019: fig. 42

Lenders to the Exhibition

D.Daskalopoulos Collection
Duerckheim Collection
Dr Michael Gormley
Jill and Peter Kraus
PinchukArtCentre, Kiev
Museum Voorlinden, Wassenaar

and others who wish to remain anonymous

Index

All references are to page numbers; those in **bold** type indicate catalogue plates, and those in *italic* type indicate essay illustrations

Afghanistan 259
Agamben, Giorgio 50
Alaska 263
Amazon Basin 261
Ambrose, Father 259
Ampleforth College 259
Andre, Carl 260
Anthropocene epoch 46–48, 52
Antigone (Sophocles) 54
Antony Gormley: Being Human (BBC film) 263
'Antony Gormley: Essere', Florence (2019) 34, *35*
'Antony Gormley: New Sculpture', New York (1984) 20
'Antony Gormley: Still Standing', St Petersburg (2011) 31–34, *34*
Arctic 262
Arendt, Hannah, 'The Conquest of Space and the Stature of Man' 55
Arizona Desert 22
Art Gallery of New South Wales, Sydney *27*, 261
Auschwitz 46
Australia 24, 27, 228, 262, 263
Austrian Alps 54, 263
Aztecs 260

Bałka, Mirosław 261, 262
Ballard, Lake 27, 262
BALTIC Centre for Contemporary Art, Gateshead 262
Bamiyan Buddha 259
BBC 48, 51, 263
Beijing 262
Bellenden Road studio, Peckham, London *21*, 261
Bengal 259
Benjamin, Walter 52
Berger, John, *Ways of Seeing* 66
Berlin 262
Bern 263
Bernhard Heiliger Award for Sculpture 262
Beuys, Joseph 263
Big Bang 56, 58, 60, 63
Bihar, India 259
Birmingham 261
black holes 56, *57*, 59, 63
Brancusi, Constantin 42–46, 263
 Le Commencement du monde 46, *46*
 Endless Column 24, 42, 46

Brand, Stewart 261
Brecon Beacons 260
Brighton School of Art 260
British Council 260, 261
British Museum, London 51, 259
Brixton, London 261
Brody, Hugh 262
Buddhism 17, 52, 134, 259
Bunting, John 259
Burnett Miller Gallery, Los Angeles 261

Calais 50
Cambridge University 259
Canada 261
Cape Farewell 262
Carnac, France 260
cave art 48, 51, 156, 260, 263
Central School of Art, London 259
CERN 263
Channel 4 television 261
Charleston, South Carolina 261
Cherkaoui, Sidi Larbi 262
Chiapas people 260
China 259, 262
Chipperfield, David 262, 263
Chomsky, Noam 259
Chongqing, China 262
Cipolla, Roberto 263
Clay and the Collective Body project 263
Clerkenwell, London 259
Cleveland, Ohio 46
CND 47
Cold War 47, 48
Cologne 31
'The Condition of Sculpture', London (1987) 259
Coniston Water 138
Connemara, Ireland 260
consumerism 66
Coomaraswamy, Ananda 259
Copenhagen 263
Copernicus, Nicolas 54, 58
Cosmic Background Explorer (COBE) satellite 60–63
cosmology 56–63
Cragg, Tony 260
Craig-Martin, Michael 259
 An Oak Tree 259
Crosby Beach, Merseyside 24, 262
Cuxhaven, Germany 24, 262

Dalhousie, India 259
Dark Ages 59
dark energy 56, 58–59
dark matter 56, 58–59, *59*, 60–63, *62*, *64–65*

Darwin, Charles 54
De Maria, Walter 17–20, 22
 Lightning Field 24, 260
 Mile-Long Drawing 260
Deacon, Richard *20*, 260
Death Valley, Arizona 260
Delos, Greece 263
Denmark 261
Derry, Northern Ireland 22–24, *22*, 261
Documenta 8, Kassel (1987) 261
Dordogne, France 260
Drury, Alfred 9, 72

Earth Summit (1992) 160, 261
Edward III, King 50
Egypt 259
Einstein, Albert 58, 60
Elbe estuary 24
Eliot, T.S. 20
Enlightenment 37, 46
Epstein, Jacob 263
 Elemental 260
ether 59–60

Fishbourne Roman Villa, Sussex 259
Florence 34, 35, 263
Forte di Belvedere, Florence 263
France 260, 263
Freud, Sigmund 54
Friedmann, Alexander 58

galaxies 58, *59*, 60–63, *61*
Galerie Nordenhake, Stockholm 261
Galerie Thaddaeus Ropac, Paris 261, 262
Galleria Continua, San Gimignano 262
Gateshead 9, 24, 262
Gavrinis, France 260
Germany 24, 27–31, 46, 261, 262
gestures 50
Giacometti, Alberto 52, 263
 Cave Model 51
 Piazza 50, 51
Gill, Eric 259
Giza, Great Pyramid 259
Goenka, S.N. 259
Goethe Institute 261
Goldsmiths College, London 259
Gormley, Antony *258*
 art education 259–60
 body and light drawings 160, **162–67**
 body-case sculptures 17–22, 260
 childhood 47, 259
 clay works *9* (works in progress), **222–23, 226–27**, 246, **247–49**
 Clearing drawings 168, **169–73**
 concrete works 198, **199–209**

early drawings 134, **135–37**
exhibitions 14–17, *16*, 20, *20*, *22*
honours and awards 261, 262, 263
landscape drawings 138, **139–45**
Matrix drawings 210, **211–13**
North Light drawings 122, **123–25**
public sculpture 22–27, 67–68
Red Earth drawings 228, **229–45**
studios *17*, *21*, 259, 261, 262, 263
Testament drawings 146, **147–55**
travels 17, 259
woodblocks and body prints 156, **157–59**
workbooks 174, **173–83**
According to the Earth **237**
Allotment II 262
American Field 26–27, *54*, 261
Angel of the North 9, *23*, 24, 52, 261, 262
Another Place 24, *25*, 262
Apart **149**
Asian Field 262
Attempting Re-entry **162**
Baobab II **164**
Base **200**
Bed 260
Between People Between Worlds **165**
Black **240**
Blanket Drawings 17
Blanket Drawing V **98**
Blind Light 38, *38*, 262
Blockworks 31, 262
Body 39, 192, **193–97**, 198
Body and Light **164**
Body Light Weight Water **162**
Body Prints 156
Border VII **78–79, 82–83**
Brain **233**
Branches **232**
Bread 17
Bread Line *20*, 260
Breathing Room 262
Brick Man 261
Brink **162**
Broken Column 24
Cave 37–38, *39–40*, 51, **200–01**, 214, **215–27**
Cells **232**
Chord 263
Chromosphere **125**
Clearing 54
Clearing I *39*, 262
Clearing L **171**
Clearing VII 37, 38, 39, 100, **101–07**, 109
Clearing 57 **170**
Commune II **165**

267